CAMBIOS:

The Spirit of Transformation in Spanish Colonial Art

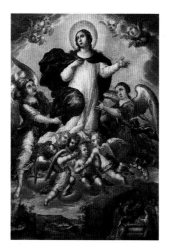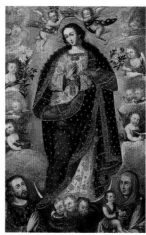

FRONT COVER

The two Baroque paintings that grace the cover are *The Assumption of the Virgin*, from the workshop of Juan Correa (left), and *The Immaculate Conception*, from the school of Diego Quispe Tito (right).

Quispe Tito was an Indian, proud of his Inca heritage, who worked in Cuzco. Correa was a mulatto who directed a large workshop in Mexico City. Thus these two artists exemplify the rich ethnic diversity that characterized Spanish colonial society and represent, as well, the two principal viceroyalties of the Spanish empire, Mexico and Peru.

In Europe the coming of the Baroque style marked a shift from cool classical restraint to a growing freedom of form and color. In the New World the Baroque was expressed in unfurled, open silhouettes and the bold articulation of three-dimensional forms, in an emphasis on decorative surfaces and the inclusion of naturalistic details—in short, in representations enlivened by color and native vitality. Colonial artists such as Quispe Tito and Correa found in the Baroque a style through which they could express their own individuality.

Stylistically and chronologically *The Immaculate Conception* is the earlier work. This painting owes much in composition and form to Spanish prototypes. However, in the colonial work the figure of the Virgin almost fills the canvas, and the love of decorative detail, which would become one of the hallmarks of colonial art, is already apparent. The distinctive protrayal of feminine grace and religious sentiment also reveals the subtle transformation of European forms modulated by colonial sensibilities.

In Correa's *Assumption of the Virgin* the fullness of Baroque vitality is even more apparent. The Virgin is borne to heaven on a wedge of flying angels. Again, the composition owes much to its European parentage, although the design speaks of an American spirit. In the victorious ascendancy of the Virgin, it is easy to read an assertion of the colonial artist's own growing claim to freedom, which both anticipated and mirrored the future of Spanish colonial society as a whole.

CAMBIOS:

THE SPIRIT OF TRANSFORMATION IN SPANISH COLONIAL ART

ESSAYS BY GABRIELLE PALMER AND DONNA PIERCE

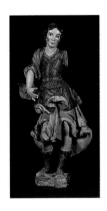 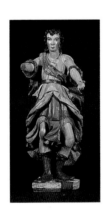 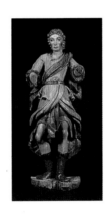 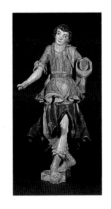

To Tim Sandlin —
With much respect
and affection —
Donna Pierce
July 31, 1993

PUBLISHED BY
SANTA BARBARA MUSEUM OF ART
IN COOPERATION WITH
UNIVERSITY OF NEW MEXICO PRESS

PUBLICATION CREDITS

Published by the Santa Barbara Museum of Art
in cooperation with the University of New Mexico Press
1720 Lomas Blvd. N.E., Albuquerque, NM 87131

Designer: John Balint
Editor: Andrea Belloli
Publications Manager: Cathy Pollock
Printed in Japan by Dai Nippon

PHOTOGRAPHY CREDITS

Damian Andrus: cat. nos. 1-3, 9, 11-16, 21, 24-26, 30, 31, 32A-B, 33, 64, 66A, 67B, 69, 70B, 71A-B, 72A-B, 80A.
Arizona State Museum, University of Arizona: pp. 18 (top & bottom), 60 (right), 78 (bottom), 81.
Scott Borden: cat. nos. 19, 20, 27, 36, 37, 38A-B, 40A-B, 43, 46, 47, 49, 54, 80B, 81A, 82A, 85, 97, 103, 104A, 105, 106B, 107.
Blair Clark: cat. nos. 8, 17, 28, 48, 53, 58A-D, 62, 67A, 67C, 70A, 74, 77A-D, 78, 81B, 87-91, 93-96, 98, 102, 108-112, 113A-B, 114, 117.
Bill Dewey: cat. nos. 4, 5, 22, 35, 39A-B, 44, 76, 86, 92, 99, 106A, 116.
Foto Estudio Bodo Wuth: p. 42.
Foto Hirz: pp. 30 (top & bottom), 35 (top & bottom), 46 (bottom).
Foto Teresa Gisbert: pp. 15, 16, 19, 45.
Roger Fry: cat. nos. 68B, 79, 82B, 118.
Susan Hamilton: cat. no. 50.
Wayne McCall: cat. nos. 23, 82C, 104B.
Hispanic Society of America, New York: p. 63 (left).
Museum of the Banco Central del Ecuador, Quito: p. 54 (top & bottom).
Anthony Peres: cat. nos. 18, 41, 63, 73, 81C, 82D, 83, 100, 101.
Craig Smith: cat. no. 75A.

LIBRARY OF CONGRESS
CATALOGING-IN-PUBLICATION DATA

Palmer, Gabrielle G., 1938-
 Cambios: the spirit of transformation in spanish colonial art / essays by Gabrielle Palmer and Donna Pierce.
 p. cm.
 Includes bibliographical references and index.
 ISBN 0-8263-1408-2. ISBN 0-8263-1408-0 (pbk.)
 1. Art, Latin American. 2. Art, Spanish colonial—Latin America.
I. Pierce, Donna. II. Title
N6502.2.P35 1992
709'.8' 09032—dc20 92-16521
 CIP

BACK COVER

Miguel Cabrera
Castas (Depictions of Racial Mixtures), 1763, oil on canvas
Collection of Elisabeth Waldo-Dentzel, Multicultural Arts Studio, Northridge, CA.

TITLE PAGE

Unknown artist
Four Angels, wood, paint
Collection of Constance McCormick Fearing

NOTE TO THE READER

All measurements are given in inches; height precedes width precedes depth.

ABBREVIATIONS

IFAF, MOIFA, Santa Fe: Collection of the International Folk Art Foundation at the Museum of International Folk Art, Museum of New Mexico, Santa Fe.

IIICA, Palace of the Governors, Santa Fe: International Institute of Iberian Colonial Art, Palace of the Governors, Museum of New Mexico, Santa Fe.

IIICA, UNM: International Institute of Iberian Colonial Art, University of New Mexico, Albuquerque.

MOIFA, Santa Fe: Museum of International Folk Art, Museum of New Mexico, Santa Fe.

SCAS, MOIFA, Santa Fe: Collections of the Spanish Colonial Arts Society, Inc., on loan to the Museum of International Folk Art, Museum of New Mexico, Sante Fe.

UNM: University of New Mexico, Albuquerque.

TABLE OF CONTENTS

PREFACE

ROBERT HENNING, JR.

OVER THREE YEARS AGO this project was conceived and launched during a series of discussions with a small group of advocates and friends, notably Marie Carty, Michael Haskell, and Constance McCormick Fearing. Throughout every stage they have continued to assist and encourage me while providing many helpful suggestions. Once it was decided to organize an exhibition based on broad themes and illustrated as much as possible with little known examples of Spanish colonial art from regional collections, we met frequently and refined our ideas while compiling lists of collectors and of specific works that would exemplify the range and quality of artistry and craftsmanship needed for our thematic approach. These discussions and the on-going support of local individuals have been of great help as the complex process of shaping the exhibition developed. Key to this process was the selection of the appropriate scholars to oversee and coordinate the two main sections of the exhibition, while working together to maintain a balanced view and communicating with experts in the various fields represented by the array of objects that make up the exhibition. Thus, the entire project is the result of a vital collaboration between the consulting curators, Donna Pierce and Gabrielle Palmer who, in addition to their specific knowledge, brought a truly open, enthusiastic spirit to the difficult task of elucidating the broad themes of the exhibition while selecting and researching works of quality and authenticity to demonstrate the key points that would substantiate our thesis. This involved many hours of meetings, diplomatic negotiations with lenders, careful consultation and research with experts in Europe, Latin America and the United States, and a high degree of 'give-and-take' in our endeavor to create an effective exhibition as well as a publication of merit and usefulness. Due to our curators' unfailing patience and professionalism, this project has been thoroughly enjoyable and rewarding. We presented the project to Dr. Jacinto Quirarte in its final stages and are grateful to him for his support in the form of his perceptive introductory statements which set the stage for the essays that precede the two sections of this book.

We strove to create an exhibition representing both the art and decorative arts of Mexico and South America produced during the Vice-regal period (approximately mid-sixteenth through the early nineteenth centuries), not as seen in their chronological or stylistic contexts but rather as individual masterpieces, selected to illustrate several related themes, the central guiding theme being the process of 'transformation' by which various elements—indigenous art forms, motifs and skills; the European influences that were either imposed or absorbed; the imported artists and objects—were fused over time into new, vital artistic styles and forms. In the profusion of publications and exhibitions inspired by the 1992 anniversary of the historical turning point in 1492, there seemed to be a place for reflecting in the form of a broad overview on the variety and originality of works of art created during the period of Spanish rule in Latin America and a need to study what attributes the art of this period share in common. It is gratifying to know that our efforts have resulted in discoveries and new attributions, that hitherto unexhibited works of importance have been brought to light and that needed conservation work on a number of objects was carried out for this project.

From the beginning, our plan was to select paintings, sculptures, furniture, ceramics, textiles and silver

objects from the broad geographical and chronological span of the colonial period, using American collections and selecting, whenever possible, works that were previously unpublished. We sought works of art that would "speak" about the complex process of transformation, to show what endures as lasting evidence of the interaction of very different cultures: the established, highly developed indigenous pagan cultures of the New World, the conquering, evangelizing Christian cultures of the Old World. The works of art produced in this process of "cambios," or transforming change, are eloquent testimony to a creative force that is strong and new, a force that informs and shapes the art of the colonial period. In the diversity of media from some two hundred and fifty years, we sought the threads that wove the syntax of Spanish colonial art and that tied together the experience of transformation and the spirit or "will to create" that brought it about.

Many knowledgeable people have had a role in this project, among them collectors and lenders have played a crucial part. Their names appear throughout the book but a few must be singled out here for special mention; among these, Mr. Pál Kelemen was an enthusiastic guiding spirit; and Edward Holler and Samuel Saunders were models of flexibility, hospitality and generosity who, like the other lenders, allowed us to pick and choose among their treasures, providing helpful guidance without imposing their opinions on the process. John Conron and John Jacobsen, representing the International Institute of Iberian Colonial Art, facilitated the loan of many important paintings from that collection; Mr. Tom Livesay, Director, The Museum of New Mexico, working with his staff at the Palace of the Governors and the Muse-

um of International Folk Art, made it possible to obtain numerous loans; the Arizona State Museum provided comparative photos on short notice; Lewis I. Sharp and The Denver Art Museum staff were generous although in the midst of a major renovation. Dr. Michael Weber, Executive Director of the Arizona Historical Society; Johanna Hecht, Associate Curator, Department of European Sculpture and Decorative Arts, The Metropolitan Museum of Art; and Peter Walsh, Director of the Art Museum of the University of New Mexico are among those who cooperated with us in the lengthy process of research and preparation for the exhibition. Individual collectors were most generous in allowing us to visit and study works in their collections, and the photographers—credited elsewhere in this publication—went to great lengths often in difficult circumstances to obtain the best possible reproductions.

It would never have been possible to carry out this extensive process of planning research, travel, photography, correspondence and the creation of a major exhibition with its accompanying publication without the extraordinarily generous aid of the Dan Murphy Foundation both through the on-going support of the Bernardine Murphy Donohue Exhibition Fund established at the SBMA in 1985 and also with a special contribution from the Foundation made for this project in particular. We are deeply indebted to Mr. Daniel Donohue, President of the Foundation and Richard A. Grant, Jr. for their assistance and their confidence which enabled us to realize our fullest ambitions for the project.

As co-publisher of this book, the University of New Mexico Press has been supportive from the beginning and thanks go to Dana Asbury and Beth

Hadas for their suggestions and expertise. Andrea Belloli ably edited the text and John Balint's book design provides an excellent showcase for the material. It is our hope that this publication provides a part of the foundation and an encouragement for further studies of Spanish colonial art leading to the understanding and appreciation it deserves.

On behalf of Gabrielle Palmer, thanks are extended to the following: Arq. Alfonso Ortiz C., Director of the Museums of the Municipality of Quito and his assistant, Nancy Moran de Guerra; Magdalena Gallegos de Donoso, Director of the Museum of the Banco Central del Ecuador; Lcda. Ximena Escudero de Terán; Sarita de Lavalle; The John Davis Family; Raul Apestaguía; Mariano Paz Soldán; Vivian and Jaime Liébana; Teresa Gisbert de Mesa; Teresa Villegas de Aneiva; Victoria Cabrera; Richard Ahlborn, Museum of American History at the Smithsonian Institution; Dr. Cristina Esteras Martín for the introduction and captions on South American silver; Bruce Takami, and Imelda de Graw of the Denver Art Museum; Margaret Oppenheimer of the Hispanic Society of America; and Anne Peacocke.

On behalf of Donna Pierce, appreciation is extended to Dr. Marcus B. Burke; Johanna Hecht; Marita Martínez del Río de Redo; Dr. Cristina Esteras Martín; Dr. Thomas E. Chávez and the staff of the Palace of the Governors; Charlene Cerny, Robin Farwell Gavin, Claire Munzenrider and the staff of the Museum of the International Folk Art; Dr. Marion Oettinger of the San Antonio Museum of Art; Paul Gerber and the Spanish Colonial Arts Society; Dr. Bernard Fontana, University of Arizona; Cathy Hubenschmidt of the Arizona State Museum; Clayton Kirking, Phoenix Art Museum; Nora Fisher; Timothy Dwight Hobart; Drew Allen; Sandy Oesterman; and Joan Tafoya. ∎

CONTRIBUTORS

GABRIELLE PALMER, Ph.D. (Art History, University of New Mexico), is a specialist in Spanish colonial art and author of *Sculpture in the Kingdom of Quito*. She directed the restoration of the Santuario de Guadalupe, an eighteenth-century church in Santa Fe, NM. Since 1989 she has been director of the Camino Real Project, which has undertaken a number of initiatives to preserve and publicize the Camino Real de Tierra Adentro, an historic trail which for 300 years linked New Mexico to Mexico City. A related travelling exhibition, *El Camino Real: Un Sendero Histórico*, was funded by the National Endowment for the Humanities.

DONNA PIERCE, Ph.D. (Art History, University of New Mexico), has consulted and organized exhibitions of Mexican art at numerous museums including the Brooklyn Museum, the Minneapolis Institute of the Arts, and most recently the Metropolitan Museum of Art in New York, where she participated in the major exhibition *Mexico: Splendors of Thirty Centuries*. She has authored two books featuring the photographs of Eliot Porter and Ellen Auerbach, *Mexican Churches* and *Mexican Celebrations*, both published by UNM Press, and holds the position of curator and research consultant at the Palace of the Governors of the Museum of New Mexico and the Spanish Colonial Arts Society in Santa Fe.

JACINTO QUIRARTE, Ph.D. (Art History, National Autonomous University of Mexico), is a professor in the Division of Art and Architecture, College of Fine Arts and Humanities at the University of Texas at San Antonio. His specialty is the history and criticism of Latin American and Hispanic American art. He is the author of several books, monographs, articles, and reviews on pre-Columbian, colonial, and modern Mexican art, including *Mexican American Artists*, *Izapan Style Art*, and *The Art and Architecture of Ancient Guatemala*.

Other contributors include Dr. Cristina Esteras Martín (CEM) and Brian Parshall (BP).

INTRODUCTION JACINTO QUIRARTE

A LARGE NUMBER OF BOOKS and countless scholarly papers and newspaper and magazine articles have been published on the art and architecture of the Americas over the last sixty years (Burke 1979, pp. 16-18). Such studies have helped to define the national identity of the countries in which the objects and monuments were produced. In the vast majority of these publications, scholars have grappled with questions about the nature and quality of colonial art and architecture. Is it European, Indian, or a combination of the two? Which tradition is dominant? The art and architecture of some of the former Spanish dominions is clearly a direct translation of European models. In other countries with large indigenous populations, objects and monuments are the result of an amalgamation of European and Indian traditions.

Today scholars continue to study these as well as many other questions as they seek to gain a fuller understanding and greater appreciation of these materials. *Cambios: The Spirit of Transformation in Spanish Colonial Art* adds to this effort. This book and related exhibition are unique for two reasons. First, they include objects from the entire hemisphere. Second, they organize those objects thematically. A thematic focus frees us from having to place each object within a particular stylistic sequence. Instead we appreciate it in the context of a particular thematic structure. This approach allows us to see the many variations of a single theme over a vast area in which certain beliefs and points of view were shared but in which artists responded to their own particular circumstances in individual ways.

In order to understand the significance of this kind of organization, it is useful to review previous exhibitions of colonial art (Quirarte 1988, pp. 68-71). Two examples, representing two extremes in focus, selection, and interpretation of works from a single country, encapsulate the ways in which these materials have been studied. Rene d'Harnoncourt, who organized the 1930-31 exhibition entitled *Mexican Arts* for the Metropolitan Museum of Art, New York, included works of colonial art which reflected an indigenous sensibility. He was concerned to present objects that were "an expression of Mexican civilization;" his aim was to present "a Mexican interpretation of Mexico" through its arts. This approach was in keeping with all the efforts to find a new Mexican identity based on the ideals of the Mexican Revolution of 1910—to bring the indigenous populations into the economic, political, and educational life of the nation.

Almost fifty years later, Linda Bantel and Marcus Burke sought to draw formal and thematic parallels between Spain and her former colony in the 1979 exhibition *Spain and New Spain*, organized for the Art Museum of South Texas, Corpus Christi. Bantel and Burke were interested in displaying "Mexican colonial arts in their European context," in stressing what was European rather than Mexican in those arts. This approach contrasted with that of the vast majority of scholarly publications and exhibitions mounted during the previous fifty years, which emphasized the Mexican nature of colonial art.

Other exhibitions with a focus on the richness and variety of Mexico's vast artistic heritage have been, and continue to be, presented in the United States. Among these have been *Two Thousand Years of Mexican Art* (1940), organized for the Museum of Modern Art, New York; *Treasures of Mexico* (1978), organized for the Smithsonian Institution, Washington, D.C.; and *Splen-*

dors of Mexico (1990-91), also organized for the Metropolitan Museum. These exhibitions and others like them aimed to define Mexico's national identify, enhance its image abroad, and strengthen its relations with other countries.

Numerous exhibitions of the colonial art of the rest of Latin America were presented during the same period. Among these were *Peruvian Colonial Painting* (1971-72), organized by Pál Kelemen for the Brooklyn Museum, and *The Cuzco Circle* (1976), organized by Leopoldo Castedo for the Center for Inter-American Relations, New York. In each case the aim was to emphasize the artistic quality of the works displayed.

Historians of colonial art and architecture have used the "generating centers model" to explain the development of these arts in the Americas. This model posits that all forms were created in Europe and then transmitted to the Americas, where local artists and craftspeople received them from their European masters (Quirarte 1979, pp. 1-3). Such a model is based on the idea that styles originate in major centers of production, which serve as sources for forms transmitted to the periphery. Other factors considered in relation to this model are the distance of the artist on the periphery from the center and the length of time it takes to receive signals or forms from there (Kubler 1962). The further away from the center, the weaker the signal and the longer the delay in its reception. With this model in mind, historians can place works of art within their respective spheres of influence.

Each major European style was introduced into the Americas in a variety of ways by friars, architects, artists, craftspeople, and others over a period of many years. They were first transmitted to the capitals of the viceroyalties. From there they were sent on to the provinces and far reaches of the realm, including the frontiers, where styles often arrived long after they had reached their fullest development or been superseded elsewhere. Some centers and outlying areas favored certain styles over others due to local conditions, among them being economic, political, demographic, and geographic conditions, as well as available resources.

In the Americas, where major civilizations developed over thousands of years in Mesoamerica and the Andean region, the relationship between the centers and the periphery following the Spanish conquest was far more complex than in other parts of the world. It was a matter of one civilization superseding another, one race dominating another. The introduction of new forms and concepts, techniques, and other innovations led to the creation of art and architecture that differed in form and spirit from models found in metropolitan centers.

How is this art to be interpreted? Is it the result of an indigenous sensibility, or is it simply provincial or folk art? While most scholars accept the former interpretation, others prefer the latter one. Scholars have posed two questions in their efforts to determine the extent and nature of the contributions made by indigenous artists and craftspeople. First, did any forms and ideas survive from the pre-Columbian world? Second, could forms created in rural areas be attributed to an indigenous sensibility? Although there is general agreement regarding the first question, there is little agreement on the second. Most scholars believe that very little indigenous culture survived the conquest, that the overall development of art and architecture in the Americas was essentially European in form and meaning (Kubler 1961, pp. 14-34).

The controversy revolves around the interpretation of works produced by largely indigenous artists and craftspeople in rural areas. The standard designation for rural areas inextricably linked to an urban metropolitan center that serves as a source for ideas, forms, and training is *province*. Art produced in such areas is rightly called provincial. If the outlying areas are too remote, and artists and craftspeople have to rely on their own resources, without adequate training and despite being bound to models emanating from the center, then what they produce can be designated as folk art.

Those who acknowledge an indigenous sensibility in the art and architecture of the Americas have used the words *tequitqui* and *mestizo* to describe it. José Villa Moreno used the Nahuatl word *tequitqui* (tribute) to describe the Indian sensibility in Mexican colonial sculpture over fifty years ago (Villa Moreno 1942, p. 16). The term *mestizo* was first used by Harold E. Wethey over forty years ago to describe the architectural style that had developed in the Andean highlands between 1680 and 1780 (Wethey 1949). Marcos Dorta preferred to call this style "Andean Baroque" (Dorta 1946-47). The term *mestizo* eventually came to be used to describe other forms that are a mixture or hybrid of European and Indian components. Not all scholars accept the term or the genesis and substance of the forms described by it, however. George Kubler objected to the use of a racial term to describe art forms (Kubler 1961). He further believed that such forms should be called "folk art" because their planiform aspect was more the result of constant repetition by craftspeople far from the centers of production than the result of an indigenous sensibility. Other scholars agree with Kubler's assessment, among them Graziano Gasparini, who has discussed these issues in several publications (Gasparini 1965, pp. 51-66). Other Latin American scholars have used the term *mestizo* without major reservations, among them José de Mesa and Teresa Gisbert (de Mesa and Gisbert 1965, pp. 9-44; idem 1968).

Ultimately, the art and architecture of the Americas can be broken down into two broad categories, that produced in the metropolitan centers, where new ideas and forms were generated, and that produced in rural areas, where these new ideas and forms were received and integrated into yet other formulations and expressions. The disagreement regarding the origin of these forms does not affect the assessment of their artistic quality. That is beyond question. The artistic heritage of the Americas stands as a unique contribution to the history of art and architecture, and it is as an appreciation of that uniqueness that this book and exhibition should be experienced. ■

THE VICEROYALTY OF PERU

The Viceroyalty of Peru, established in 1542, comprised all of the land in South America ruled over by the Spaniards. This territory was gradually increased and eventually subdivided into the Viceroyalties of New Granada (1717) and Buenos Aires (1778), and the Captaincy-Generals of Venezuela (1773) and Chile (1778). These in turn gave way to the modern countries of today.

1 NOMBRE DE DIOS
2 PUERTOBELO
3 PANAMÁ
4 CHOCÓ
5 CARTAGENA
6 BOGOTÁ
7 QUITO
8 GULF OF GUAYAQUÍL
9 GUAYAQUÍL
10 TUMBES
11 LIMA
12 CALLAO
13 CUZCO
14 LAKE TITICACA
15 LA PAZ
16 POTOSÍ
17 VALPARAÍSO
18 BUENOS AIRES

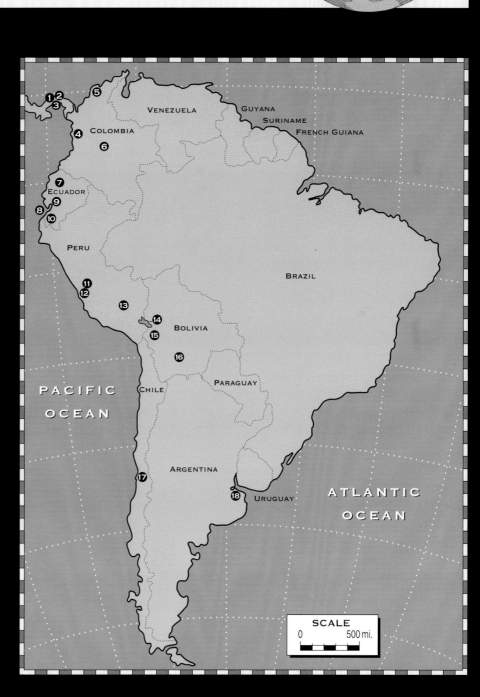

MESTIZAJE

GABRIELLE G. PALMER

THE CHANGING FACE OF SPANISH COLONIAL ART IN SOUTH AMERICA

It is now well known that Columbus wasn't really looking for America when he stumbled on it. While this world he helped to discover may have been new to the Europeans, it was home to civilizations as old as their own, as deeply rooted in time. Once conquered by Spain, the colonial empire of South America was to be ruled by the Spanish monarchy for three hundred years. In the resulting encounter between the peoples of these two worlds, inevitable political, economic, and sociological changes took place. The Spaniards introduced new methods of government, a new language, new crops and livestock, new technologies, a new religion, and new forms and styles of European art. At first these changes were imposed; in time they were accepted and assimilated; eventually, they were totally integrated and became rooted in the very fabric of colonial life.

The change from domination to accommodation, from submission to independence, can be traced in many ways. In the history of art this change is revealed through transformations of European styles and iconography, through the emergence of local artists and themes, and through innovations in local style and iconography. Just as the mestizo, a child born of a European and an Indian parent, symbolizes the emergence of a new self in whom the inheritance of two races is inseparably united, so did Spanish colonial art fuse various elements into a new whole. Two worlds met and something new was born. A seed transplanted to new soil bore new flower, new fruit.

The year 1492 was a fateful one for Spain. In July the Catholic monarchs Ferdinand V and Isabella I celebrated the liberation of the city of Granada from eight hundred years of Moorish domination and the consolidation of the Spanish monarchy in their joint hands. Several months later they gave official sanction to the ambitious Genoese merchant Christopher Columbus to sail in search of the Indies. The old century was coming to an end, a new one was about to be born. The energies the Spaniards had galvanized in the wars against the Moors were now to be released in a new direction that Columbus was to provide.

On his first voyage Columbus, sailing from Gomera in the Canaries, discovered the Caribbean islands. On his third adventure, in 1498, with six square-rigged *caravelas redondas*, he made landfall near the Gulf of París, near the mouth of the Orinoco River on the northeast coast of South America. Other expeditions sailing from Spain undertook further explorations of this area and ascertained the existence of a large land mass lying to the south. By 1519 the Spaniards were situated in Panama. It was during his exploration of the isthmus in 1513 that Vasco Núñez de Balboa sighted the "other sea," the Pacific Ocean, and first heard of a great and rich civilization to the south. In 1522 Pascual de Andagoya sailed as far south as the province of Chocó in Colombia and there received detailed information from merchants and interpreters who knew this kingdom and its people firsthand. However, it would be left to Francisco Pizarro to effectuate the conquest of the Inca kingdom and its vast treasures in a series of explorations which would test his tremendous physical endurance and attest to the tenacity of his ambition. With Pizarro's conquest of Peru, following Hernán Cortés's

earlier conquest of the Mexican Aztec empire, Spain came into possession of one of the greatest overseas empires history has witnessed.

Pizarro had been born in the province of Estremadura, Spain. By 1509 he was in Panama, taking part in a number of expeditions. The news of Cortés's conquest of the Aztecs must have spurred many a soldier of fortune to new dreams, and Pizarro, recalling the earlier accounts told to Balboa and Andagoya, joined forces with Diego de Almagro to finance a modest two-vessel expedition in search of this rumored empire. Their first voyage, which set sail in 1524, returned months later with little more than tales of extreme hardship. On the second expedition, accompanied by the seasoned mariner Bartolomé Ruíz, whom the queen of Spain would in time name Grand Pilot of the Southern Ocean, they reached as far south as the Gulf of Guayaquil on the coast of present-day Ecuador and anchored before the "well-built and well-ordered" town of Túmbez. There they met native tribes, saw clear evidence of an advanced civilization, and heard of its capital far inland. The gold ornaments and emeralds they seized caused a sensation on their return to Panama. Since their plans to mount an even more ambitious expedition soon became mired in local politics, they decided to appeal directly to the Spanish court.

After some delays, Pizarro found himself in Toledo, Spain, in the presence of the young king, grandson of Ferdinand and Isabella, who had inherited much territory in Europe and was about to be crowned Charles V of the Holy Roman Empire. Pizarro's vivid tales and the objects he brought—gold ornaments, live llamas, and some fine weavings—amazed and convinced those who heard him. By July 1529 he had been named governor and captain general of the provinces he had discovered and, enjoined to observe faithfully the tenets of good government and to act as protector of the natives, had returned to his hometown, Truxillo, in triumph. He recruited a cousin and four half-brothers for his new adventure and with them set sail again for Panama. Once there Pizarro organized his third and final expedition, which culminated in the conquest of Peru.

Over the centuries scattered cultures had developed in South America that cultivated maize, beans, and squash and domesticated the llama. In time more sophisticated civilizations settled in the deserts that rim the Pacific and in the valleys leading to the highlands. It was, however, the central Andean region that became home to the greatest civilization in pre-Hispanic South America, the Inca.

With Cuzco as its capital city, the Inca empire, Tahuantinsuyo, came to include an immense territory that stretched from Chile to Ecuador. The Incas administered this vast area by means of a well-ordered hierarchical bureaucracy. They developed a sophisticated urban environment and an advanced system of roads, parts of which were landscaped and paved with stone blocks. Their agricultural practices included irrigation and elaborate terracing. Among their arts were remarkable clay vessels and incredibly refined weavings, as well as a wealth

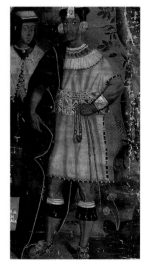

The Royal Inca as portrayed in Spanish colonial times.

of gold and silver ornaments. The Inca himself, the supreme ruler, absolute and autocratic, wore finely woven and embroidered garments made of vicuña, and earlobe and breastplate ornaments fashioned of thinly beaten sheets of gold whose reflected light was an offering to the sun, from which he claimed direct descent. This was the majestic civilization the Spaniards met and vanquished.

Huáscar was ruler of the Incas when the Spaniards made their first tentative landings on his shores and he was told of their coming. It was his brother, Atahualpa, who later met and surrendered to them. On Pizarro's third voyage he and his crew retraced the route they had previously taken. After landing and spending some time exploring the coast, Pizarro set off in May 1532 into the mountainous interior. With only 177 men, 67 of them cavalry, he netted for the Spaniards a king's ransom in gold and a dominion so extensive that it dwarfed the country that was to rule it for the next three hundred years.

After a series of adventures, Pizarro came face to face with the Inca Atahualpa near present-day Cajamarca. Through both courage and duplicity, the Spanish forces were able to capture the ruler. Even after accepting a staggering ransom in gold gathered from his subjects, the conquistadors found a pretext to put Atahualpa on trial and sentence him to death. Pizarro and his men continued their march forward and on November 15, 1533, captured Cuzco, the royal heart of the Inca empire.

In 1493 Pope Alexander VI, in a cavalier gesture, had divided the right to the lands of the South American continent between two loyal Catholic constituents. As formalized in the Treaty of Tordesillas of 1494, the territory that lay west of the line of demarcation was awarded to Spain, that which lay to the east to Portugal. The Viceroyalty of Peru, which Spain established to rule this region, could thus lay claim to lands that stretched from Panama to Chile. It would be years before the Spaniards would begin to have an idea of the vast scale of the South American continent and of the difficulties its topography would present. Sailing along the western shore of South America, the mariners with Pizarro were the first Europeans to sight the glistening summits of the

The Andes, seen from the Bolivian *altiplano*.

Andes, among the highest mountains in the world. Cupped between their parallel ranges stretched high inland valleys; to the east lay the steaming tropics of the Amazon basin. As late as the eighteenth century, Pedro Maldonado, governor of the province of Esmeraldas in the *Audiencia* (an administrative and judicial district) of Quito, addressed a meeting of the Royal Geographic Society in London as follows: "[T]he Kingdom of Peru is wilder and less cultivated than you in Europe can imagine."[1]

The city of Lima was founded on January 6, 1535, as the seat of the Viceroyalty of Peru. One can only imagine the first lonely days, the uncertain attempts at building. But the boldness the Spaniards had already shown was not to desert them now. From the beginning their plans were visionary, and there soon sprang up colonial cities—Quito, Cuzco, and others—whose artistic wealth and architectural beauty remain a source of wonder.

Spanish colonial towns, obediently laid out according to law in regular square blocks, were on the whole airier and more spacious than their European counterparts. The city would become the center of Spanish colonial life, the hub of administration, commerce, and social and economic activity. Each town developed its own character. Lima was situated on a flat plain by the seaside, often bathed in pale mists. Quito lay in a green, fertile land surrounded by volcanoes. Far to the south and even higher in the Andes, La Paz clung to the side of ash-colored hills, brooded over by frozen peaks. The ethnic composition of these towns also developed along different lines. By the eighteenth century the population of Lima was predominantly European and black, since a number of Africans had been introduced through the slave trade. In Cuzco, however, the Indian population was in the

majority, with a sprinkling of Europeans and a fair number of mestizos. In Quito the population was more evenly divided among Europeans, mestizos, and Indians.

Architecturally, these towns shared some important features. A central plaza—the focus of activity—lay at the heart of every city, flanked by the administrative offices of church and state. Nearby stood the convents of the Franciscan, Dominican, and other monastic orders that were authorized to evangelize the natives of America. These enormous complexes included a church, living quarters, arcaded patios, laundries, kitchens, gardens, and orchards. In the New World the medieval monastic institution found new life and renewed purpose. The Catholic church was the most progressive institution in the colonies, taking initiative in the field of charitable works, hospitals, education, commerce, and art. It was also the richest.

It has been estimated that at the end of the colonial period, one-third of the town of Lima was owned by various church entities, and throughout the colonial empire this pattern was to be repeated. The various orders owned and administered vast lands and many properties in both city and countryside. This allowed the churches to become patrons of the arts on a grand scale. They introduced and continued to foster European architecture, painting, sculpture, woodworking, silversmithing, and the like. Art was the means by which the priests first instructed the Indians whom they converted to Catholicism; it was the image—not language—on which the church first depended to disseminate its message.

Spain was still building the last of its Gothic monuments when Ferdinand and Isabella reigned. This medieval style was swept away with the coming of the Renaissance and the Baroque. In general terms, the Renaissance style prevailed from the fifteenth to mid-seventeenth century, the Baroque through the seventeenth and eighteenth, with Mannerism providing a transition, a bridge in between. All of these styles originated in Italy, but it was the Baroque whose influence spread far beyond its geographical borders. Renaissance classicism drew on the artistic forms and precepts of Greco-Roman antiquity to express the tenets of Christianity. Its classical order, lucid articulation of space and clearly ordered compositions reflected the conviction that all fundamental moral and aesthetic canons had been discovered and, in a definitive manner, codified. In the sixteenth century Martin Luther contested the claims of the Catholic church to be the sole interpreter and mediator of the word of God. The appearance of Mannerism coincided with this moment of transition, whose turbulence was expressed in art by the uneasy distortion of forms and juxtaposition of colors. The Catholic church's answers to the Protestant challenge were formulated during the Council of Trent (1545-1547, 1551-1552, 1562-1563), and the emerging Baroque style served to give visible form to the resurgent vitality and faith of the Counter-Reformation.

From Spain the Baroque spread to her overseas colonies, where it held sway in the late seventeenth and eighteenth centuries. As a style it looked back to Roman antiquity for inspiration, favoring themes such as portraiture, landscape, and mythology. Grounded in mystic faith and militant fervor, the Baroque was high-keyed, emotional, florid, and colorful, evidencing an interest in rich textures and the play of light and shade.

Two other styles ran parallel courses with the Baroque: Realism and Classicism. Realism, best exemplified by the works of Caravaggio (1573-1610) portrayed not idealized figures but individuals in the grip of strong emotions. This style found ready acceptance in Spain, where artists reveled in dark religious passions, and a particular resonance during that country's Golden Age of Sculpture in the work of Juan de Mesa (1583-1627) and Juan Martínez Montañés (1568-1648), as well as in the paintings of Francisco de Zurbarán (1598-1662).

While the Catholic countries of Europe fell under the sway of the Baroque, the rational spirit of classicism predominated in France. There too the Rococo was born, reducing the large passions of the Baroque to human dimensions, exalting sensual pleasures and lighthearted play. The Rococo introduced a new decorative system based on light colors and an asymmetrical line, and a new art form, the porcelain figurine. Initiated in France around 1700, the Rococo achieved

its fullest development thirty years later and was particularly influential in Spain. The Rococo in turn was succeeded by the Neoclassical style, which again turned to the forms of classical antiquity for authority, shrugging off decorative excesses.

All of these styles were transmitted to the colonies. In some cases pre-Columbian styles and techniques existed. For example, the Incas were remarkably adept at weaving and working stone. In other cases entirely new techniques, such as easel painting, were introduced. These new forms and technologies were conveyed by European artists and artisans who emigrated to the colonies, through works of art brought from Europe, and by means of engravings. In the course of colonial history, these models were accepted, copied, modified, and then re-expressed in original local styles.

The number of churches built in colonial times is astonishing. There are hundreds of them, not only large, magnificent edifices in populous centers but also more humble ones in remote highland settings. Although faint traces of Gothic architecture still exist in a few colonial churches, the Renaissance, Baroque, and Rococo styles predominate. The coming of Neoclassicism coincided with the end of the colonial era. Colonial churches rarely exhibit unity of style; buildings took a long time to complete, and Europe was far away. A finished church therefore might include a Gothic arch, a Renaissance nave, an elaborate coffered Moorish ceiling, and Baroque altars at the crossing. In time local styles such as the unique planiform designs of highland Peru emerged, while naturalistic motifs and pre-Columbian symbols were taken into the more conservative European vocabulary.

Raw materials had to be obtained for colonial buildings and their decorations. In Quito the quarries of Mount Pichincha lay close by, as did great stands of red cedar. By contrast all the wood used to construct Lima had to be shipped from Guayaquil. The *altiplano* too was bare of trees, and cities in the highlands had to rely on distant sources such as the *Oriente*—the tropic lowlands to the east of the *cordillera*—for wood. Here a wealth of native woods unknown in Europe could be found. They were used for construction as well as for sculpture and furniture making.

Experts in the art of stone construction, the Incas must have adapted easily to European techniques of stonecutting and carving, although wood framing, scaffolding, and carving were new to them. Indians provided the major labor pool for the construction of towns and churches, and they also supplied free labor for the mines, haciendas, and textile workshops from which much of colonial wealth was derived.

Certain innovations in building techniques were introduced in the colonies. *Quincha* was a type of building medium in which gesso was applied over a lightweight structure of cane and then carved into Rococo motifs—a prudent expedient in earthquake-prone Peru. Lima boasted the most beautiful and intricate Moorish wooden balconies, *calles en el aire*, "streets in the air." In Cuzco the presence of the defeated Inca empire was everywhere apparent, and Spanish builders often incorporated huge Inca stones

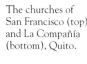

The churches of San Francisco (top) and La Compañía (bottom), Quito.

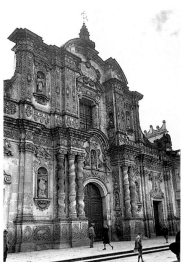

into the foundations of their own buildings. In Quito no vestiges of this past remained. However, only two city blocks separated the churches of San Francisco and La Compañía; to walk this short distance was then (and still is today), to pass from the Renaissance to the Baroque and cover two centuries of art history. The greatest of these colonial churches provide a kind of overwhelming lyric profusion of elements—the huge silver *blandones* (six-foot-high candlesticks), a wealth of gold and silver ornaments glimmering in the half-light, the cloying scent of fresh tuberoses on the altars, and the great organs thundering.

The principal stylistic currents to influence South American colonial painting came from the Low Countries, Italy, Spain, and, toward the end of the colonial period, France. In some cases the transfer from European master to colonial disciple can be documented. The Italian Jesuit Bernardo Bitti (active in Peru 1575-1610) was called to the colony to help in the work of evangelization. He traveled extensively, and examples of his work— delicate paintings of the Virgin and child, beautiful anatomical studies of the resurrected Christ—can be found not only in Lima but also in Cuzco, Potosí, Sucre, La Paz, Arequipa, and Ayacucho. Among a group of disci-

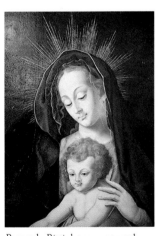

Bernardo Bitti, late seventeenth century, *Virgen del Pajarito* (detail). Cathedral of Cuzco.

ples to whom Bitti taught the stylistic tenets and techniques of Renaissance and Mannerist painting was the Dominican Fray Pedro Bedón. Born in Quito of a Spanish father and Quitenian mother, he came under Bitti's influence in Lima.

When one of Bitti's contemporaries, Mateo Pérez de Alesio arrived in the New World to find his fortune, he brought with him woodcuts and other prints, including a series of engravings by Albrecht Dürer (1471-1528). Engravings and other printed illustrations played a major role in the transmission to the colonies of architectural plans, subjects and styles of painting and sculpture, and designs for ecclesiastical silver and for furniture. European artists had long relied on engravings as sources for composition and detail, and colonial artists and artisans followed their example. The first book to be published in Lima—in 1584 by Antonio Ricardo—included woodcut illustrations, and by 1613 books published in the colonies included engravings. However, European engravings continued to provide the principal source of inspiration for colonial artists. Although these artists remained dependent on imported sources for inspiration, they always maintained a creative attitude toward their models. This is evident in their choices of subjects and in the addition, subtraction, or combination of compositional elements.

The Plantin Press in the Netherlands is often mentioned as one of the organizations most responsible for the dissemination of large numbers of engravings to the Spanish colonies. Flemish engravings, considered the finest in Europe, had a marked effect on painting in the Potosí and Cuzco areas, where the greatest number of original Flemish paintings of the sixteenth century are presently found. Both paintings and engravings by Martín de Vos (1532-1603) and Peter Paul Rubens (1577-1640) exerted a major and long-lasting influence on highland painting.

Imported objects of art also served as models. Numerous works found their way to the colonies, not only to the major cities but to remote areas as well. Since Lima was the capitol of the viceroyalty, it is not surprising to find numerous paintings from the workshops of Rubens and of the Spaniard Zurbarán, as well as a whole series on the zodiac by the Bassani, a family of Italian artists. Commercial organizations played a role in the dissemination of fine arts to the Americas. By the mid-seventeenth century, a number of international firms had been established throughout Europe with representatives in Seville. They were dedicated to the sale of works of art, not only paintings but also carpets, fine furniture, and carved ivory figures.

Southern Spain played a major role in the distribution of art to the colonies. During the reign of Charles V, the Council of the Indies and the *Casa de Contratación* were established in Seville, charged with

managing the administrative, judicial, and commercial affairs of the colonies. Seville continued to serve as the principal link between the Spanish monarchy and its overseas empire until the mid-eighteenth century, when its monopoly was broken and trade with the Americas was liberalized under the reforms of the Bourbon monarchy. Trade with the colonies was a lucrative affair, and as Seville grew in wealth and importance, money was lavished on the arts and a brilliant artistic milieu developed. Architecture, painting, and sculpture all flourished, and quantities of engravings and art goods went to the Indies from Seville and Granada's most important artists and their workshops. Thus, not only the Andalucian style of sculpture was transmitted to the colonies but the religious art of Bartolomé Esteban Murillo (1618-1682) and the Baroque sensibilities of Juan de Valdés Leal (1622-1690) as well.

The materials available to European painters—tightly woven linen canvas stretched over well-constructed frames, and a wide range of colors—were always scarce in the colonies. While some raw materials continued to be imported, attempts must have been made to replace these with less costly local materials that the painter and his apprentices could prepare themselves. Some colonial paintings were executed on wooden panels, although the majority were easel paintings on canvas. Since flax, the preferred material, was imported and thus expensive, smaller pieces were often sewn together to make a larger canvas. In some cases cloth used for packing merchandise brought from Europe was also reused. Cotton or wool was increasingly put to use in the eighteenth century. Exact local sources are unknown, although cotton cloth was manufactured near Quito, as well as in Cajamarca and Chachapoyas, where strong canvas for ship's sails was made. Canvas was glued directly to the edge of the stretcher made of local cedar or alder. Priming material consisted of a red clay ground or of local gypsum and chalk mixed with charcoal or ashes. Linseed and walnut oils were produced locally, as was tempera, made of egg yolk, and varnish, made from resins. The range of available colors increased greatly by the eighteenth century. It was rare that the colonial artist achieved the subtle

transitions and range of color of his European contemporary, relying frequently on bolder, broader designs. *Azul de Castilla* continued to be imported from Spain, as was indigo from Central America. Locally produced colors included ocher, raw or burnt sienna, raw or burnt umber, *oropimente* or *azafrán de Roma* for yellow, and *carmín de cochinilla* or *sangre de dragón* for red, while greens came from copper silicate or green earth.

Religious sculpture carved of wood was also widely distributed throughout the colonies. Diego de Robles (active 1575-1594) provides one example of a Spanish sculptor at work early in colonial history. A native of Toledo, he had worked at the Escorial and at Aranjuéz before emigrating to Seville. By 1584 he was in Quito working on a statue of the Virgin in conjunction with Luís de Rivera (d. 1619), who painted and gilded it. Artists such as these instructed local artisans in the styles, subject matter, and technique of Spanish sculpture. As in other disciplines, engravings provided a principal means of transmission of accepted styles and subject matter. Figures taken from the Old and New Testaments—angels, mystics, monks, and martyrs, as well as various advocations of the Virgin Mary—were oft-repeated themes. Much of early Spanish sculpture had concentrated on panels composed of many figures, carved in high relief and destined for inclusion in altar screens. In the colonies such panels were rare; Fray Pedro Bedón executed a few in Quito. In addition there are a number of fine low-relief carvings in choir stalls, including examples in the cathedral in Lima and in the church of San Agustín in Quito. But it was on the single free-standing image that sculptors eventually focused.

Of all the arts, sculpture was most closely tied to the style and great workshops of southern Spain. Spain's Golden Age of Sculpture is considered to cover a period from 1580 to 1660. The forms of the Italian Renaissance and Baroque were adapted to Spanish sensibility with its emphasis on religious subjects and emotional intensity. Pivotal figures were Juan Martínez Montañés, Juan de Mesa, and Pedro de Mena (1628-1688). Examples from the workshops of these great masters all found their way to South America and continued to influence South American

sculpture throughout the colonial period. Spanish sculpture exhibited a more profound knowledge of anatomy than did its colonial counterpart; the carefully observed and rendered detail of which European artists were routinely capable was rarely grasped by colonial artists, who concentrated on simpler volumes and broader planes.

In Europe pine was one of the woods preferred for sculpture; in the colonies cedar was the most highly prized. Other local woods such as *platuquero, aliso,* and sometimes balsa were also used. One adaptation of a pre-Columbian technique was the use of *maguey* fiber as an armature which, when covered with layers of gesso, could be carved and finished in the same manner as wood sculpture. Although archives in Quito have yielded some names of early colonial sculptors, not infrequently Indian, in general the panorama is one of almost total anonymity. The eighteenth century witnessed the emergence of great mestizo artists such as the Baroque sculptor Bernardo Legarda (active 1731-1762) and Manuel Chilí (active 1750?-1795?), who was most influenced by the Rococo. The distinctive characteristics of Quitenian eighteenth-century sculpture were the buoyancy of its carvings, its spirit and energy, and its brilliant polychrome decorations.

Toward the end of the eighteenth century, new themes were introduced into sculpture and a shift toward smaller scale was evident in carvings of nativity scenes, called *Nacimientos* or *Belenes,* and in copies of the porcelain figurines introduced during the Rococo period in Europe. The inclusion in nativity scenes of small genre figures allowed the colonial sculptor to use as models people from his own society—the mestizo woman carrying poultry to market, the *sereno* or night watchman, Negro dancers whirling to a licentious fandango, while the more circumspect upper classes performed the minuet. This change in subject matter, from sacred to secular, also reflected a change in patronage. At first there was an exclusive dependence on the church and the wealthy upper classes for commissions. Eventually, the middle classes also became patrons. Finally, artists came to rely on the open market.

In the sixteenth century Spain had been ruled by the Hapsburgs. First Charles V, then his son Philip II, had consolidated this absolutist monarchy, reinforcing its political and ideological alliance with the Catholic church, and further developing the authoritarian and monopolistic policies that characterized Hapsburg rule. After the death of Philip II, Spain was ruled by a succession of increasingly inept Hapsburg kings, of whom Charles II (1665-1700) was the last. During this decade, the country suffered from poor administration, the decay of its economy, and a steady loss of political prestige. Continual wars with other European countries drained its energies and diverted its attention from its overseas colonies. Blockades interrupted colonial trade, and Spain's bureaucratic power over the colonies gradually waned. In the last decades of the seventeenth century, the French king Louis XIV established his nephew, Philip of Anjou, as Philip V, the new king of Spain, thus inaugurating the rule of the Bourbon dynasty.

As Spain's powers waned, the strength of the colonies increased. In the course of the seventeenth century, Lima rose to become a glittering city, its growing wealth garnered from trade, agriculture, and mineral sources. Throughout the viceroyalty cities grew and flourished, although in mining centers such as Potosí the Indian population decreased alarmingly. There was a rise in intercolonial trade and in the general level of wealth and well-being in the colonies.

The coming of the Bourbon monarchy, at the dawn of the eighteenth century, initiated a gradually accelerating progress toward liberal reform that was felt in the colonies. Allied to the courts of both Italy and France, Spain became increasingly receptive to the current of more modern and liberal European thought. The forces for renewal culminated in the enlightened rule of Charles III, under whom Spain prospered again. Governmental policies included a reorganization of the bureaucracy, legal reforms, urban renewal, liberalization of guilds, freedom of trade, and a separation of the secular government from religious institutions and affairs. This spirit of reform and the specific measures taken by the Spanish government had a decisive and beneficial effect on the life of the colonies, an effect that was particularly apparent in the last quarter of the eighteenth century. It was left

to Charles IV (1788-1808) and Ferdinand VII (1808) to preside over the dissolution of the colonial empire. One by one in the early nineteenth century, the colonies of Spanish America won independence from the country which had ruled them for almost three hundred years.

Charles III is recognized as one of the greatest monarchs of modern times. During his reign (1759-1788), liberal administrators, who were friends of Voltaire, Rousseau, and other French intellectuals and thus were open to the newer currents of thought, effectuated both economic and political reforms. The writings of John Locke and Isaac Newton were also eagerly received. Belief in a free trade policy allowed relaxation of the trade monopolies with America. This trade had previously been restricted to the ports of Cádiz and Seville; in 1765 and 1778 trade with the colonies was opened to all of Spain's major ports and to other countries. This signaled an influx of new merchandise into the colonies, of new books and of new liberal ideas.

In the second half of the eighteenth century, the age of science was sweeping Europe. The Royal Botanical Gardens of Madrid had been founded in 1755. Its directors, recognizing the potential contributions of botanical studies to the fields of agriculture and medicine, were in the forefront in organizing scientific excursions to the Americas. Of the three great botanical expeditions launched during the reign of Charles III, two worked exclusively in South America: the Ruíz and Pavón expedition in Peru (1777-1815) and the Mutis expedition in Nueva Granada (1783-1816). Colonial artists from workshops in Quito and elsewhere were recruited to execute the drawings of specimens of native American plants carefully chosen by professional botanists. Accustomed to painting the subjects of mythology and religion, their work now focused on factual observation. They were asked to draw, in full color and precise detail, various phases of the development of the living specimens placed before them, according to the categories formulated by Carolus Linnaeus. Not only did this new subject matter require new skills; it implied a totally new orientation. The beauty and precision of the many thousands of plates in *La flora de Bogotá* and *La flora huayaquilense*, which survive

today in the collections of the Royal Botanical Gardens, Madrid, attest to the artists' success. In this new work science and fine art met and a new sensibility was born.

Soon after Charles IV mounted the Bourbon throne, the French Revolution erupted. In the turbulent years that followed, power shifted back and forth between those who defended tradition—the church and the monarchy—and those who subscribed to more modern, liberal ideas and the hope for reform. The role played by Luís Héctor, Baron de Carondelet, appointed president of the Audiencia of Quito in 1797, is emblematic of the changes that were taking place in both Spain and her colonies. A man of some renown in Spain, once in Quito the baron drew around him a group of the local intellectual elite, Creole professionals and young university graduates imbued with liberal ideals. They strongly opposed religious dogmatism and defended individual and political liberty and equality. Carondelet, openly critical of the failures of the colonial government, proposed broad economic and political reforms. Though few of these were implemented, the groups around him and the ideals they espoused underscored growing sentiment in favor of independence. This sentiment was reflected in the highland Indian communities, which rose in revolt against the forced labor still demanded of them. By the end of the eighteenth century, Spain had become unable to sustain and govern her colonies. Although colonial politics in many respects continued to reflect the confrontation between liberal and conservative forces, the die had been cast. The colonies broke away from Spanish rule. Venezuela declared independence in 1811. In 1824, in Ayacucho, Peru, the last vestige of Spanish resistance was crushed, and the countries of America were free to step into modern times.

Toward the end of the eighteenth century, a number of images appeared which explored the theme of colonial ethnic groups and their intermarriage. Mestizaje began with the birth of the first child of mixed blood. This ethnic group continued to grow in size and importance as mestizos became rich through trade and successful in the arts, culminating at the end of the colonial era in such exemplary personages as Antonio Espejo in Quito and the Indian Andrés de

Santa Cruz y Calahumana in La Paz. Espejo was a distinguished doctor and journalist, Santa Cruz a humanist in the best European tradition. Both were politically active and liberal—Espejo paid for his convictions with his life. Both were deeply interested in reform, education, art, and philosophy. They carried in their veins both the blood of the conquered and that of the conquerors.

The whole trajectory of Spanish colonial art was also a subtle process of mestizaje. The sixteenth century was one of total European dominance; it was the age of discovery and conquest during which all of the institutions necessary to govern and evangelize the colonies were established. By the end of the sixteenth century, the first important European artists and works of European art had begun to appear in the colonies. Their influence continued to be paramount until the mid-seventeenth century, when there were signs of a subtle shift. By the last quarter of the seventeenth century, the emergence of a strong native mestizo voice was apparent. While the language of art remained indebted to European prototypes, the accent was now American. Master painters such as Miguel de Santiago and Nicolás Goribar in Quito, Melchor Pérez Holguín in Potosí, and Inca Diego Quispe Tito in Cuzco were the harbingers of a new order. Their skill was acknowledged by their contemporaries, their forms were freer and more original. The trend they heralded came to full flower in the eighteenth century with the emergence of distinctive regional schools.

Toward the very end of the eighteenth century, the mestizo emerged as the subject of art as well. Ethnic groups and the flora and fauna of South America were now introduced as secular subjects of art. In this light it can be seen that all of the subtle changes revealed in the development of Spanish colonial art—not only in painting and sculpture but in the decorative arts as well—point to a deeper reality: the emergence of national identity. ■

1 Rumazo (1948), vol. 1, p. 63.
2 Querejazu (1986), pp. 78-81.

THIS GROUP OF PAINTINGS depicting several male saints represents distinct European styles and differing colonial responses. Shown are Saint James the Apostle of Spain and Saints Ambrose and Augustine, two of the four Latin doctors who established the doctrinal authority of the Catholic church in its early days. Also shown is Anthony of Padua.

Each saint represents a fundamental aspect of the authority by means of which the Spanish came to dominate the colonies. Saint James the Apostle symbolizes the initial phases of Spanish physical conquest. Fresh from battle with the Moors, he stands for militant Christianity, which, in close alliance with the conquistadors, sought to conquer souls. That dominion, once established, gave way to a period of psychological persuasion—epitomized by Saint Ambrose—with an emphasis on the pronouncements of the Bible and on the prestige and power of the clergy. The figure of Saint Augustine suggests the link between the colonies and a powerful European intellectual tradition, as well as the victory of the Catholic faith over heresy in both the Old and New Worlds. From these concepts the church derived its entire didactic and aesthetic program of instruction and illustration.

Taken together these paintings also represent the styles that dominated painting in the seventeenth and eighteenth centuries. The image of Saint Ambrose illustrates realism and tenebrism. Those of Saints James and Augustine exemplify the free and vigorous action, love of texture, and mystic fervor characteristic of the Baroque. The last image, that of Saint Anthony, completes the progression as a classical image of colonial Rococo. ■

1. This forceful portrayal of Saint Ambrose (circa A.D. 339-397) recalls the vital strength of character for which he was famous. As bishop of Milan, Ambrose helped to consolidate the symbolic and sacramental power of Catholicism in the dying days of the Roman Empire. Renowned as an orator, he also composed some of the earliest church hymns and wrote lengthy commentaries on biblical texts. The beehive on the table draws a symbolic parallel between his name and the sweet honey in the hive.

The composition is a simple pyramidal one. The figure of the saint emerges from a dark background into the light, which reveals the decorative details of the miter and the chasuble he wears. His sober gaze claims the viewer's attention. This rich, somber work may have been executed in the early seventeenth century by the Jesuit father Diego de la Puente. Born in Malines in present-day Belgium, de la Puente was active in Peru between 1620 and 1663, working in Lima and Trujillo, as well as in Cuzco, La Paz, and Santiago de Chile. This canvas is similar in style and detail to a Saint Augustine painted by de la Puente and now in the Museum of San Francisco, Lima, and must have formed part of a series depicting the four doctors of the church.

The artist's probable sojourn in Rome may account for the influence on his work of the tenebrism of Caravaggio (1573-1610). De la Puente's style also links him to Zurbarán, the "Spanish Caravaggio" who exerted a strong influence on the art of the viceroyalty in the late seventeenth and early eighteenth centuries.

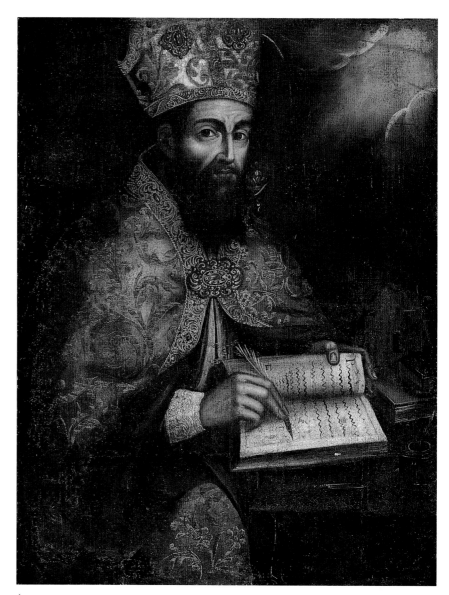

1.
Diego de la Puente(?)
Lima, active 1620-1663
Saint Ambrose, early seventeenth century
Oil on canvas, 42 x 32 ¼ in.
IIICA, UNM
L87.3.29

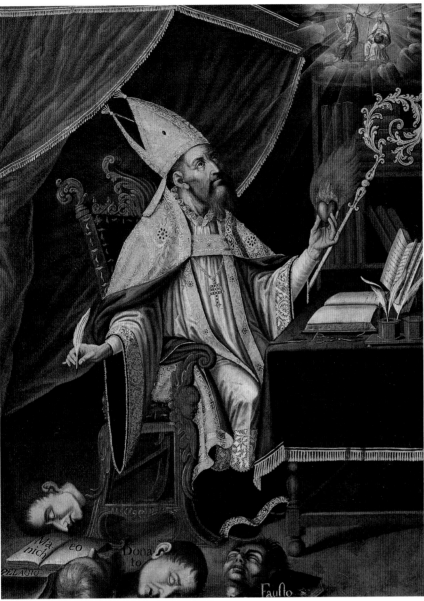

2.
Melchor Pérez Holguín
Potosí, circa 1660-1730
Saint Augustine, early eighteenth century
Oil on canvas, 49½ x 36½ in.
IIICA, UNM
L87.3.14

2. Saint Augustine (d. A.D. 430) was born in Tagaste (present-day Souk-Abras, Algeria) in A.D. 354. His mother, Monica, was a devout Christian who rejoiced in his conversion to that faith, an event preceded by the years of hedonistic living and troubled intellectual exploration detailed in his famous autobiographical *Confessions*. Augustine's philosophical writings, which reconcile the classical philosophies of Plato and Plotinus with biblical teaching, served as the foundation for Catholic thought from the Middle Ages to the Counter-Reformation.

This painting represents the colonial Baroque in one of its most serious and accomplished moments. All elements are permeated with the Baroque style—the elaborately carved bishop's chair, the wealth of heavily brocaded fabric, the golden crozier leaning against the desk. The saint's hands and face were modeled with feeling and delicate precision. The severed heads lying on the floor represent the heresies against whom Augustine waged and won major theological battles.

This work bears the stamp of Melchor Pérez Holguín and is either his own work or that of a talented disciple. The modeling is characteristic of this Potosí master's oeuvre, as are the palette and details such as the angel painted as a decorative element on the arm of the chair. The sweep of the red *palium* is reinforced by the axis that binds the saint's gaze to the figures of the Trinity. This axis is reiterated by the position of his open arms, while the upright book case and square *scriptorium* anchor the composition solidly in space. Composed of an ambitious number of elements, the painting exhibits a dynamic tension separating the two competing centers of attention—the flaming heart and the saint's face—by means of a dark, empty space.

Pérez Holguín was born in Cochabamba, but spent all of his artistic life in the silver-wealthy town of Potosí. While his work represents a culminating moment in the development of

viceregal art, his classicizing tendency was nonetheless imbued with colonial spirit. He borrowed from many sources and developed an individual style. After an initial stage during which he focused on monochromatic images of ascetic penitent saints, he worked in a more relaxed and colorful manner, of which this painting is an example. During his last phase he suppressed the representation of three-dimensional space in favor of flat surface design.

3. Images of Saint James were widely disseminated throughout the Hispanic world. They depict not only his decisive intervention in Spain's war again the Moorish infidel but also many subsequent miraculous appearances in which he helped to turn the tide of battle toward victory. Here he towers over vanquished Moors, although many colonial paintings portray him as *Santiago Mata-Indios,* defeating Indians. In Peru Saint James became identified with the Inca god Illapa, to whom a great temple was dedicated in Cuzco and who personified the forces of thunder and rain.

Here Saint James, astride a white horse, is lifted into the realm of light, while his enemies occupy the heretical darkness below. The rising horizon line adds dynamism to the composition, as do the lavish curves and countercurves of the billowing cape. The saint brandishes a gold-hilted sword, his hat is brave with plumes, lace cuffs decorate his wrists and ankles, and his waist is small enough to be the envy of any debutante. But it is the horse—with almost human eyes and a fiercely determined look—who is the most active participant. A combination of ingenious portrayal and decorative detail, such a painting could never have been executed in Europe and has correctly been identified as Mestizo Baroque.

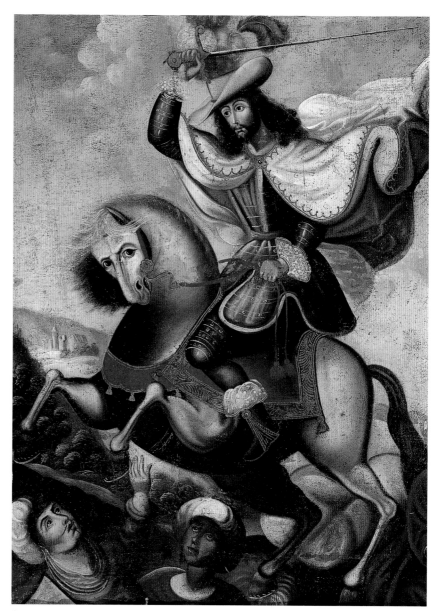

3.
Unknown artist
Alto Peru, eighteenth century
Saint James the Moor-Killer
Oil on canvas, 33¾ x 25¼ in.
IIICA, UNM
L87.3.38

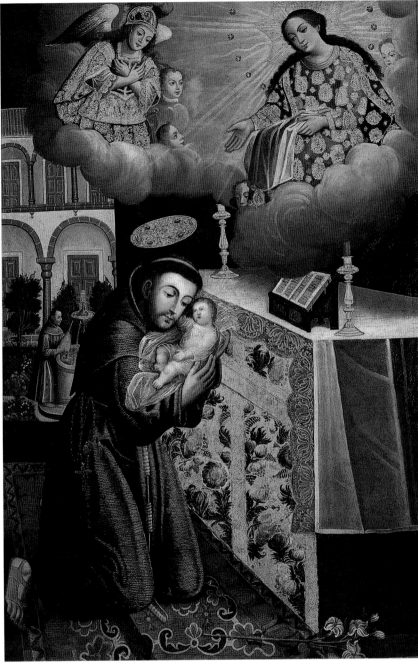

4.
Unknown artist
Cuzco(?), eighteenth century
Saint Anthony of Padua
Oil on canvas, 44 x 66⅛ in.
Michael Haskell Collection

4. Saint Anthony kneels before an altar covered with a cloth embroidered in a pattern known as *primavera.* Above, the angel of the Annunciation and the Virgin Mary appear to him in a vision. In the background a Franciscan monk draws water from a fountain centered in a medieval cloister, while bright red Peruvian birds perch in the trees behind. The brilliance of the decoration, gently persuasive religious feeling, and beautiful modeling epitomize the best in Spanish colonial painting.

A closer look at this work reveals profound symbolism. The unknown colonial painter chose as his inspiration a European engraving and amplified its meaning by adding components of his own. All energies converge on the small figure of the Christ child, who not only occupies a central place but is the symbol on which this visual parable turns. The Franciscan "background," the foreground in which the present action takes place, and, above it, the realm of heaven are all defined. With an open-handed gesture, Mary "presents" the Christ child to Saint Anthony, transferring her grace from one plane to another. The fountain, often included in paintings as a symbol of the Immaculate Conception, is an allusion to Mary as an inexhaustible wellspring of generative power. The seemingly casual addition of the lily—one of Saint Anthony's traditional attributes— allowed the artist to draw a parallel between the gift being made to the saint and the angel of the Annunciation, with whom the lily is also identified and who heralded the coming of the Christ child to Mary. The *primavera,* the coming of the new year expressed in the flowers of spring embroidered on the altar cloth, indicates the parallel in nature. Rebirth is symbolized on three planes and in a series of interdependent symbols—new year, new self, new mystic birth—binding all to a common axis.

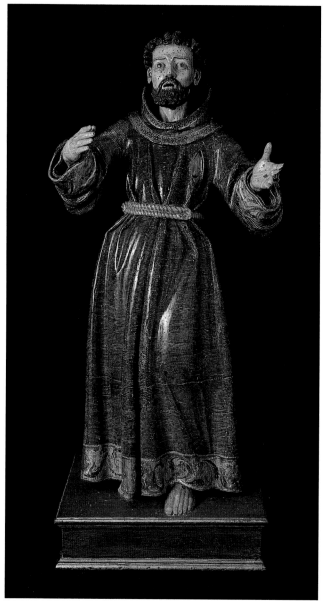

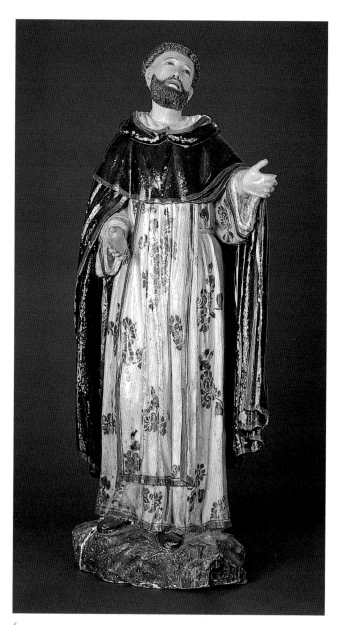

5.
Unknown artist
Colombia(?), late seventeenth/early eighteenth century
Saint Francis of Assisi
Polychrome wood, H.: 32½ in.
Collection of Mrs. Charles Harrington

6.
Unknown artist
Ecuador, late eighteenth century
Saint Dominic
Carved wood, H.: 36 in.
Collection of Mr. and Mrs. Donald Willfong

5. Spanish colonial churches were filled not only with paintings but also with realistic sculptures of idealized religious figures. The first images of Saint Francis came to the colonies from some of the greatest Andalucian *talleres* (workshops). Here an unknown colonial sculptor has borrowed from several of these sources. From Juan Martínez Montañés he took the strong modeling of the face and man-

ner of carving the hair. The V-shaped pleats over the torso are reminiscent of the style of Pedro de Mena, as is the pose in which Francis holds his hands to show the wounds of the stigmata, which he suffered in imitation of Christ. The artist adorned the normally sober Franciscan habit with an elaborate floral border and made a bold decorative element of the simple knotted cord. The bent leg gives

the figure a gentle swing.

6. Saint Dominic (d. 1221) was the founder of one of the most influential monastic orders to come to Spanish America. Descended from a noble Spanish family, the Guzmán, he was famous for his preaching. Here he is shown wearing the black and white Dominican habit which, in this statue,

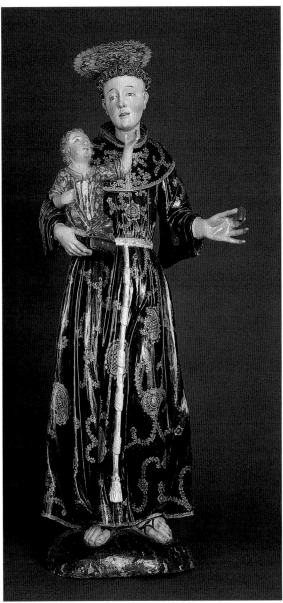

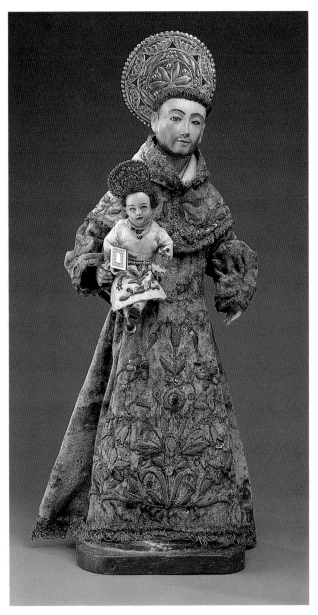

7.
Unknown artist
Ecuador, late eighteenth century
Saint Anthony of Padua
Wood, H.: 36 in.
Collection of Mr. and Mrs. Donald Willfong

8.
Unknown artist
Bolivia(?), eighteenth century
Saint Anthony of Padua
Wood, 25 x 9 x 7½ in.
MOIFA, Santa Fe
FA 76.122-1

has been decorated with roses, a proba-
ble reference to the fact that this saint
instituted the devotion to the rosary. His
gaze, raised ecstatically to heaven, and
his wide-open arms are traditional
Baroque qualities.

7. The affectionate gesture made by the
Christ child to Saint Anthony is typical
of Ecuadorian Rococo sculpture, as is the

small unidentified red object the saint
holds in his right hand. The flesh tones
are light and clear, and Anthony's dark
robe acts as a dramatic foil for the child's
brilliant red tunic.

8. This small statue of the Franciscan
Saint Anthony of Padua represents a type
of sculpture which became immensely
popular in late colonial times. The face

and hands were *encarnado*—realistically
rendered to resemble flesh tones—in the
style of many other statues, but the body
was carved in a rudimentary manner,
since the statue was meant to be
"dressed" in real clothes—as it is here, in
an embroidered velvet habit. The
suggestion of a bluish beard points to a
growing emphasis on realism.

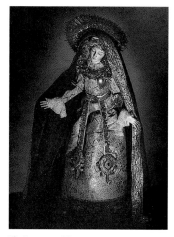

The Sorrowing Virgin,
eighteenth century.
Museum of Colonial Art,
Quito

I N EVERY CHURCH IN SOUTH AMERICA there are
crucifixes. From the earliest colonial days, carved
images of the crucified Christ were imported from
Spain. The crucifix form had originated in Italy, whose
artists were heir to the Greco-Roman tradition, which
idealized the human nude. Spain never completely sur-
rendered to this "pagan" impulse, and, with few excep-
tions, Spanish artists rejected the nude. However, the
greatest of them carried on the ancient tradition in a
wholly religious context, in representations of the figure
of Christ nailed to the cross.

The sculptures of Martínez Montañés and others
portray this subject superbly, with accurate anatomical
details and deep religious conviction. In both painting
and sculpture, colonial artists followed their lead, illus-
trating various aspects of the life and Passion of Christ.
This devotion reached an annual climax in solemn
Easter celebrations, which survive to this day in South
American cosmopolitan centers and rural settings. A
popular couplet captures the poignant juxtaposition of
dark and light, life and death, signified by these celebra-
tions:

Easter, mixture of happiness and sorrow,
One dove is white,
The other the color of ashes. (Vaca Guzmán 1989, p. 19)

The theme of Christ's death and Resurrection,
which lies at the heart of Christian belief, can also
serve as a metaphor. For in the somber encounter
between the indigenous and Spanish peoples, both in a
sense were sacrificed. Alien European authorities over-
whelmed native South American cultures, severing
them from their own institutions. The Spanish too
were isolated from their home and from the historic cir-
cumstances whose gradual development had given birth
to their own conventions, organizations, and beliefs.
Both would be reborn, not separately but together, to
form a mestizo society which would forge their separate
contributions into a new whole. ■

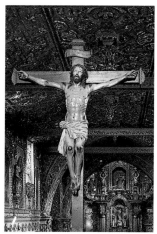

Spanish? *Crucifix,*
seventeenth century.
Church of San Francisco,
Quito

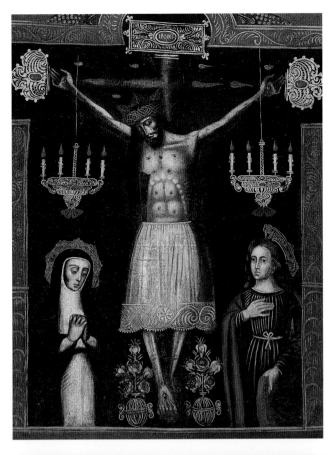

9.
Unknown artist
Cuzco(?), eighteenth century
Christ of the Earthquakes
Oil on canvas, 41 x 31 in.
IIICA, UNM
L87.3.7

9. Known popularly as *Taitacha Temblores*, the carved image on which this painted version of the Crucifixion is based hangs in a niche in the Cuzco cathedral. Believed to be miraculous, it is highly venerated throughout the Andes. In the painting Saint John the Evangelist and the *Mater Dolorosa*, the Sorrowing Virgin, flank the central figure. Huge silver finials decorate the cross. Christ wears a decorous lace-edged skirt.

Legend has it that the sculpture in Cuzco was sent to Peru by Charles V; however, the present version is a later carving made of maguey. On the occasion of a disastrous earthquake in 1650, the sculpture was carried in a procession and is credited with having brought the catastrophe to a halt. On the Monday before Easter, the first day of Holy Week, this crucifix is carried from the cathedral in midafternoon on a huge silver *anda*, a type of portable dais. Followed by throngs of the faithful, it is borne through the center of town, which has been decorated with triumphal arches. At nightfall the sculpture is returned to its niche.

10.
Unknown artist
Eighteenth century(?)
La Soledad
Oil on canvas, 23 x 13 in.
Collection of Mr. and Mrs. Donald Willfong

10. The theme of *La Dolorosa* or *La Soledad* often appears in conjunction with the Crucifixion. The Virgin, dressed in stark black and white, kneels in prayer. The objects in front of her—the crown of thorns and nails—refer to Christ's Passion. The candles at either side suggest that this is a painting of a statue, although few carvings of the Virgin Mary kneeling in this attitude were ever executed.

WITH THE WHOLEHEARTED ACCEPTANCE of Christianity, a number of legends grew up around such figures as the Virgin Mary which embellished the spare details of biblical narrative. In an apocryphal book attributed to Saint John the Evangelist and, subsequently, in the writings of Dionysius the Areopagite and others, details of Mary's life and death and of her Assumption into heaven become the basis for dogma and belief. These accounts provided subjects for art that were disseminated throughout Europe during the Counter-Reformation. At this time increasing emphasis was placed on the doctrine of the Immaculate Conception. Images of the Virgin were also worshipped by religious fraternities—Our Lady of the Rosary by the Dominicans, Our Lady of Mercy by the Mercedarians, and so on. In the New World, as in the Old, images of Mary came to be identified with particular localities or sanctuaries.

In portraying Mary, colonial artists represented the universal feminine symbol of regeneration, an analogue to their own creative spirits. The images of the Virgin included here illustrate a progression of styles. They also mark the passage of colonial art from timid dependence on imported models to a time of liberation during which artists relied on their own inventions, individual styles, buoyant use of color, self-assertion, and clear sense of place. ■

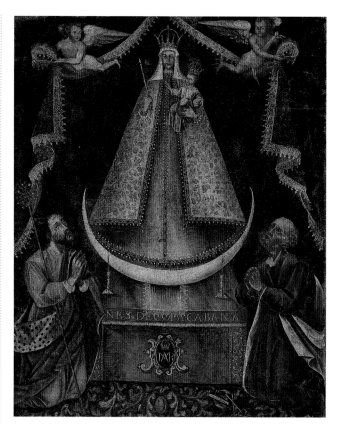

11.
Circle of Gregorio Gamarra
Alto Peru, early seventeenth century
Our Lady of Copacabana
Oil on canvas, 37⅛ x 30 in.
IIICA, UNM
L87.3.21

11. On the shores of Lake Titicaca, the Inca site that represented the birthplace of the sun, moon, and first man, two Christian churches were built to honor different advocations of the Virgin Mary: Copacabana and Pomata. The present church dedicated to Our Lady of Copacabana marks the spot where an anthropomorphic image, half-human and half-fish, was found by the Augustinian father Ramos Gavilán and thrown into the lake as a heathen idol. The image was replaced by a new one, of the Virgin Mary as Our Lady of Copacabana, carved by the Indian artist Francisco Tito Yupanqui in 1583. The sanctuary, which sits on a peninsula jutting into the lake, was built between 1614 and 1641 and dedicated to her. In the form of a Latin cross, it still bears remnants of Gothic vaulting and is entered through a large square atrium at whose corners stand four *posa* chapels.

This painting of Our Lady of Copacabana, to whom many miraculous interventions were ascribed, can be attributed to a follower of Gregorio Gamarra. Its severe frontality looks back to Gothic images such as Our Lady of Guadalupe of Estremadura, of which Gamarra painted a similar image in 1709. Here the pyramidal figure has been placed against a dark background and stands on the wide arc of a thin silver moon,

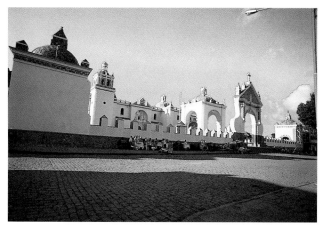

The church of Copacabana on the shores of Lake Titicaca.

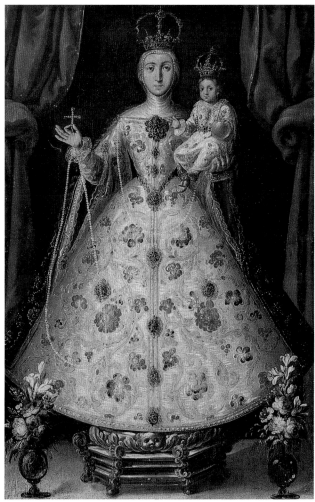

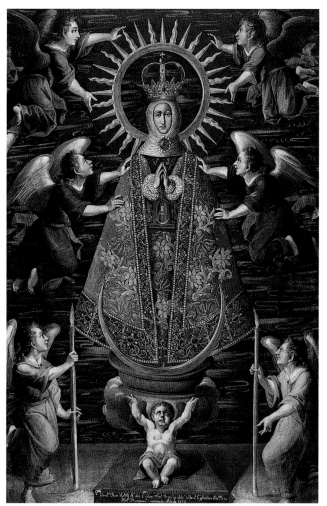

12.
Melchor Pérez Holguín (?)
Potosí, first half of the eighteenth century
Our Lady of the Rosary
Oil on canvas, 74¼ x 48¼ in.
IIICA, UNM
L87.3.2

13.
Melchor Pérez Holguín
Potosí, circa 1660-1730
Our Lady of Lidon, 1716
Oil on canvas, 86 x 52½ in.
IIICA, UNM
L87.3.15

while two angels hold fine lace-edged curtains aside—a Gamarra trademark. At the left kneels Saint Joseph, with ermine-lined cape, and on the right Saint Peter, whose keys are on the carpet in front of him.

Gamarra (active 1601-1642), a prolific painter, was one of the most original followers of Bernardo Bitti, the Italian Jesuit who introduced Mannerism in the early days of the viceroyalty. This image represents the Virgin as Our Lady of Candlemas, *Nuestra Señora de la Candelaria,* a type introduced by the Jesuits in 1598 and worshipped throughout Peru. It honors a celebration that

took place on the fortieth day after Christ's birth, when it was believed that the soul infused the body. On this day the Virgin went to the temple to be purified and to present her child. The custom of lighting candles goes back to pagan Roman festivities that were absorbed into Christianity and given new meaning.

12. This artist sought for his inspiration a Spanish prototype transmitted to the colonies by means of an engraving. Heavy velvet draperies hang on either side of the statue of the Virgin, which is presented with rigid symmetry—a single dominant figure poised on a silver

pedestal. Her Spanish face framed by a veil serves as a counterpoint to the lavish roses and jewels and cartwheel designs that decorate her robe. The flowers in vases have been rendered with such impressionistic ease, it suggests that the work is that of Melchor Pérez Holguín.

13. The inscription at the base of this painting of a statue reads as follows: A true image of Our Lady of Lidon venerated in the town of Castellón de la Plana in the kingdom of Valencia. Year 1716. In all likelihood this work was commissioned by a Spaniard who provided the artist with an engraving of an image he had

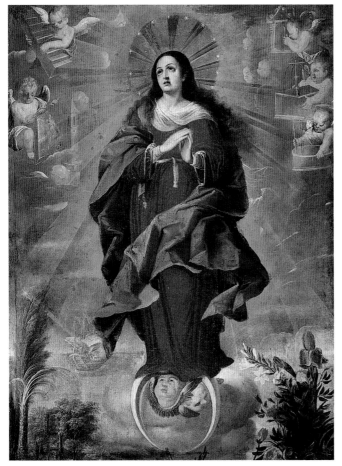

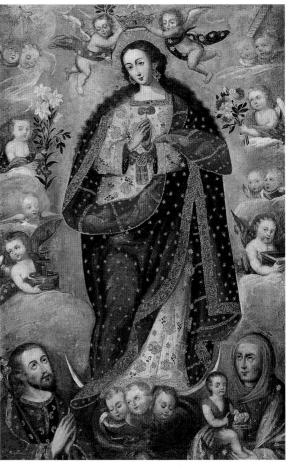

14.
Melchor Pérez Holguín
Potosí, circa 1660-1730
The Immaculate Conception, circa 1716
Oil on canvas, 56 x 41 ½ in.
IIICA, UNM
L87.3.17

15.
School of Diego Quispe Tito
The Immaculate Conception, first half of the eighteenth century
Oil on canvas, 49 x 73 ½ in.
IIICA, UNM
L.92.3.3

worshipped in his homeland. In the same year that this painting was completed, Pérez Holguín executed a huge canvas depicting the formal entrance of Viceroy Morcillo into Potosí (Madrid, Museum of America). In precise detail the artist portrayed the people in the procession, architectural features of the town, and other details, all of which provide invaluable information about colonial life.

This painting of the Virgin is a severely frontal icon, although bravura passages keep it from slipping into archaism. The chilly blue tone was often used by Holguín, and the highly individual angels also appear in other works of his. The delicate rose tones of their gowns, the modeling, and the fine drafts-

manship all reveal the master's hand.

A fascinating comparison can be made between this image and catalogue numbers 11 and 12. All three depict pyramidal forms rising from broad bases and focusing their energies at their apexes. In the image by Gamarra the pyramid is crowned by a timid little head. In the second example, although the image is bolder, the manner in which the head is bound still suggests the tightly enclosed form of a bud. In the present image the energy traveling upward along the converging lines of the pyramidal dress explodes into the full flower of an immense aureole. While the face of this Virgin may still be Spanish, the spirit of the painter is already American.

14. Although unsigned, this painting appears to be by Holguín. To the conventional theme of the Immaculate Conception, he added touches of his own, portraying Mary as a mature woman, not as a young girl, and dressing her in a red gown, not in the traditional white. He placed her against a background of soft orange on which the heavenly rays of her "glory" are inscribed. The realistic details of landscape and flowers are beautifully painted. A bank of clouds forms a gradual transition from sky to heaven. Not an "empty" world, but an "other," spiritual domain, outside the realm of ordinary experience, gives rise to the diaphanous allegorical symbols that refer to Mary's qualities. One of

The Immaculate Conception,
mid-eighteenth century.
The Convent of San Francisco,
Quito.

The Immaculate Conception,
mid-eighteenth century.
Private collection, Quito.

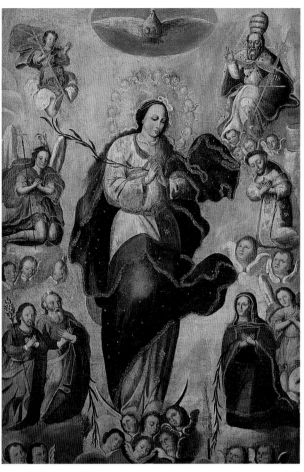

16.
Unknown artist
Late seventeenth century(?)
The Immaculate Conception
Oil on canvas, 58⅜ x 39½ in.
IIICA, UNM
L87.3.24

the plump angels holds a mirror "without blemish" in which the Virgin's own image can be seen.

15. Cuzco, the imperial city of the Incas, developed into a strong colonial center that gave rise to a school of art with its own characteristics. The coming of Bishop Mollinedo in 1673 had signaled the beginning of a period of economic prosperity and artistic flowering which converted Cuzco into an immense treasury of colonial art. The city also developed into a commercial center from which objects of art, particularly paintings, were exported throughout Peru.

One of the pivotal figures was Diego Quispe Tito. He added "Inca" to his name when he signed his work to underscore his Indian birth and brought to his painting much of that indigenous sensibility, many of the vital energies of the past, which, mingling with Spanish contributions, produced mestizo art.

Little is known of Quispe Tito's life beside the fact that he was born in 1611 and died sometime after 1681, having lived and worked most of his life in the pueblo of San Sebastián near Cuzco. Thirty signed paintings are documented, and many others are attributed to him. They reveal an artist capable of handling complicated compositions, replete with details and figures. A number of painters followed his style.

The central image of the Virgin, standing on a new moon supported by three angels, fills the canvas. Angels holding symbolic attributes surround the main figure, while two others grasp a crown above her head. Her gown is covered with roses, her mantle with stars. A praying figure of Saint Joseph can be seen at the left; the image at the lower right is Saint Elizabeth, who holds Saint John the Evangelist(?) in her arms.

A contemporaneous painting of the same theme by an unknown Quitenian artist reveals a similar form rendered in a slightly different style. This suggests that an engraving may have served as the model for both of these images. Cuzco and Quito were both capital cities under Inca rule; in colonial times each

developed into an independent artistic center. Images of the Immaculate Conception were also carved, as is evidenced by this Quitenian statue executed around the mid-eighteenth century.

16. This painting epitomizes the challenges faced by the art historian in identifying Spanish colonial works. The style is distinctive and the content original, yet no comparable work is known.

The composition is reminiscent of the organization of altar screens. It is dominated by a central image of the Virgin and bordered by three tiers of figures in an ascending hierarchy. At the lower right kneels Saint Anne, Mary's mother, and at the left her father, Saint Joachim. Saint Joseph, identified by the lily staff, kneels beside Joachim. A vine issuing from Mary's heart terminates in a lily blossom from which the figure of the Christ child emerges. God the Father raises his right hand in blessing. At midlevel the angel of the Annunciation clasps his hands in prayer, while at the right a member of the Mercedarian order echoes the gesture. Angels flutter around the canvas and form a halo around the Virgin's head.

The symbol of the vine, usually associated with Jesus, has been borrowed to link all members of Mary's family, even as she, Queen of Heaven, binds the realms of earth and heaven together. A restrained emotional tone permeates the canvas, which is replete with elegant details: the delicate gold lace edging on the blue mantle sprinkled with stars, the halo of cherub heads, the robe of God the Father decorated with roses as a tribute to Mary.

The elongated figure of the Virgin points to the influence of late Mannerism and thus suggests a work executed in highland Peru or Bolivia. But the flying draperies point to a later influence, that of Murillo. In short, elements were borrowed from various stylistic and iconographic sources. The inventive many-leveled symbolism indicates that the artist clearly understood and appreciated the nature of Christian theology. The synthesis of various ele-

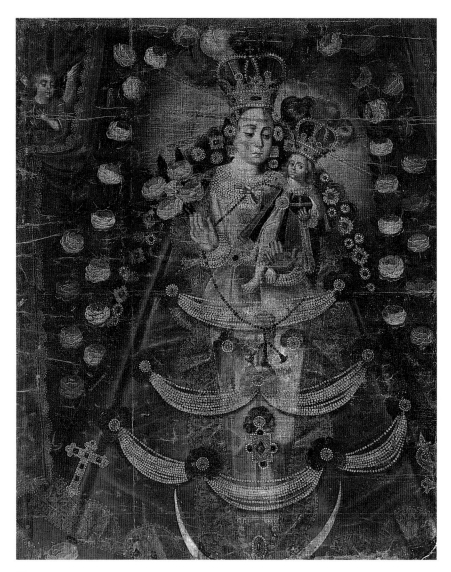

17.
Unknown artist
Collao, late seventeenth century(?)
Our Lady of Pomata
Oil on canvas, 45 x 36 in.
IIICA, UNM

ments into a single whole signals the emergence of Spanish colonial art and reveals the hand of a confident and accomplished artist at work toward the end of the seventeenth century.

17. Here an Inca princess has become the Virgin Mary as Our Lady of Pomata. The crowns she and the Christ child wear are European symbols of royalty, while the towering feathers were used by the Incas to designate royal rank. The

Virgin's robe is covered with a wealth of rosettes, jewels, and huge swags of Oriental pearls. In this painting of a statue, probably executed in the last quarter of the seventeenth century, the Virgin stands in a curtained niche on a pedestal formed by a partly visible new moon. The angel holding back the lace-edged drapery looks back to the art of Gamarra, but in every other aspect this painting looks forward. It announces the coming of the mestizo style with its abundance of deco-

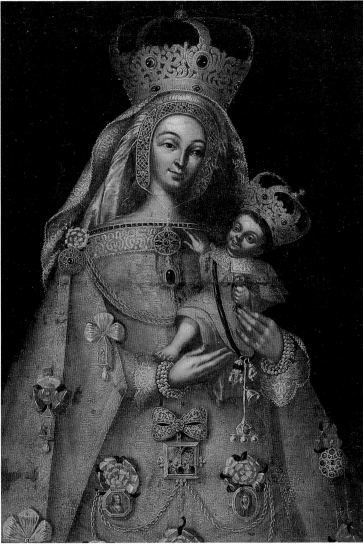

18.
School of Leonardo Flores
Alto Peru, late seventeenth/early eighteenth century
The Virgin Mary with the Christ Child
Oil on canvas, 96 x 56 x 28 in.
Mt. Calvary Retreat House, The Order of the Holy Cross, Santa Barbara, CA

18. Neither European nor Indian, the features of this Virgin Mary are those of a mestiza. The child she holds in her arms is a real child, laughing and reaching toward her with a loving gesture. From the cord around his neck hang real toys—a silver rattle, a bell, and a *figa,* the Moorish good luck charm in the form of a clenched fist. The huge crowns and the Virgin's gown are encrusted with jewels. The manner in which they are painted suggests the work of Leonardo Flores, an itinerant artist at work in the highlands of Peru in the late seventeenth century. The details of dress and jewelry clearly portray the decoration around the Virgin's face, the patterned brocades she wears, and the rosettes from which hang a variety of *relicarios* (reliquaries), a prominent feature in the religious life of the eighteenth and nineteenth centuries. One of these contains a small carved image of Christ bound to a column, another a kneeling Franciscan saint; others include framed and painted images of the Virgin and Saint Joseph.

rative detail and lavish use of color.

The sanctuary of Pomata lies in the heart of Indian country, in the area around Lake Titicaca known as the Collao. The church was completed around 1790. It is built of rose-colored stone in the richly patterned, planiform Mestizo Baroque style that reached its apogee in such church facades as that of La Compañía and the *retablo*-like San Lorenzo in Potosí. The Virgin of Pomata, identified with the Dominicans, came to rival Our Lady of Copacabana. The members of this order worshipped the Virgin Mary as our Lady of the Rosary, and it is to this that the roses in the painting refer. Although innumerable paintings of this Virgin were executed by anonymous artists between 1660 and 1720, this is one of the finest.

19. The style of this painting situates it midway between the cultivated art of Holguín and the very popular style of eighteenth-century Cuzco painting. A hint of spatial recession is indicated by the shadows on the lace-edged altar. The three roses refer to the worship of the Trinity. The gold decorations are not painted but embossed, while complementary shades of red and blue-green complete the color range.

A number of large canvases in Lima—one in the cathedral—reveal similar stylistic characteristics that suggest the work of an unknown master. This painting's flowing lines and sustained emotional tone place it at the summit of colonial art.

20. Much emphasis has been placed on the prolific output and influence of the eighteenth-century workshops of the Andean region and on the Mestizo Baroque, in which decorative tendencies were barely held in check. While this painting also exemplifies a high moment in colonial art, its somewhat more conservative style suggests that it may have been executed in a metropolitan center such as Lima.

The Virgin, with demure gaze and clasped hands, occupies the center of the composition. She is framed by the three identical figures of the Trinity. Although this type of representation was forbidden by the Council of Trent, the edict was routinely ignored in Spanish America, where it was thought that the dove of the Holy Spirit might be misunderstood by the Indians as a sign of animist belief. The red linings of the robes provide a contrast to the central figure's blue mantle sprinkled with stars.

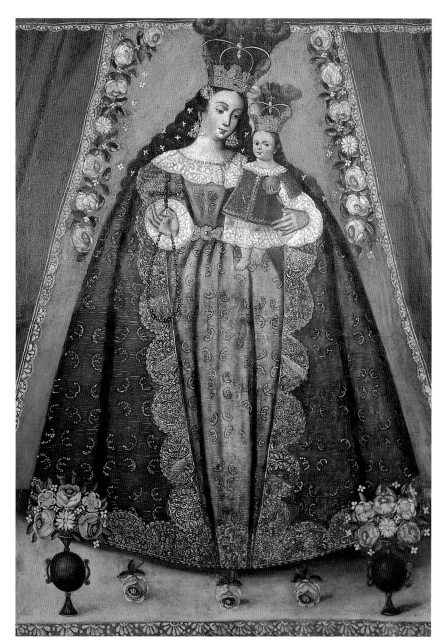

19.
Unknown artist
Lima(?), mid-eighteenth century
Our Lady of Pomata
Oil on canvas, 74¼ x 47 ¼ in.
Holler and Saunders, Ltd.

20.
Unknown artist
Lima(?), eighteenth century
The Coronation of the Virgin
Oil on canvas, 58 x 38 ¾ in.
Holler and Saunders, Ltd.

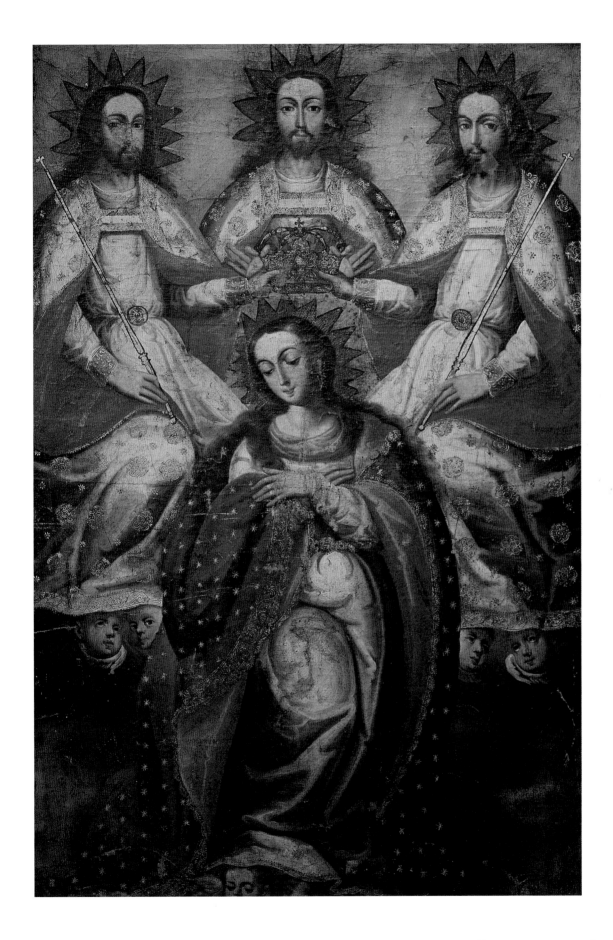

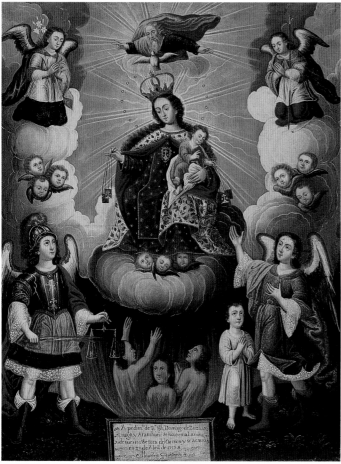

21.
Mauricio García y Delgado
Cuzco, active mid-eighteenth century
Our Lady of Mount Carmel, April 23, 1752
Oil on canvas, 41 ¼ x 32 ¾ in.
IIICA, UNM
L87.3.3.

22.
Unknown artist
Cuzco, eighteenth century
Saint Helen
Oil on canvas, 33 x 49 in.
Michael Haskell Collection

21. This painting, which represents Our Lady of Mount Carmel, is a rather stiff devotional image executed according to an accepted formula. It is a commercial work. Both the Virgin and the Christ child, surrounded by golden rays, hold scapulars, devotion to which was supposed to rescue souls from the flames of hell. At the right the guardian angel stands protectively next to a small child, while in the opposite corner Saint Michael, holding the flaming sword of justice, weighs the souls of the departed. The archangel Gabriel kneels on a cloud at the left, while Raphael (with a wonderfully dead fish!) can be seen at the upper right. The inscription indicates the date on which the painting was finished and the name of the person who commissioned it, Don Joseph Domingo de Zuzunaga y Aramburu.

By the eighteenth century Cuzco had become an important center for the commercial distribution of paintings. García, who directed a large commercial workshop, may have been one of the city's more prolific artists. Around midcentury he signed a contract promising to execute literally hundreds of paintings within a short period of time. Some of these may have been commissioned by middlemen or by itinerant traders who attached themselves to armed mule trains, selling their wares from town to town.

22. After the Roman emperor Constantine's conversion to Christianity in the fourth century A.D., the veneration of holy relics grew in importance. Mementos of Christ's Passion—the crown of thorns, the nails that pierced his hands and feet, the cross on which he died—were the most ardently sought. The True Cross of the Crucifixion was, according to legend, discovered by Helen, Constantine's mother. Supposedly carved from the Tree of Life, it was considered to be a powerful talis-

23.
Unknown artist
Lima(?), first quarter of the eighteenth century(?)
Santa Rosa de Lima
Oil on canvas, 65 x 41 in.
IIICA, UNM
L87.3.24

23. Santa Rosa, the daughter of a Puerto Rican *conquistador,* was born and lived her thirty-eight years of life in seventeenth-century Lima. As a young woman she entered the third order of Saint Dominic. Her charitable works were many, her penances severe, and, legend has it, such was the sweetness of her nature that birds in nearby trees would join her when she sang. In 1671 she was proclaimed patroness of Peru and all the Americas, and in 1668 she was beatified.

The anchor Santa Rosa holds in her left hand signifies Callao, Lima's port, into which poured goods from Europe as well as the rich trade from the Orient. From this harbor too sailed the vast silver treasure from the Potosí mines, wealth that not only enriched the distant Spanish Crown but also accounted for much of the feverish accumulation of wealth in colonial society, a society that combined deep religious sentiment with material excess and moral laxity.

Santa Rosa developed great mystic powers. One of her most famous visions is recorded in this painting, in which the Christ child holds up a gold wedding ring symbolizing their mystic marriage. The saint's black and white Dominican habit is covered with gold designs, and her figure is framed by a lavish wreath of flowers—a device borrowed from Flemish engravings. Roses provide the dominant motif. The saint's bust is poised on a full-blown flower. The beads are carved in the form of roses, she wears a fresh rose at her throat, and roses are twined into the crown of thorns, from which shine golden rays. The whole painting is an allegory of the Passion of Christ, on which the saint meditates with eyes lowered, gazing inward. Just as roses die, Christ's death was foreshadowed in his childhood. However, that which dies will be born again.

The artist was filled with emotion toward his subject, seeking to portray her quiet heart and the depth of her physical and moral beauty. In the process he revealed his own mature skill in his deft use of color and creation of a unified, balanced composition.

man as well as a symbol of death and renewal.

While Saint Helen was, in the Italian Renaissance, portrayed as a subject of high art, in Cuzco she became the object of popular piety. This portrayal of her dates from the mid- or late eighteenth century. Spiritual content was of little concern to the anonymous artist, who relished exuberant color and gold surface decoration. The latter, termed *sobredorado,* came to identify the work of the popular Cuzco school. In the best paintings these embellishments were applied by hand; in other instances, as in this one, stencils were used. Here the artist employed the voluminous drapery to advantage as a surface on which to apply a variety of designs—rosettes, stars, and medallions. The borders, lace edge, and crown are also picked out in gold. A brief passage of Flemish landscape can be seen in the background, along with a bush bright with red birds. Tulips, roses, and other flowers edge the canvas. Helen's slightly crooked crown gives her a rakish air.

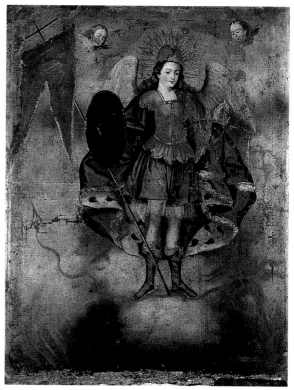

ERHAPS IT WAS THE ALTITUDE! Whatever the cause, there are more angels in Spanish colonial art—with an acute concentration in the highlands of Peru—than could ever be crowded on the head of a European pin. In style they range from pure Renaissance and Baroque types to the *ángeles arcabuceros*, representations from the Cuzco area of the militia of God, whose mild demeanor belies their military dress and whose style is flat enough to have been ironed. A favorite subject of painters, sculptors, silversmiths, and even furniture makers, angelic images based on European prototypes gradually gave way to distinctive mestizo representations. Indigenous influence was particularly evident in the areas of Cuzco and La Paz, while a certain classical tendency continued to characterize the art of Lima and Quito. In sum, angels crowd the arena of colonial art with ephemeral beauty, making visible the invisible signs of the spirit. ■

An eighteenth-century Ecuadorian angel.

24. The small blaze at the lower right alludes to the archangel Uriel's flaming religious ardor and symbolically identifies him as *lum dei*, fire of God. Wearing the elegant, lace-trimmed clothing of the elite—a doublet with slit sleeves, a three-quarter-length coat, knee breeches, silk stockings tightly gathered at the knees, and broad-brimmed hat crested with plumes—Uriel sights along the barrel of an accurately detailed gun. But his round, soft eyes and his finger resting negligently on the trigger hardly suggest a militant demeanor. Elements in the composition are divided into pairs—the two halves of the coat are disposed in a pyramid, the two sleeves billow like twin scoops, and the head and gun form a single diagonal element with the butt of the gun and the curve of the neck echoing each other in opposing curves. In the background can be seen part of a huge red sash, and at the left are the flowing ribbons to which the powder flask is attached. This iconography was unique to the area around La Paz and Lake Titicaca.

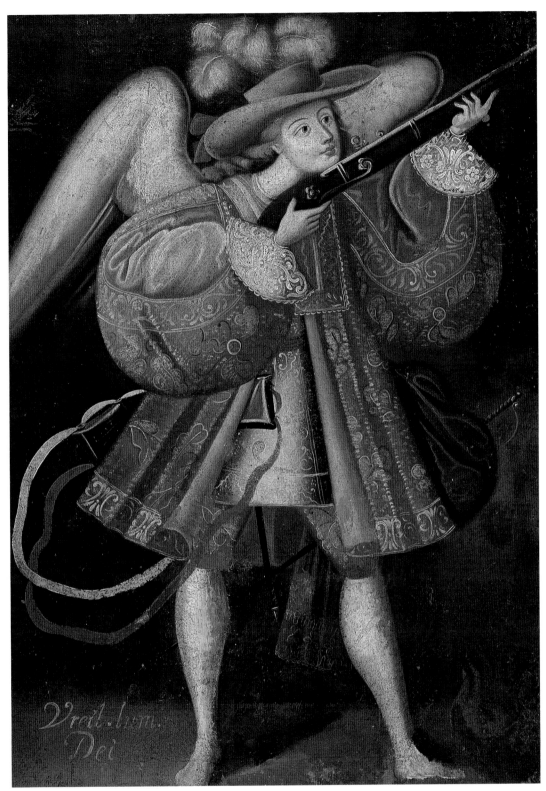

24.
Unknown artist
Alto Peru, early eighteenth century(?)
Archangel Uriel
Oil on canvas, 39 x 28½ in.
IIICA, UNM
L87.3.5

25. "Peace of God" is Salamiel's title. Here parallel lines formed by the lace trim on his square lace ruff and doublet plunge toward his sword, almost cutting the figure in half. A play of warm reds on the doublet, sash, and ribbons is echoed in the wings and one red feather on the hat. The flaring sleeves stand out against the rich background of the dark velvet coat, and a gold chain loops from the saint's fingers. When Pérez Holguín painted *The Entrance of Viceroy Morcillo into Potosí* in 1716, he included among the retinue a company of militia dressed in the same manner as these angels and carrying banners identifying them by name—Salamiel dei, Uriel dei, Isrriel dei, and so on. The costume depicted in the present painting dates from the last years of the seventeenth century, and it seems likely that the representation of angels as soldiers arose from an interpretation of the Counter-Reformation's vigorous defense of Catholicism.

26. Balboa named a bay after him, and Pizarro a town. The Archangel Michael made numerous miraculous appearances on behalf of the Spanish and turned the tide of battle in Cajamarca and in Cuzco. On January 12, 1656, the town council of Quito named this "Glorious Archangel and Prince" patron saint of their city, vowing to commission an image of him and honor him with an annual festival.

Here he wears a plumed helmet and carries a round shield whose shape is echoed by a stiff little lace-edged skirt. Impressionistic passages suggest light glinting off the breastplate and overskirt. The saint is posed against a typical Flemish landscape filled with birds perched in trees and flying in symmetrical formations—three red and three white at the right, four red and four white at the left. In nearly all cultures birds are seen as messengers of the spirit; here, as in other highland painting, they may represent a sense of unity with nature.

This painting bears the general stamp of the commercial art of mid-eighteenth-century Cuzco. Gone is the

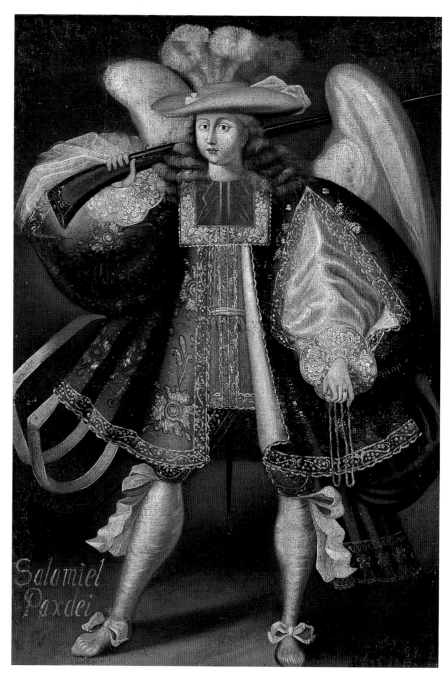

25.
Unknown artist
Alto Peru, early eighteenth century(?)
Archangel Salamiel
Oil on canvas, 39 x 28 ½ in.
IIICA, UNM
L87.3.6

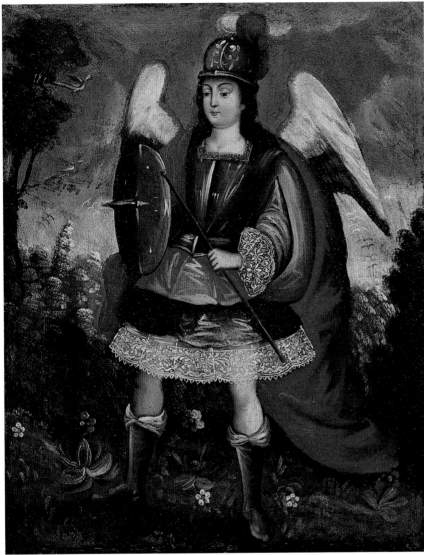

26.
Unknown artist
Cuzco, mid-eighteenth century
Archangel Michael
Oil on canvas, 28 x 34 ¼ in.
IIICA, UNM
L87.3.4

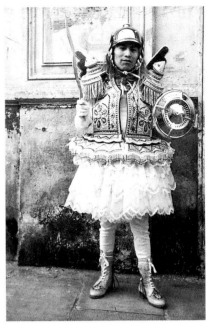

A modern-day "angel" in popular folklore:
a participant in the *Diablada* dance, during the
Carnaval festivities in Oruru, Bolivia, 1970s.

bravura with which this archangel vigorously brandished a sword in earlier representations. Here he stands looking quizzically at a stick with two blunt ends.

The costume worn by a modern participant in Carnaval in Oruro, Bolivia, attests to the ongoing identification in popular folklore with the angels portrayed in colonial art. It recalls the dismay of Fray Juan Domenico Coletti, who reported the presence of Indians in the town of Quito days before the celebration of Corpus Cristi. In *Il gazettiere americano*, a compendium of his travels in South America published in 1763, he wrote, "They are dressed in women's hats and dance incessantly to the monotonous beat of drums. Furthermore, they have the impertinence *[hanno la vanitá]* to call themselves angels!" (Coletti 1763, vol. 2, p. 84.)

N O EARLY SCULPTURES OF ANGELS have sur-
vived or are documented to have arrived in the
colonies. Soon enough, however, large sculptures of
angels—the militant Saint Michael, the angel of the
Annunciation, and others—appeared. Colonial sculp-
tors quickly became enamored of this theme and carved
free-standing sculptures of angels, as well as images of
them on pulpits, retablos, and confessionals, until they
multiplied at an alarming rate. European engravings
helped in this dissemination, as did the symbolic role
angels played in religious doctrine. ■

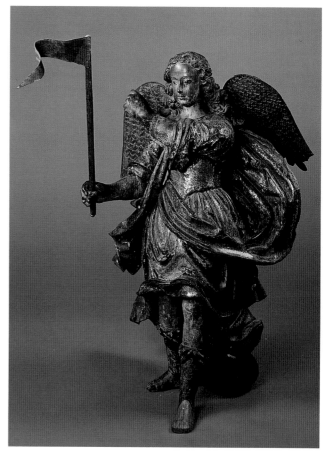

27.
Unknown artist
Peru(?), late seventeenth/early eighteenth century
Saint Michael Archangel(?)
Carved wood, 33 ½ x 22 x 20 in.
Holler and Saunders, Ltd.

The Guardian Angel, polychrome
wood. Church of San Francisco,
Quito.

27. The vigorous three-dimensional form and the swirling
draperies of this sculpture exemplify the Colonial Baroque.
Once the figure brandished a sword in his upraised hand.
Faint traces of *estofado* and *encarnado* are visible, the tech-
niques a painter, working in close collaboration with the
sculptor, used to complete the decoration of a statue. Faces,
hands, and bare torsos were *encarnado*. *Estofado* and *policromía*
were used to simulate clothing. The former technique
involved painting over a gold ground, while the latter
employed a simpler painted surface elaborated with floral and
abstract motifs. A fine example of the eighteenth-century
polychromy for which the Quitenian school of sculpture
became famous is illustrated by a figure of the Guardian
Angel.

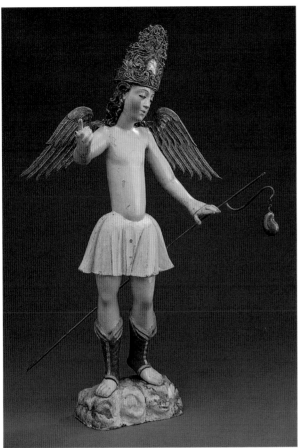

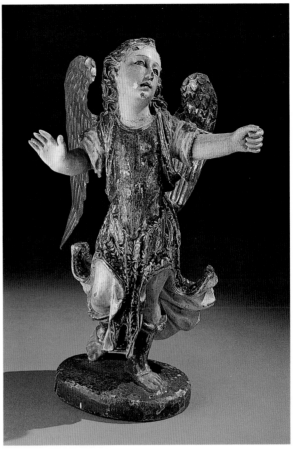

28.
Unknown artist
Quito, late eighteenth century
San Rafael Archangel
Wood sculpture, 20½ x 11 x 3½ in.
MOIFA, Santa Fe
FA 82.3.2

29.
Unknown artist
Quito, late eighteenth century
Miniature Angel
Polychrome wood sculpture, 8¼ x 5½ x 2¾ in.
Stapleton Foundation Bequest, National Museum of American History,
Smithsonian Institution, Washington, D.C.
1988.0616.10

28. San Rafael was probably one of a series of four archangels which also would have included Gabriel, Michael, and perhaps Uriel. This piece illustrates the type of small sculpture in vogue in the late eighteenth century. The influence of Rococo porcelain figurines is evident in its graceful demeanor and light, clear *encarnación*. Wearing a silver crown and bright silver wings, the figure was no doubt intended to be "dressed" in a stiff little brocade skirt. This representation—a Quitenian invention—captures the light-hearted charm of the Rococo.

29. Such brilliantly polychromed images of diminutive size appeared toward the very end of the colonial period and exemplify the late Rococo style. This dancing angel wears an embossed corselet, fluted skirt, greaves, and shiny tinsel wings.

THE THEME OF CHILDHOOD WAS EMPHASIZED increasingly in colonial art during the second half of the eighteenth century. In sculpture the Nativity became the preeminent subject. In Quito, as in other colonial centers, artisans carved small, brilliantly poly-chromed figures portraying the Holy Family, the Magi, worshipful shepherds, and folk who joined in the pilgrimage to Bethlehem. Painting turned to similar themes.

This emphasis on genesis at just this historic moment was deeply significant. A parallel can be drawn between the Christian Nativity scene's powerful reaffirmation of life and the vitality of the forces that were gathering in the name of political independence. For almost three hundred years the colonies had been developing their own unique society. Mestizo and Indian artists simultaneously were able, through skill and imagination, to shape a new art. ∎

Two eighteenth-century engravings showing the racial composition of colonial society in Lima and Quito.

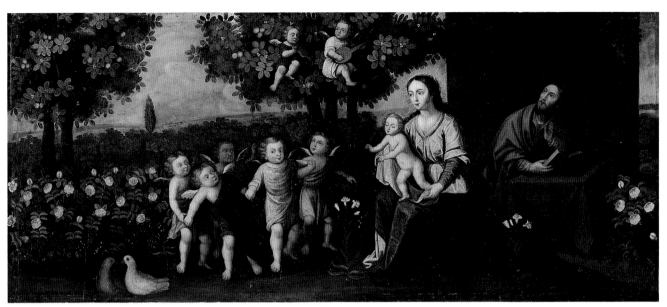

30.
Unknown artist
Alto Peru, seventeenth century
The Holy Family with Angels
Oil on canvas, 39 x 89 ½ in.
IIICA, UNM
L87.3.30

30. This painting is based on a composition by Rubens, *The Virgin and Child with Saints*. A copy on a copper plate (Museum of La Paz Cathedral) from Rubens's workshop may have provided the model for the anonymous painter of this colonial canvas. Saint Joseph, some angels, and a pair of turtledoves (symbols of love) have been added and other elements subtracted, making a scene of tranquil pastoral sweetness out of a rather serious subject.

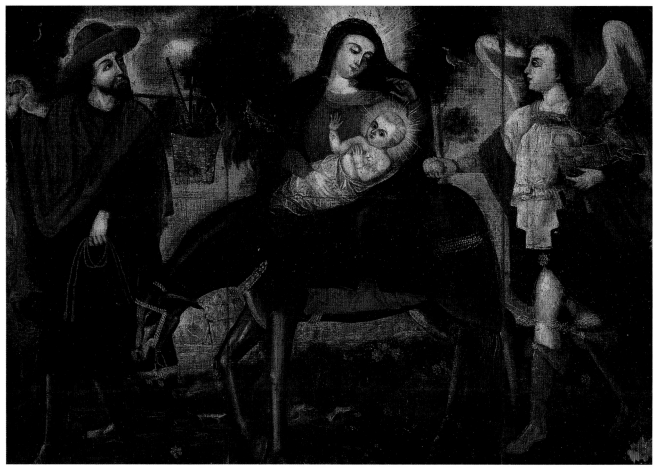

31.
Unknown artist
Cuzco, mid-eighteenth century
The Flight to Egypt
Oil on canvas, 37⅛ x 54 in.
IIICA, UNM
L87.3.27

31. This theme and composition were rendered countless times in eighteenth-century Cuzco art. A mystical amber glow accompanies the Holy Family on its flight to Egypt. The light is concentrated most dramatically on the figure of the Christ child, whose blonde head is surrounded by a golden nimbus. Joseph leads the way, his carpenter's tools crowded in a basket, while a protecting angel offers Mary some fruit. The foreground plane reiterates the horizontal format of the painting. Bright red accents lend warmth to the presentation.

32. An anonymous painter executed both of these canvases using the same composition, probably derived from a Flemish engraving. Together they tell the story of the Massacre of the Innocents and the Holy Family's flight to Egypt. In each painting a large tree divides the action into two temporal and spatial zones. The smaller vignettes provide the "backgrounds," both literally and symbolically, for the principal figures. In *The Flight to Egypt*, Joseph leads the donkey on which Mary and the Christ child are mounted, while in the distance Herod, seated on a throne, watches Roman soldiers murdering the innocents. Below, Herod's legions ride by a field of harvested wheat that sprouts again as the Holy Family passes.

The Holy Family's stay in Egypt is pictured idyllically. Joseph looks up in amazement as three angels in a tree play musical instruments. Peacocks, emblems of eternity, occupy the center of the canvas, reiterating the theme of death and resurrection. The grouping of flowers, grapes, and other fruits in threes is a guileless reference to the Trinity. The row of angels who nudge each other in wonder rises gently like balloons on a string. The vivid splashes of red and the many decorative elements all point to the animated popular art of the mid-eighteenth century.

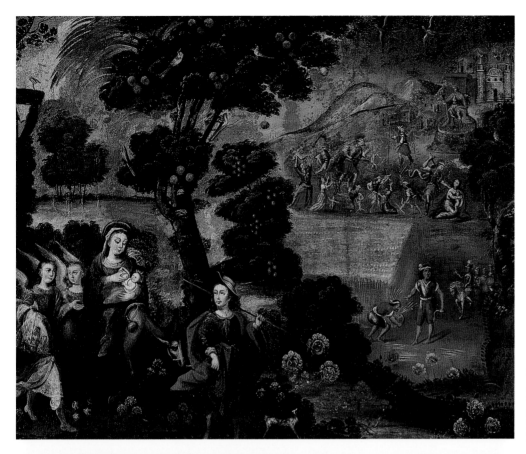

32A.
Unknown artist
Cuzco(?), mid-eighteenth century
The Flight to Egypt
Oil on canvas, 41 x 51 in.
IIICA, UNM
L87.3.43

32B.
The Holy Family
Oil on canvas, 41 x 51 in.
IIICA, UNM
L87.3.44

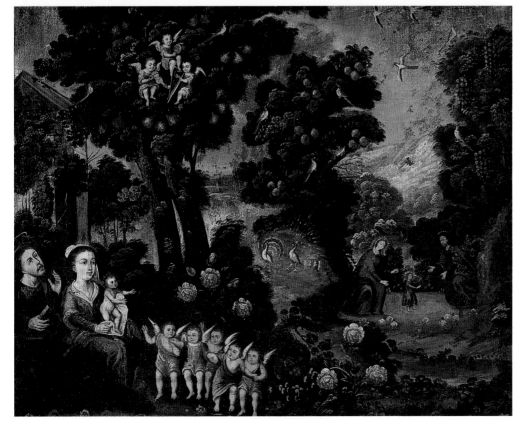

33. If this painting were not so adorable, it would be downright silly. The artist has transformed Saint John the Baptist into an adolescent wearing the three-quarter-length coat and tricorn hat of an eighteenth-century gentleman. Pointing to the Lamb of God, he carries a banner. Standing in an edenic landscape full of flowers and birds, with ringlets and rosebud mouth, he is as far from any biblical prototype as this colonial image is from European art.

34. Charles III, when he arrived in Spain from Naples to ascend the throne, brought many Neapolitan artisans with him. Through them the artistic tradition of the *Nacimiento* or *Belén* received new impetus, gaining wide currency in Spain and, subsequently, in her colonies. Although Nativity scenes continued to be carved well into the nineteenth century, the present examples belong to the late 1700s and represent the late Rococo phase of the Quitenian school of sculpture.

Central to the presentation of the Nativity scene were the figures of the three wise men, Caspar, Melchior, and Balthasar. In the colonies—as can be seen here—these figures came to represent three races—blacks, Europeans, and Indians or mestizos.

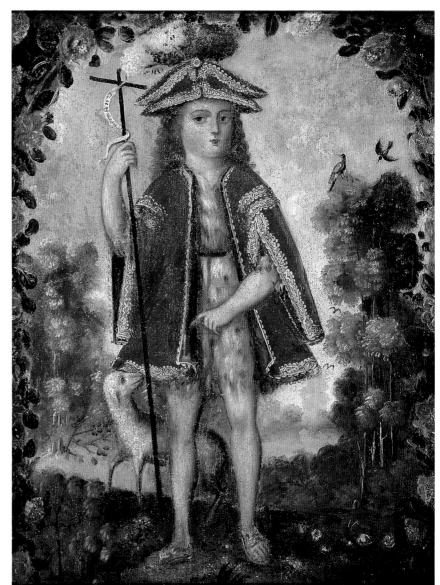

33.
Unknown artist
Cuzco(?), late eighteenth century
The Young Saint John the Baptist
Oil on canvas, 21 ½ x 16 ½ in.
Collection of Dr. James F. Adams

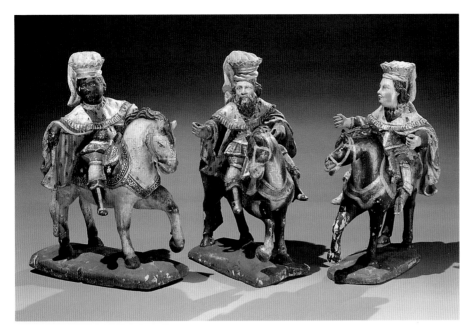

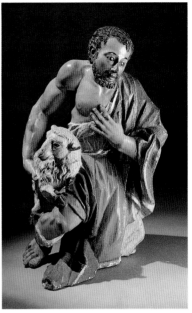

34.
Unknown artist
Quito, late eighteenth century
The Three Kings and a Kneeling Shepherd
Wood, 9 x 6⅞ x 5¼ in.;
8⅝ x 6⅞ x 4¾ in.;
9½ x 7½ x 5¼ in.;
11¾ x 8⅝ x 7⅛ in.
Stapleton Foundation Bequest, National Museum
of American History, Smithsonian Institution,
Washington, D.C.
1988.0616.06/.07/.08/.18

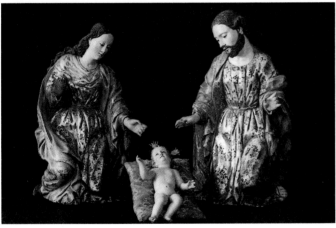

The Holy Family, late eighteenth century. Private collection, Quito.

THE ESSENTIALS OF WOODWORKING and the styles of Spanish furniture were transmitted to the colonies and ably copied by local *ensambladores* and *carpinteros*. By the end of the sixteenth century a guild system had been established that regulated the conditions of work and the products of this industry. For the churches artisans executed elaborately inlaid and coffered Mudejar ceilings, carved and gilded altar screens, and cabinets and tables for sacristies and convents.

As the wealth of the colonies increased, furniture for secular use also became more abundant and elaborate. The basic forms of secular furniture were the chair, table, chest, bed, and cabinet. The earliest designs were restrained and often austere. These gave way in the seventeenth century to more exuberant, three-dimensional Baroque forms which, in the following century, ceded to the Rococo, eventually returning to more traditional patterns with the advent of Neoclassicism. The styles of English furniture—Queen Anne, early Georgian, and Chippendale—also influenced Spanish colonial furniture, as did the decorative techniques of the Orient.

Chairs ranged from simple wooden constructions with plain seats and backs to elaborate bishops' thrones and carved choir stalls. Late in colonial times, genre motifs were introduced on the painted and embossed leather used to decorate chairs; these included motifs borrowed from European engravings as well as details based on direct observation. Tables and cabinets came to be carved, gilded, and painted; chests and *bargueños* (an early form of writing desk) were inlaid with variegated woods, ivory, tortoiseshell, and mother of pearl.

A number of regional centers sprang up for the manufacture of furniture. The Ecuadorian town of Latacunga was a major center of production for beds, tables, chairs, and writing desks. These pieces, noted the colonial historian Alcedo y Herrera, were made of exquisite woods, both plain and inlaid; their designs were based on Spanish examples brought by merchants from the factories of Panama and Portobelo (Alcedo y Herrera 1776, vol. 2, p. 31). The museums of Quito preserve extraordinary examples of Quitenian colonial furniture which allow us to trace stylistic evolution. As in all of the arts, colonial furniture was at first conservatively dependant on imported European styles. Eventually, it exhibited creative freedom with the inclusion of native motifs, a proliferation of surface decoration, and the emergence of local characteristics.

Although this field of research requires further study, these artifacts exhibit the great skill and creative genius of colonial artisans in objects that combine utility and charm. ▪

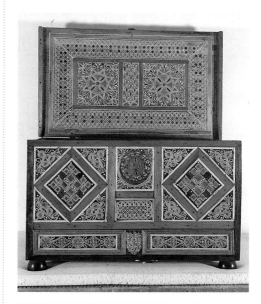

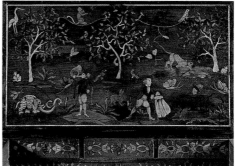

The clearly defined geometric patterns of the top example, an earlier piece, looks back to European art for inspiration. The lower piece, of a later date, is more American in spirit, with its freer, more exuberant design and naturalistic motifs.

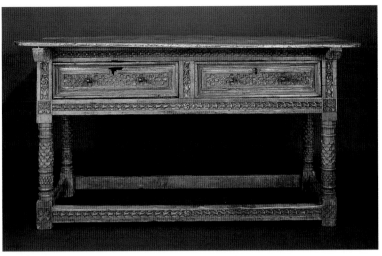

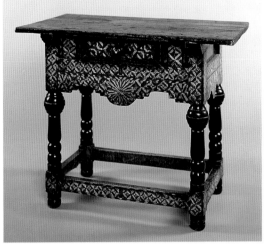

35.
Unknown artist
Alto Peru, eighteenth century(?)
Table with Two Drawers
Carved wood, 35 ¼ x 66 x 35 in.
Michael Haskell Collection

36.
Unknown artist
Ayacucho, nineteenth century
Table with One Drawer
Wood, 30 x 38 x 20 ¼ in.
Collection of Mr. and Mrs. Peter B. Foreman

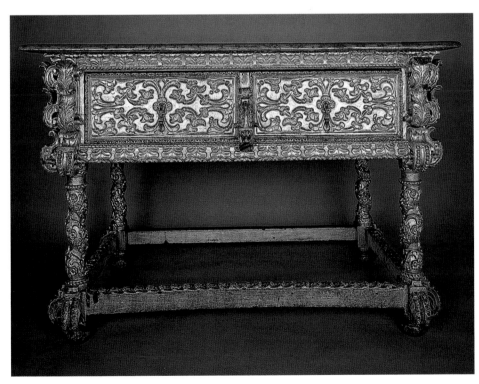

37.
Unknown artist
Cuzco, mid-eighteenth century
Table
Carved, gilded wood, 50 ½ x 82 x 31 ¼ in.
Holler and Saunders, Ltd.

35. The prototype for this and the two following examples is the sturdy Spanish table with unadorned legs, simple plank top, and one or two drawers. This piece reveals the inventive composite style of a colonial artisan who achieved a manner uniquely his own. A pair of simple brackets supports the tabletop. Linear moldings and naturalistic designs in the form of rosettes ornament the two drawers, which are separated by a narrow decorated plaque and adorned with cast metal pulls. The design of the border terminates in an ornamented square and is repeated on the stretchers. The legs are composed of various decorative elements—a hobnail pattern, a fish-scale design—stacked one above the other.

36. The town of Ayacucho in southern Peru developed into an important regional artistic center in late colonial times. Small Nativity figures, copies of European porcelains, and genre figures were carved from a soft local stone called *huamanga*. In addition Ayacucho was famous for work in silver filigree.

In the nineteenth century, during the time of the Republic, this center also gave rise to a style of furniture possessing distinctive local characteristics and employing forms and techniques introduced in colonial times. This style borrowed its motifs from various sources. The influence of Portuguese furniture is evident in the present example in the heavy, elaborately turned legs. The inlay technique was borrowed from the Spanish, who had taken it from the Moors. The severe geometric inlay pattern was achieved solely through the use of different types and colors of woods.

37. If Potosí is identified with silver, Cuzco is with gold. From the fabulous treasure of Coricancha to the lavish use of gold in their personal and religious ornaments, the Incas, who believed that this metal represented the tears of God, used it for its symbolic, not its monetary, value. When it was incorporated into richly gilded church interiors or used to decorate paintings, gold was both an adornment and an offering.

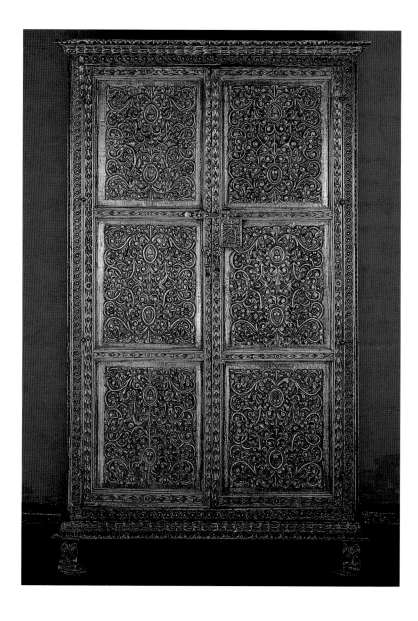

In the eighteenth century this love of gold spilled over onto secular furniture. This simple table is all but submerged in a wealth of gilded decorations. The drawers and side panels are covered with scrolled vine and leaf designs; the molding is edged with a more stylized pattern of leaves and fine beading. The legs, twisted into Solomonic columns, flare into strange forms bearing a distant relationship to the traditional lion's foot and ball. The stretchers are also carved. Matched pairs of semidetached brackets, covered with designs, spring outward in vigorous three-dimensional forms.

38. Cuzco furniture like this richly carved *armario* came to have a distinctive regional flavor. Although the form is European, the exuberance of the design suggests the resurgence of an ancient indigenous vitality. The doors open onto a lavishly decorated interior, gilded designs shine forth from the shadows, and the edges of the shelves, doors, and drawers are outlined with delicate tracery.

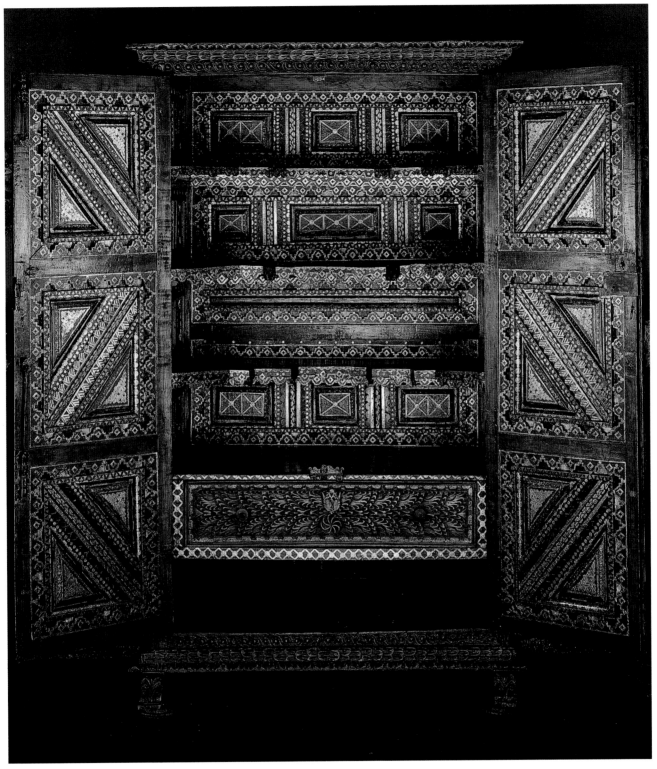

38.
Unknown artist
Cuzco, eighteenth century
Armario or *Cabinet*
Wood, 50½ x 82 x 31¼ in.
Holler and Saunders, Ltd.

THE EXACT ORIGIN of the *bargueño* and the derivation of its name are unknown. This type of furniture first appeared in Europe in the late fifteenth or early sixteenth century, retaining its immense popularity until the nineteenth century. During this time *bargueños* became highly prized not only in Spain but in her colonies as well. The Spanish *bargueño* combined European design elements with Mudejar inlay techniques known in Spanish as *taraceo* or *taraceado*.

The form of the *bargueño* comprises a simple box with carrying handles and a hinged front which, when lowered, reveals three or four rows of small drawers. While the exterior was often simply painted, the interior came to be elaborately decorated—painted, gilded, or intricately inlaid with variegated woods, ivory, bone, and mother of pearl. The earliest decorations took the form of abstract mosaics. Under Renaissance influence, architectonic motifs—columns, arches, and the like—were introduced. With the coming of the Baroque, the curved line predominated. During the eighteenth century naturalistic motifs prevailed, and, due to the increasing presence of indigenous workmen, native decorative details were included. The Mestizo Baroque thus found a form of expression in this art as it had in architecture, painting, and sculpture. ▪

39. It is unusual for the exterior of a *bargueño* or *papelera* to be inlaid. In this example a variety of woods was used to form designs of leaves and curling vines on both the interior and the exterior. Three recessed drawers are decorated with architectonic motifs; they frame a smiling sun, an eighteenth-century figure, and a siren wearing a feather skirt and playing a guitar. The right-hand drawer is a later replacement.

The Jesuits, who established fifteen missions in the remote jungle area of southeastern Bolivia, seem to have made a small cottage industry of the *bargueño*. Having gathered the Moxos and Chiquitos Indians into townships, they established autocratic rule. They organized cattle ranches and cocoa plantations and taught the Indians music, painting, blacksmithing, and other arts. Since many of the Jesuit fathers were originally from Northern Europe—Bavaria, Bohemia, Silesia, and Switzerland—the decorative influence of these countries is sometimes apparent (Bach 1990, pp. 36-41). Spanish and Moorish stylistic currents also were adopted and synthesized by the Indian artisans, who added their own deft touches with whimsical figures and a celebration of local flora and fauna.

40. Against a brilliant red background painted on the inside of the lid, a biblical drama is being played out. A woman cautions advancing Roman soldiers, chain and shackles in hand, not to wake Samson, as Delilah, bending toward him, scissors in hand, prepares to cut his hair and thus rob him of his strength. The recessed compartment is painted in imitation of richly embroidered Oriental cloth. An image of an eighteenth-century gentleman, in three-quarter coat and knee-breeches, is portrayed on the face of a recessed drawer flanked by an arch and paired columns. The other drawers are decorated with naturalistic motifs: foliage, the sun, birds, and tigers and other jungle animals. These themes and the naive style suggest that the inlay is the work of artisans from the Jesuit missions of Moxos or Chiquitos, while the painted design reveals a more sophisticated hand.

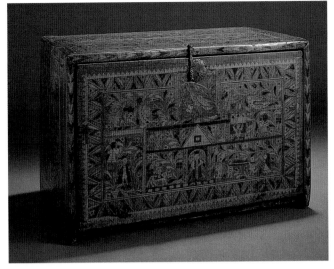
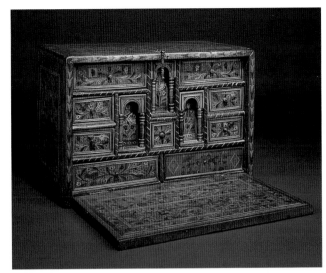

39.
Unknown artist
Bolivia, eighteenth century
Bargueño
Inlaid wood, 17¼ x 28 x 16¼ in.
Michael Haskell Collection

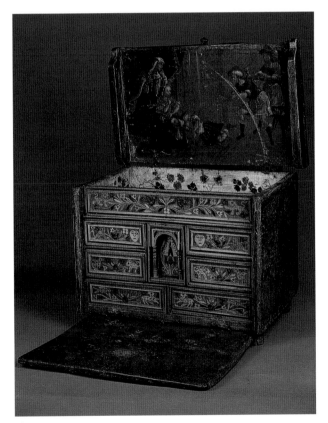
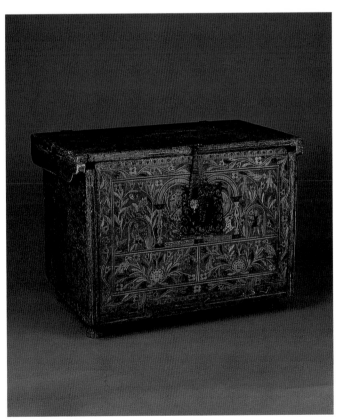

40.
Unknown artist
Bolivia, eighteenth century
Bargueño
Inlaid wood, 21½ x 14 x 13 in.
Holler and Saunders, Ltd.

41.
Unknown artist
Colombia(?), eighteenth century
Altar
Carved, gilded wood, 96 x 56 x 28 in.
Mt. Calvary Retreat House, The Order of the Holy Cross,
Santa Barbara, CA

ONCE THE BUILDING OF A CHURCH had been completed, the designing and constructing of the altars and embellishing of the interior began. The main altar, placed at the blind end of the sanctuary, was the focus for the principal liturgical ceremonies. A view of the interior of the church of San Francisco in Quito provides some idea of its splendor. With the coming of the Baroque, huge altars also were placed at the arms of the crossing. In time they came to line the walls of the nave as well.

In the colonies, as in Spain, the work of designing and executing these large structures was entrusted to the most talented designers and artisans. Few of their names have survived. A side altar from the church of Santa Catalina in Cuzco provides a detailed view of the intricate carving and many design elements that could be incorporated into a single altar. Divided both horizontally and vertically, this side altar rises in graduated steps. The niches contain statues of saints, while the upper cartouches, carved in low relief, depict biblical personages or events. On the convex surface of the central panel, a representation of the Annunciation has been executed in a manner similar to that of the altar illustrated on the opposing page, suggesting that the latter must have been an integral part of a large *reredo* or *retablo*. ■

41. The decorative motifs and bold three-dimensional carving of this altar exemplify the type of decoration which came to dominate church interiors in the eighteenth century. Once this altar had been carved, it was covered with several layers of fine gesso, which were polished between each application so that no detail of the carving would blur. The whole was then covered with gold leaf applied in small laminates and burnished into place.

Although this piece was collected in Colombia, the style and decorative motifs exemplify the High Baroque and are equally applicable to any other part of the Spanish colonial empire. Within a cartouche, the figures of the Virgin Mary and the angel of the Annunciation kneel on a pedestal of clouds from which emerges an angel's head; the dove of the Holy Ghost hovering overhead balances the composition. Floral scrolls complete the design of the main panel, which is flanked by engaged Solomonic columns entwined with eucharistic grapes. The columns terminate in an entablature that includes an architrave, frieze, and cornice with a dentil course. Floral designs interspersed with angels' heads are repeated throughout. The overall patterning demonstrates a skillful interplay between curved and straight lines and between raised and recessed surfaces.

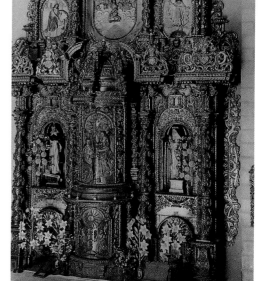

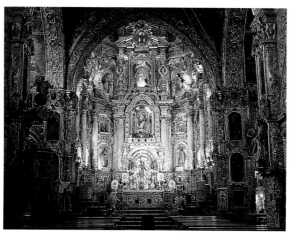

Main altar, church of San Francisco, Quito (left); side altar, church of Santa Catalina, Cuzco (right).

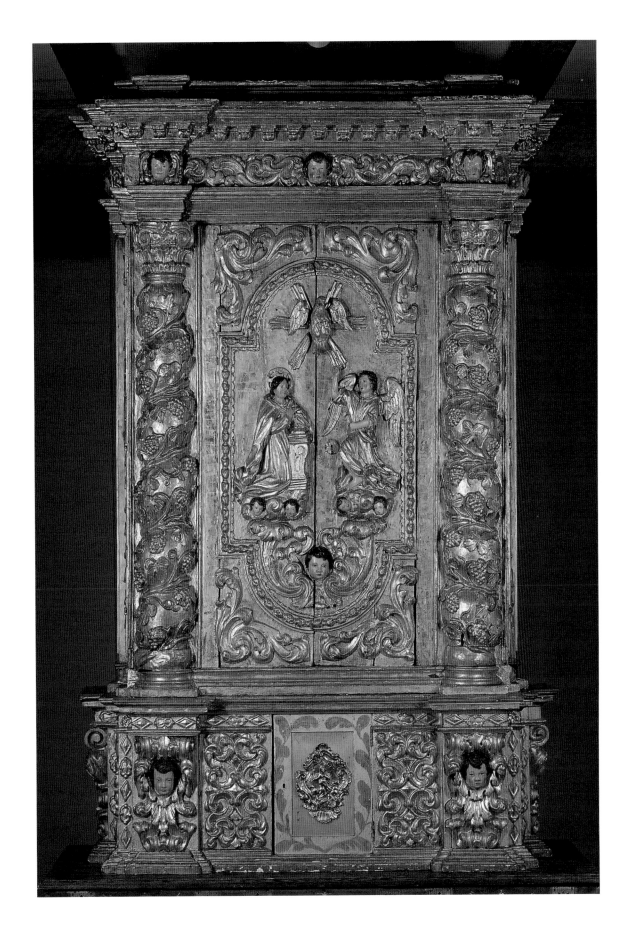

ONCE THE PRINCIPAL CITIES of colonial South America—Lima, Cuzco, Arequipa, Santa Fé de Bogotá, Quito, Potosí, and Santiago de Chile—had been established, the art of silver work began to be fostered. In many instances this work rested on a solid pre-Columbian tradition well versed in all aspects of work with precious metals, from alloying to soldering, from repoussé to casting and molding. During the first century of colonial life, exchanges occurred among European, indigenous, and Creole silversmiths who each contributed their own knowledge and aesthetic concepts.

The art of the seventeenth century began under the influence of Mannerism. After 1650 the Baroque made its first appearance, although it remained timidly dependent on Mannerist forms even in important centers such as Lima, capitol of the Viceroyalty. By the last quarter of the seventeenth century the Baroque had triumphed and from then until approximately 1790, when it was eclipsed by the Rococo, the Golden Age of Silver flourished. During this period silver work played a central role in the religious and civic life of the colonies which thrived on ostentation and pomp. The persuasive art of the Baroque epitomized the manner of living and feeling of the colonial society, making a dazzling spectacle of everyday life.

Inspired by the new Baroque current, cathedrals, monasteries, convents, and church parishes commissioned an incalculable number of pieces—frontals, monstrances, tabernacles, candleholders, crosses, and chalices—with which to enrich liturgical ceremonies and processions. Thus the art of religious silver work attained an extraordinary flowering. Formal and decorative canons were established that were common to workshops in the Viceroyalty of Peru, even though each shop retained a distinct style and personality. The design of the monstrances of the Peru-Bolivia region, for example, characteristically display a central shaft from which spring numerous curling branches ending in pairs of juxtaposed grotesques. The transparent glass was decorated with complex fretwork and adorned with *champlevé* enamels as well as quantities of pearls, emeralds, and rubies. The use of these precious stones, widespread throughout the Andean region, was

especially notable in Nueva Granada (Colombia and Venezuela), which could boast such impressive examples as the famous monstrance called *La Lechuga* (the Lettuce), because it was so richly decorated with large emeralds. The typology of this piece and others executed in Colombia indicates that the silversmiths of this kingdom were not bound by the formal canons governing Peru and Bolivia.

What best distinguishes the Colonial Baroque silver work of South America from that of Mexico and Guatemala are its decorative forms, particularly those used on religious pieces. This distinctive thematic material includes horns of plenty, sirens with feathered tails, grotesque masks, and *hombres-follaje*, concepts inspired by Mannerist designs circulated throughout the Americas in the form of books and engravings. To these forms, modified under the influence of the Baroque, were added other naturalistic motifs—birds, stalks, leaves, and full-bodied flowers—all presented in a variety of compositions, in voluptuous forms and high relief.

Thus an ornamental lexicon was established indicative of the colonial—particularly the Andean—mentality, which abhorred empty spaces and fancied grotesque designs. Repoussé was one of the preferred techniques in High Baroque silver work. Another technique, the art of filigree, required enormous dexterity. The city of Huamanga (Ayacucho) was the most important center for the latter, which reached its peak in the final years of the colonial era.

While religious silver work achieved enormous importance in South America for its quality, quantity, and variety, domestic silver destined for home use, personal adornment, and interior decoration was no less significant. Undoubtedly, the objects most representative of viceregal Peru are incense burners, *sahumadores*. Of Oriental derivation, they were intended to perfume the air and played an important role in the domestic life of the Spanish colonies. In the Peru-Bolivia area they took varied animal and vegetal forms. Among the most representative are squash, pomegranates, pineapples, llamas, lions, doves, deer, chickens, and turkeys. In addition

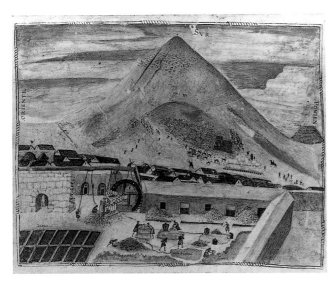

General view of the Cerro de Potosí, from which vast quantities of silver were mined. The Spanish smelting works are in the foreground.

pavas-hornillo, small kettles for boiling the water used to make *maté* tea, were fashioned with feet, spouts, lids, and handles and are round, octagonal or shaped like lions or bulls.

Since the custom of using coca leaves was so widespread, silversmiths fashioned impressive boxes in which to store them. These took the shape of small chests with scalloped lids or are round with legs. Other representative pieces were the *mates* with their complement, the *bombilla*, which grew from the widespread habit of drinking *yerva de Paraguay*, and were used in Peru, Bolivia, Chile, and Rio de la Plata (Argentina).

Without a doubt the importance of South American silver was due to the enormous mineral wealth of the Viceroyalty of Peru and to the mines of Potosí, discovered in 1545. The splendor of this art retained its importance until the final years of the viceroyalty and began to decline at the beginning of the nineteenth century. This decline resulted from diminishing production, a mining crisis at the end of the eighteenth century, and the dissolution of the guild system. Sadly, the Great Age of Silver, as Ricardo Palma considered the colonial epoch, had come to an end. ■ CEM

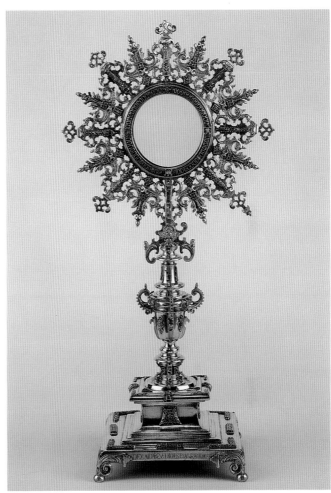

42.
Unknown artist
Lima
Portable Monstrance, 1649
Silver, gold , H.: 22½ in.
The Metropolitan Museum of Art, The Michael
Friedsam Collection, 1931
32.100.213

42. This stunning portable monstrance was designed in the form of a sunburst. It is made of cast silver, washed in gold on which designs are engraved, and adorned with *champlevé* plaques. The plaques are decorated with geometric designs in silver set off against a blue background with touches of green and honey-gold. An inscription on the base reads EL PADRE FR, po. de VRRERA NATURAL DESTA VILA DE XADARQUE DIO ESTE SAGRARIO A ESTA IGLESIA MAIOR DONDE FUE BATICADO RUEGEN A DIOS POR EL ANO 1649, thus explaining that the monstrance was sent by a Spanish priest living in Peru to his native parish in Spain. The style of the piece is

Mannerist, although the form of the sunburst anticipates the Baroque, when this pattern was frequently used by the silversmiths of Peru, especially Lima. *CEM*

43. The convex lid to this luxurious trunk is lined on both sides with repoussé and engraved silver plate. The trunk rests on four feet in the shape of brackets covered with Rococo adornments. Two cast-silver handles are affixed to the sides. Naturalistic motifs predominate—scrolls and flowers both open and in bud, clusters of grapes, and large floral vases. Added to these are birds, masculine faces with negroid features, *hombres-follaje*, and a two-headed eagle. In the center of the lid is an escutcheon on which are engraved the arms of the counts of Altamirano and a saying, *Que no es lo mismo que mi dueño guarde sin cerrar*, which means roughly "Better safe than sorry!" The hinges are executed in a floral motif, with a latch for closing. The date 1759 is inscribed on a cartouche.

The trunk's interior is lined with the same rectangular silver plates ornamented with grapes, leaves, flowers, and a C; a round plaque has been added with the inscription LAUS DEO A.D. 1747, S.P.V. The ornamentation is a copy of work seen on leather-covered trunks of Alto Peru (Bolivia), as is the planiform decorative style. This is a Baroque work, some parts of which are not original. Its style suggests that it might have been made in 1747 rather than in 1759, a date that appears to have been added later. CEM

44. These greaves, or shin guards, probably were made to decorate the statue of an archangel. Such statues were traditionally dressed in military garb in Latin America. The smooth surfaces interrupted with garlands show the early influence of Neoclassicism. The Neoclassical motifs, however, have been treated in a late Baroque or Rococo manner by the Bolivian silversmith, who draped the garlands on a diagonal, inserted floral motifs,

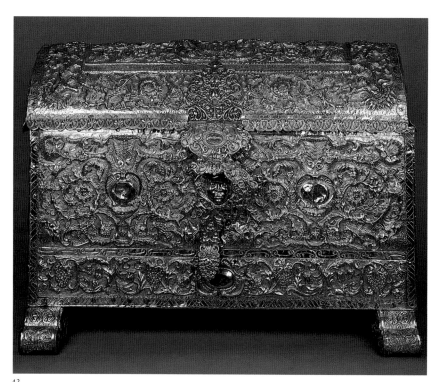

43.
Unknown artist
Lima(?), mid-eighteenth century
Trunk
Silver, wood overlaid with silver repoussé, 35 ½ x 34 x 16 ¼ in.
Arizona State Historical Society, Bequest of John and Helen Murphey
91.48.1

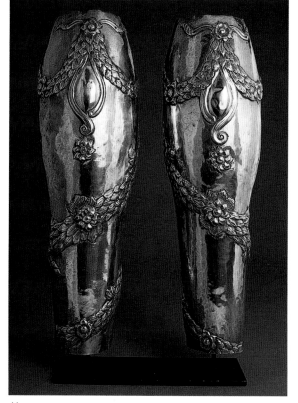

44.
Unknown artist
Bolivia, early nineteenth century
Greaves
White silver, 17 ¾ x 5 ½ x 4 in.
Collection of Carlos Osona

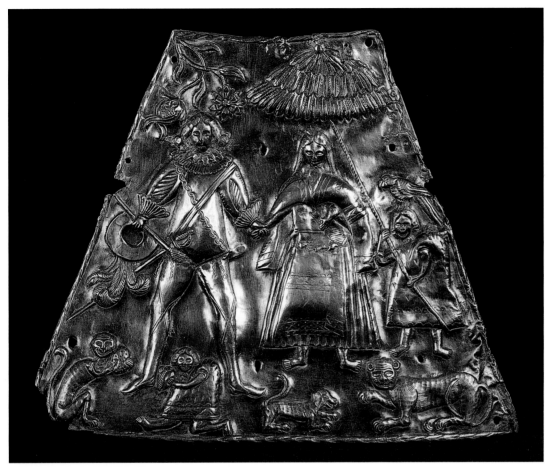

45.
Unknown artist
Alto Peru, eighteenth century(?)
Ornamental Plaque
Silver, 8⅝ x 11⅜ in.
Private Collection: Courtesy Anthony Ralph
Gallery, New York

and added an asymmetrical S-curve pendant to the upper section. Consequently, the greaves exemplify the transition from the late Baroque or Rococo style toward a purer form of Neoclassicism. *DP*

45. Ñusta Beatriz Clara was a princess, one of the last surviving members of the Inca royal line. She was betrothed, by order of Viceroy Toledo, to Martín García de Loyola, the nephew of the founder of the Jesuit order. This union not only gave García access to the lands, the sixteen hundred tribute payers, and the nine thousand Indians that comprised Beatriz's royal inheritance but also helped to legitimize the claims of Spanish power in broader terms. Their daughter, Ana María Lorenza García

Sayri Tupac de Loyola, was born in Chile in 1593, where her father was governor. When Beatriz died in Lima seven years later, Lorenza was sent to Spain, where she later married Don Enríquez de Borja, a member of the family of Francisco de Borja, a prominent Jesuit saint. Thus were mingled the blood of two aristocracies.

These two significant marriages are immortalized in an elaborate late seventeenth-century painting that hangs in the Jesuit church of La Compañía in Cuzco and of which many copies were made. The nuptial pair shown on the present trapezoidal plaque appears to be a reinterpretation of the marriage of García to Beatriz, although the original scene has been reduced to only a few figures. Fashioned of embossed and

chased silver, this type of breastplate was worn by Indian dancers to decorate their costumes. García is shown elegantly dressed in the attire of the court of Philip III. By contrast the royal princess is shown barefoot, as if she were a rustic countrywoman—a genre motif that underscores the popular character of this piece. She wears an indigenous full-skirted *acsu* and, over her shoulders, a *lliclla* attached with a *tipqui*, or brooch. The spindle she holds symbolizes her role as carrier of the royal female lineage, while the plumed parasol, or *achihua*, indicates her rank. She is accompanied by the hunchback servants, wearing *uncus* (the short Inca tunic), who traditionally attended Inca nobility. Other indigenous motifs include a shell trumpet and a par-

rot as well as a puma and monkey whose designs recall Bolivian stone carvings.

This plaque was probably fashioned in the Cuzco highlands or in the altiplano zone of Bolivia during the eighteenth century. *GP AND CEM*

46. This rectangular silver frame, mounted in turn on a wooden frame, is richly adorned with repoussé motifs—flat ribbons terminating in flowers or grotesque heads. A single angel decorates the base, while at the peak an oval medallion is flanked by Solomonic columns and two more angels. This work is typical of the La Paz region and may be dated around 1725. *CEM*

47. This elegant Baroque cast-silver table was intended to grace a lady's drawing room. The front and sides are decorated with similar scalloped edges. At the center of each panel a figure with a leafy skirt holds cornucopias filled with flowers. The curved cabriolet legs, decorated with winged cherubs' heads, terminate in decorative feet in the form lions' paws and balls. This decoration is characteristic of the Alto Peru region of Bolivia. The piece was probably executed around 1745. *CEM*

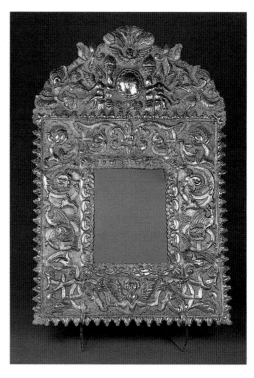

46.
Unknown artist
Bolivia, circa 1725
Frame
Silver, 12½ x 29½ x 19½ in.
Holler and Saunders, Ltd.

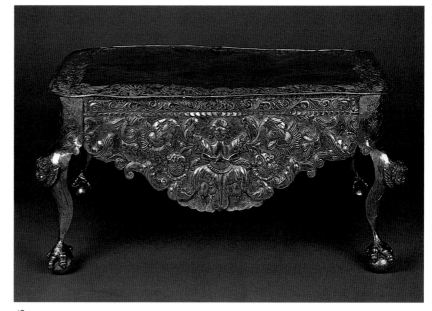

47.
Unknown artist
Alto Peru, circa 1745
Small Table
Silver, 12½ x 26½ x 19½ in.
Holler and Saunders, Ltd.

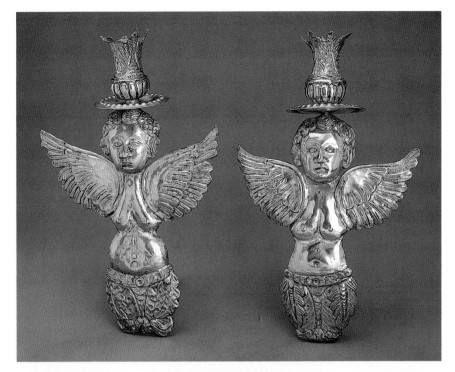

48.
Unknown artist
Paraguay, eighteenth century
Pair of Candle Sconces
Silver, each 13½ x 8½ in.
MOIFA, Santa Fe, IBM Collection
A.62.1-2a-2b

48. This pair of eighteenth-century candle sconces was fashioned of repoussé silver in the forms of angels with spread wings and foliage skirts. The iconography is typical of the *altiplano* region of Bolivia and Peru, although the round candle holders, covered with designs, are unusual. These sconces were, in all likelihood, the work of artisans attached to the Jesuit missions of Paraguay, a school strongly influenced by the silversmiths of Potosí. CEM

49. The designs on this pair of almond-shaped plaques are symmetrically disposed around cartouches in which the initials IHS (Jesus Christ) are inscribed. The elaborate motifs, executed in high relief, are composed of horns of plenty, flowers, sinuous lines, birds pecking fruit, and angels. The crests are in the form of scallop shells. This Baroque work was almost certainly executed by Indian silversmiths from the Jesuit missions in the Moxos and Chiquitos area. CEM

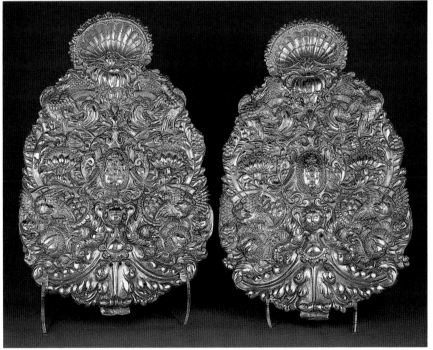

49.
Unknown artist
Bolivia, circa 1740
Pair of Ornamental Plaques
Silver, each 22 x 19½ in.
Holler and Saunders, Ltd.

50. This handsome incense burner was fashioned in the form of a turkey. It stands on an oval-footed tray decorated with a repoussé valance composed of scalloped shells and foliated C-scrolls and vines. The tail is outspread; the hinged, down-turned repoussé wings are finely incised. The head and neck are also hinged, and the latter is perforated with small star-burst openings to allow the fragrance from the burning incense to escape. The head is realistically molded in great detail, with gold-mounted stones for eyes. A hasp of plain silver was affixed to the breast, which bears the date 1767 and the crest of the city of Lima.

51. This finely wrought, whimsical armadillo is an incense burner made of molded and chased silver. The naturalism with which the subject was rendered is impressive, particularly its alert ears, marvelous feet, and rhythmically rendered scales. The hinged tail supports the top when it is open. On the interior there is a receptacle for live coals or herbs. The upper part of the figure is perforated to allow perfumed incense to be dispersed. Armadillos are native to South America, and this form of incense burner was common in the area of the Bolivia-Peru *altiplano* in the nineteenth century. CEM

52. This pair of silver incense burners has been elegantly fashioned in the form of peacocks. Each stands on a simple base with fluted edges. Raised and engraved designs provide realistic details of plumage; the wings are hinged. The bodies open to reveal small braziers on which herbs and incense were burned. Orifices hidden in the plumage allowed the fragrant smoke to disperse. CEM

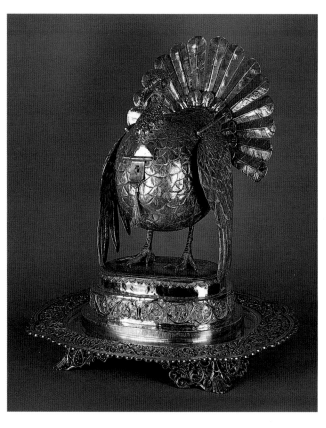

50.
Unknown artist
Lima, eighteenth century
Turkey Incense Burner
Silver, 29¼ x 24 x 20¼ in.
Arizona Historical Society
91.48.1

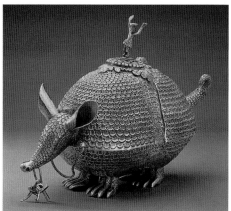

51.
Unknown artist
Alto Peru, nineteenth century
Armadillo Incense Burner
Silver, 9½ x 15½ x 6¾ in.
Collection of Martha Egan

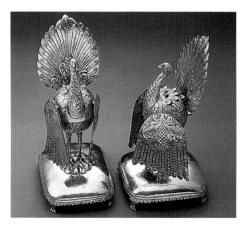

52.
Unknown artist
Peru, nineteenth century
Pair of Peacock Incense Burners
Silver, each 11 x 5 x 5½ in.
Santa Fe, Nedra Matteucci's Senn Galleries

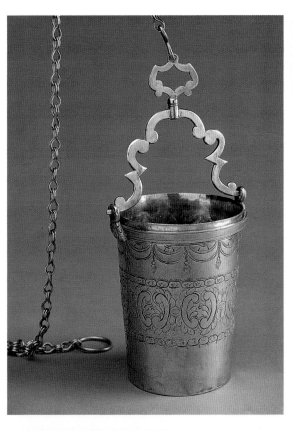

53.
Unknown artist
Rio de la Plata, nineteenth century
Cup
Silver, 8 x 4 in. (including handle)
MOIFA, Santa Fe
A.77.41-1

53. The long chain from which this cup, with its beautifully curved handle, is suspended allowed a horseman to draw water from a pool without dismounting. Finely chased designs decorate the center and rim of the vessel, which was probably executed in the northern Amazon region of Rio de la Plata (Argentina) during the nineteenth century. CEM

54. A wealthy woman would have kept her best jewels in just such a box. The filigree was fashioned by soldering finely drawn wire into decorative floral forms. The structure, hasp, and small scalloped feet were fashioned of cast silver. This small box with its semihexagonal lid exemplifies the kind of work for which the silversmiths of Ayacucho were famous. CEM

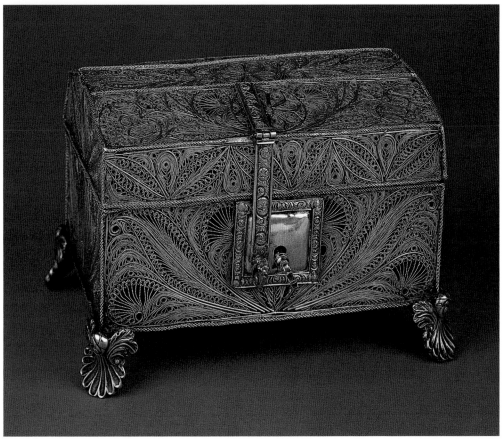

54.
Unknown artist
Ayacucho, nineteenth century
Jewel Box
Silver filigree, 4 ½ x 6 ¾ x 4 ¼ in.
Holler and Saunders, Ltd.

THE FIRST MENTION IN EUROPEAN TEXTS of fine South American cotton and woolen garments woven in a rainbow of designs and colors appears in the chronicles of Pizarro (Parry 1979, p. 180). Following the Spanish conquest the remarkable weaving skills and techniques of the South American Indians were adapted to the production of European articles. These included objects for church use such as altar cloths and chasubles, copes, and other ecclesiastical garments. Weavings for secular use consisted of wall hangings (*pabellones* or *reposteros*), furniture and floor coverings, and items of clothing.

In regions like Cuzco that boasted large Indian populations, some pre-Columbian garments continued to be used. In cities such as Lima, however, the latest European styles were adopted. At the lowest end of the economic scale, the population wore coarsely woven woolen *bayeta*, while the upper classes sported taffetas, velvets, and imported Oriental brocades. Variations on the poncho were used by both Indians and mestizos. Fine native vicuña and alpaca wools were employed, as well as that spun from the fleece of European sheep. By the end of the eighteenth century the emphasis on luxurious dress in colonial society was so excessive that it routinely called forth official sanctions—which were just as routinely ignored! ■

55. This magnificent example of a colonial textile, remarkable for its size and excellent condition, combines European and native South American elements. It may have been woven in one of the *obrajes*, or workshops, in the Cuzco or Lake Titicaca region. The indigenous technique involved wrapping yarn back and forth between the loom bars. Once removed from the loom, the loops were threaded through one another, creating a finished edge like a selvage.

A series of rectangles provides the formal elements of the design. Each rectangle exhibits a different background color—red, white, or soft greenish-gold. While the design retains some of the formal symmetry borrowed from European and Mozarabic models, indigenous exuberance erupts in a riot of elaborate borders, branching tendrils, jars full of flowers, different species of birds, and other naturalistic details. Even the two-headed Hapsburg eagle, which first appeared as a decorative motif in the late sixteenth century, has lost much of its heraldic character and is shown as a rather mild-mannered bird.

56. The poncho—a square or rectangular garment with an opening for the head and the side seams left open—presumably originated with the Araucanian Indians of Chile, although precedents may have existed in other pre-Columbian cultures. This type of garment was probably introduced into the Bolivian highlands in the late seventeenth century by the Jesuits, whose *obrajes* first produced them in large quantities in Chile.

This elegant example was woven in the traditional Indian manner—a warp-faced plain weave with

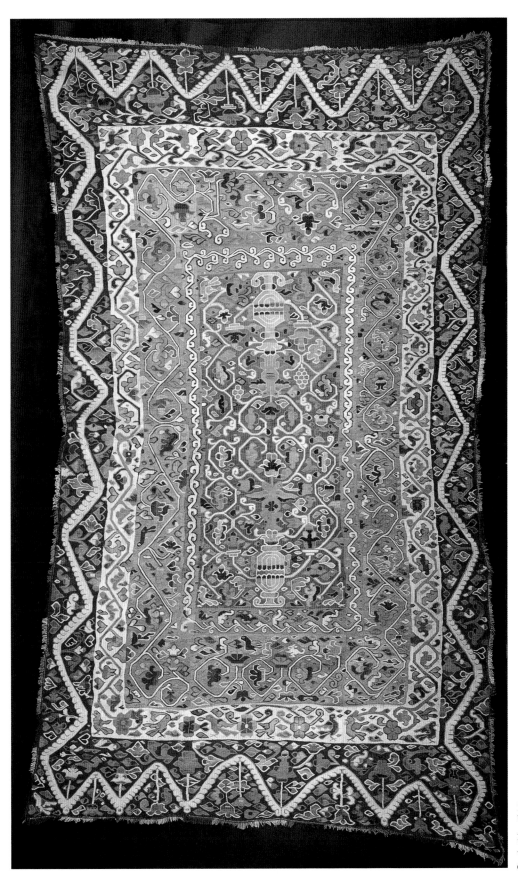

55.
Unknown artists
Alto Peru, mid-seventeenth century (?)
Woven Floor or Wall Covering
Wool, 9 ft. 3 in. x 15 ft. 6 in.
Collection of James Economos

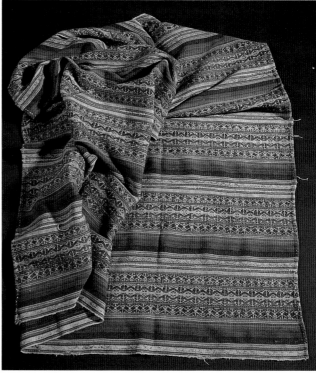

56.
Unknown artist
Juli, Peru, nineteenth century
Poncho
Alpaca, 62 x 62 in.
Collection of Martha Egan

57.
Unknown artist
Lake Titicaca region, nineteenth century
Balandrán Poncho
Cotton and alpaca or wool, 68 x 54 in.
Collection of Martha Egan

complimentary warp weaves and alternating bands of S- and Z-spun warps and a decorative woven fringe border. The background color is a rich purplish-black, a color whose use may have been inspired by the Spanish *luto*, the somber custom of wearing black during a period of mourning and during Holy Week celebrations.

57. The colonial mestizo, seeking to differentiate himself from the Indians, adopted this distinctive *Balandrán* poncho, whose name was derived from the robe worn by priests and scholars. Its design imitated that of expensive European cloth, which mestizos probably could not afford. Such ponchos were pro-

duced in the Jesuit *obrajes* of the Lake Titicaca area, in such localities as Juli and La Paz, and executed in a manner that distinguishes them from the native poncho. Whereas two identical pieces woven on a horizontal loom with continuous warp would have been sewn together to form the indigenous poncho, this mestizo garment was fashioned of smaller pieces cut from long, ten-inch-wide strips woven on a simple European treadle loom. These strips were sewn together to form the larger finished rectangle. Thus Spanish design and technology were combined with an indigenous costume form.

Many famous Creole generals instrumental in the movement for indepen-

dence—Bolívar, San Martín, and Santa Cruz among them—embellished their *Balandrán* ponchos with decorative borders and coats of arms. The tricolor bands of red, yellow, and green on this poncho echo the colors of the national flag of the Republic of Bolivia, which proclaimed its independence in 1825.

THE VICEROYALTY OF NEW SPAIN

1 SAN FRANCISCO
2 MONTEREY
3 SAN DIEGO
4 SANTA FE
5 TUCSON
6 EL PASO
7 CHIHUAHUA
8 SALTILLO
9 DURANGO
10 ZACATECAS
11 SAN LUIS POTOSÍ
12 GUADALAJARA
13 GUANAJUATO
14 QUERÉTARO
15 MEXICO CITY
16 ACOLMAN
17 PUEBLA
18 TAXCO
19 ACAPULCO

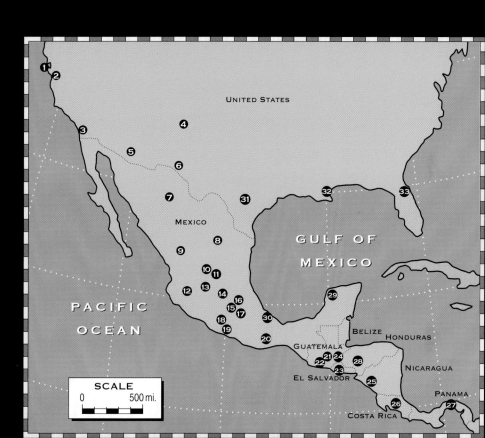

UNITED STATES

MEXICO

GULF OF MEXICO

PACIFIC OCEAN

BELIZE
HONDURAS
GUATEMALA
NICARAGUA
EL SALVADOR
PANAMA
COSTA RICA

SCALE
0 500 mi.

New Spain

Donna Pierce

Metamorphosis in Spanish Colonial Art

All over Latin America during the Spanish colonial period, local artists—whether indigenous, Spanish, or of mixed descent—borrowed ideas from the art of Europe, the Orient, and, in some cases, from local traditions. Colonial artists then manipulated and combined diverse motifs to create distinctively new and regional styles. Artistic elements from other cultures were not only mixed, but their proportions were often exaggerated, details multiplied, space distorted, and surfaces manipulated, imbuing each piece with a feeling that is recognizably Spanish colonial in spirit. In the process of borrowing motifs from various styles and combining them freely, the New World artists changed them into their own style, related to, yet decidedly distinct from their myriad sources.

Religion and government were tightly interwoven in Spain, a condition inherited from the Middle Ages and reinforced by centuries of religious warfare against the Moors. The discovery of North and South America, with their large, gold-rich civilizations, came to be seen by Spaniards as both a reward from God and an obligation to spread Christianity. Subsequently, the religious fervor of the recent reconquest of Spain was carried over into the conquest and colonization of the Americas.

During the conquest of Mexico between 1519 and 1521, Hernán Cortés wrote to King Charles I of Spain, encouraging him to send mendicant friars to the New World as soon as possible, to convert the huge number of Mexican Indians to Christianity.[1] The first Franciscans arrived in 1523 and 1524, followed shortly by Dominicans, Augustinians, Mercedarians, and Jesuits.[2] The missionaries in Mexico began their work by baptizing Indians by the thousands and then attempting to teach them the basics of Christianity in preparation for confirmation. Temporary chapels were built on the rubble of pyramids while plans were drawn up for large, permanent churches.

Some of the civil and ecclesiastical officials of "New Spain," including the first viceroy, Antonio de Mendoza, and the first archbishop, Fray Juan de Zumárraga, were well versed in the new humanist philosophies of the Renaissance and shared the desire to implement them in the New World. Inspired by the writings of Erasmus and Thomas More, they founded hospitals and schools for Indians, designed town plans and buildings, and established a university and printing press.

As early as 1524, the capital of the Quiché Maya Indians was seized by the Spaniards, and Cortés himself led an ill-fated expedition to the south as far as present-day Honduras. By 1527 a Spanish capital had been founded on the slopes of an extinct volcano in what is now Guatemala. The area known today as Central America (Guatemala, Honduras, El Salvador, Nicaragua, Costa Rica, and Panama) became a province of New Spain and was administered by a captain general and an audiencia under the jurisdiction of the viceroy in Mexico. Both the Dominicans and the Franciscans apparently founded establishments in Guatemala in 1529, but the Dominicans dominated the area until at least 1540, when the Franciscans dispatched a large contingent of missionaries. The Mercedarians, destined to become one of the most influential orders in Guatemala, established their first mission there in 1539.

By midcentury the standard plan for the mission church establishment, influenced by the comprehensive design theories of Renaissance writer Leon Battista Alberti, had evolved.[3] Built as Christian Renaissance

utopias all over New Spain, the sixteenth-century religious complexes usually included a single-nave church, a cloister around a patio, and a large walled courtyard, or atrium. Some atriums had small structures in their four corners, called *posas,* whose function is unclear, but which may have housed processional altars.

Many of the mission establishments included an open chapel, a structure unique to the New World.[4] Basically an open-sided chancel, the chapel sheltered the altar, and the congregation occupied the atrium, which functioned as an outdoor nave. This architectural solution made it possible to accommodate large crowds in the early period of mass conversions, before proper churches had been constructed. In some cases the open chapel was eventually incorporated into the structure of the church; in others it continued to function alongside the church.

Although the Indians of central Mexico had large cities with monumental architecture, they had no knowledge of the true arch. As a result, theirs was an architecture characterized by exterior mass rather than interior space, with rubble-filled pyramids topped by small post-and-lintel temples. Large, enclosed interior spaces were unknown in ancient Mesoamerica. According to one of

Facade, church of the Augustinian convent, Acolman, Mexico, 1560.

the earliest Franciscans, Fray Toribio de Benavente, known as Motolinía, "The church of San Francisco in Mexico City was built in the year 1525. The church is small with a vaulted chancel constructed by a stonemason from Castille. The Indians were amazed to see the vault and they could not believe that upon removing the scaffolding, the whole would not collapse. Later the Indians of the province of Tlaxcala built two small vaulted chapels."[5]

In the early years, because of the small number of trained architects in New Spain, most religious buildings were constructed by Indians under the direction of the missionaries. With designs based on the friar's memories of structures in Europe and on quasi-architectural book illustrations, the result was often a random mixture of late Gothic, early Renaissance, and Mudejar (Moorish-Christian) motifs sometimes executed with a vaguely pre-Hispanic feeling. A single church may have a Renaissance-style portico, Gothic ribbed vaults, and Mudejar woodwork. The combination of distinct styles in one structure or work of art, whether intentional or inadvertent, is a characteristic of New World art which recurs throughout the colonial period.

In spite of the unorthodox mingling, and occasional misunderstanding, of diverse

Facade, church of the Augustinian convent, Yuriria, Guanajuato, Mexico, circa 1566-1567.

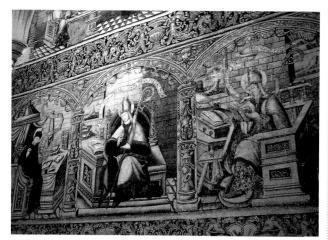

Mural paintings, stairwell of convent, Augustinian convent, Actopan, Hidalgo, Mexico, circa 1570.

styles, a series of elegant and functional religious complexes resulted, in which Indians were converted and educated. Under the direction of several hundred friars and an occasional master craftsman, almost a hundred mission establishments had been constructed in Mexico by 1560, using untrained Indian labor.

By the mid-sixteenth century a small group of trained architects had emigrated to Mexico, but their direct influence was minimal and concentrated in the metropolitan areas. They introduced purer forms of the two distinct Renaissance styles that had developed in Spain: the Plateresque (Silverlike), characterized by classical surface ornamentation, and, later, the severe Herreran, or Purist, style, exemplified by the Escorial, which was built by Philip II between 1563 and 1582.[6] The Plateresque style served as a transition between Gothic and true Renaissance architecture, with rounded arches replacing rib vaults and ornamentation no longer emphasizing function.

In some instances, as the designs of Spanish craftsmen were transmitted and copied elsewhere in New Spain, they were embellished by local artisans with fanciful and unconventional decoration. For example the correct Plateresque facade of the Augustinian mission church of Acolman near Mexico City was copied in more remote Augustinian establishments, including Ixmiquilpan, Metztitlán, Yuriria, and Cuitzeo. The facade of the latter, which

incorporates a third story and cuts off the cornices in midair, is proudly signed by the native stone carver, Francisco Juan Metl. Regional elaboration of the original design culminates in Yuriria, constructed by local Chichimec Indians under the direction of the friar Diego de Chávez, with the addition of a web of strapwork patterns branching out from the portal to take over most of the central facade of the church.

Imported European oil paintings and sculptures of saints were used in New World churches as didactic tools to teach the stories of Christianity. During the early period, church establishments were decorated with stone carvings and mural paintings, usually executed by Indian artists under the direction of friars. Based on illustrations in religious books, early mural paintings were often executed in black, white, and gray, like their models; only later were they executed in polychrome.[7] In stone carving, Mexican Indian craftsmen adapted quickly to the metal tools introduced by Spaniards, and elaborate relief carving is one of the highlights of early colonial art in Mexico.[8] In both the relief carvings and the mural paintings of the sixteenth-century missions, a tendency toward repetitive patterning is noticeable; it is also a characteristic of the wall painting and relief sculpture of pre-Hispanic Mexico and Guatemala.

Before the conquest, the native groups of New Spain had highly developed art forms, including stone sculpture, mural and manuscript painting, gold and silver work, feather mosaics, and so on. The continuation of

Main portal, church of the Franciscan convent, Uruapan, Michoacán, Mexico, 16th century.

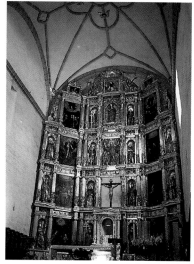

Retablo, church of the Franciscan convent, Xochimilco, Mexico, circa 1590-1610.

native crafts employing Christian iconography was encouraged in the sixteenth century, particularly in several Franciscan schools in Mexico. European techniques were introduced, such as perspective and the use of a ground line in painting. In feather mosaics and in corn-pith sculpture, the techniques remained indigenous, but the subject matter was replaced by Christian imagery. Indian artists were quick to adopt European techniques through instruction from friars or Spanish craftsmen or by observing imported works of art. Art made by Indians in the service of Christianity is referred to as *tequitqui*, meaning "one who pays tribute." [9]

In Europe Protestant attacks on the Catholic church provoked the Counter-Reformation. Consequently, the Council of Trent (1545-1563) initiated numerous reforms, including the mandate that religious art be accurate and realistic and that it depict acts of piety to inspire the faithful.[10] As a result orthodox subjects dominated the religious art of Europe and the Americas for the next century. By the late 1500s the Renaissance ideal of a utopian society in the New World had come under suspicion with the Counter-Reformation and its backlash of conservatism. A series of plagues, overwork, and rebellion had greatly reduced the Indian population, causing increased conflict between the clergy and civilians over the remaining labor force. By the 1570s the powerful mendicant orders were being replaced as ministers to the Indians by secular priests. The friars had the options of moving on to the frontiers or of returning to monastic life in their large establishments, where they often maintained schools and hospitals. At the end of the sixteenth century, many Franciscans chose to follow the expansion of the northern frontier or to sail to the Philippines. Throughout the 1600s they worked among the Pueblo Indians of New Mexico, where they supervised the construction of large adobe churches and also ministered to the Spanish civilian population.[11] In the eighteenth century the Franciscans and Jesuits, in conjunction with Spanish military and civilian settlers, expanded their missionizing efforts into what is now Texas, northern Sonora, Arizona, and California.

In the late sixteenth century European-trained artists and architects emigrated to Mexico in significant numbers for the first time. In the 1580s cathedrals were constructed in the major cities of the New World to pre-

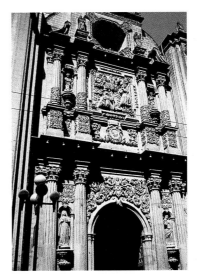

Facade, church of Jesuit convent, La Profesa, Mexico City, Mexico, 1714-1720.

pare for the ratification of the Council of Trent by the Third Provincial Council of 1585. The Spanish population in Mexico had increased, creating the need for churches in Spanish settlements. For the first time large integrated construction projects were drawn up and coordinated by academically trained artists.

Painters and sculptors from Flanders, Italy, and Spain worked together to create large conglomerate altar screens, or *retablos*, in the Renaissance and Mannerist styles of Europe.[12] Combining painting and sculpture in a gilded architectural framework, the early altar screens were dominated by narrative paintings in the wake of the Counter-Reformation's emphasis on didactic art. Through father-son and master-apprentice training, the late Renaissance/Mannerist style dominated Mexican painting and sculpture for the next hundred years. Mannerism initially developed in Europe as a reaction against the classical balance of High Renaissance art. Mannerist artists originally presented religious imagery in an anxious and disquieting way, with agitated figures, acidic colors, and sharp-edged planes. The style soon softened into the depiction of impossibly elongated figures with alabaster skin in dreamlike settings of languid, unearthly perfection. In sculpture, figures often appeared with angular, emaciated bodies, clawlike hands, and fixed, wide-eyed stares, or with willowy limbs, delicate hands, and remote gazes. Both the agitated and languid manifestations of Mannerism conveyed a visionary or supernatural quality. While extreme Mannerism was soon subdued, the less radical aspects persisted in both Europe and Mexico for quite some time.

Beginning in 1565, the Spanish Crown opened up a trade route to the Far East via the Philippines and Mexico. Oriental trade goods were transported on

Spanish galleons from Manila to Acapulco, on the west coast of Mexico. There they were off-loaded onto mule trains for the overland journey to Mexico City or the east coast. Many Oriental objects remained in Mexico; others were reloaded onto galleons in Veracruz for the trip across the Atlantic to Spain. The large

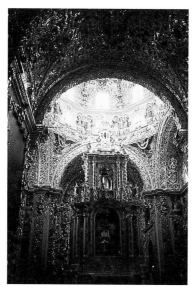

Rosario Chapel, Dominican church of Santo Domingo, Puebla, Puebla, Mexico, 1690.

quantity of Oriental merchandise remaining or passing through Mexico had a major impact on the decorative vocabulary there, reinforced by the influence of Far Eastern motifs on the art of Europe at the same time.

At the end of the sixteenth century, Baroque architecture originated in Rome with large church commissions inspired by Counter-Reformation reforms. The overriding concern of Baroque religious architecture was the creation of a dramatic spiritual environment. To this end the different artistic disciplines—architecture, sculpture and painting—were integrated on both interiors and exteriors in a way not seen since the Gothic period.

By the second half of the seventeenth century, the art of Mexico had begun to develop a discernible national style.[13] The country's Baroque architecture exhibits little concern with manipulation of space and more with manipulation of surface. In early Mexican Baroque architecture, exterior decoration remained concentrated around the facade portal, as in the previous century. Large narrative reliefs flanked by columns were placed over the main door and functioned as the centerpieces of these facades. As in Europe, the classical vocabulary was retained, but liberties were taken in its application. In Mexico classical motifs such as columns and entablatures were "decorated" with foliage, zigzags, scrolls, or filigree patterns.

A classical column with a twisted shaft, supposedly

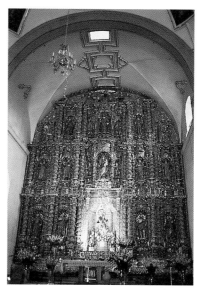

Retablo, church of the Franciscan convent of Ozumba, Mexico, 1730.

reminiscent of those of King Solomon's temple in Jerusalem, was revived in the early seventeenth century by Gianlorenzo Bernini (1598-1680) for the renovation of Saint Peter's in Rome. Known as the Solomonic column, this form is thought to have been introduced to Mexico from Spain in 1646, when a new altar screen was commissioned for the cathedral of Puebla. The design for this altar has been attributed to the great Spanish sculptor from Seville, Juan Martínez Montañés. The spiral column became extremely popular in Mexico, dominating church interiors and, later, facades for at least a hundred years.

Beginning in 1541 with the destruction of the first capital by a landslide, the colonial history and art of the Audiencia of Guatemala was influenced by the frequent earthquakes that plagued the area. The second capital, Santiago de los Caballeros (now known as Antigua), was struck by major tremors in 1590, 1689, 1717, 1751, and in 1773, when the administrative capital was moved again, this time to Santa María de la Asunción, present-day Guatemala City.

By the seventeenth century geological instability

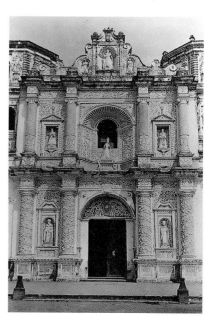

Church of La Merced, Antigua, Guatemala, circa 1670-1700.

had molded the architectural style of the area into a recognizable regional variant.[14] Buildings were constructed with low, wide proportions and buttressed with massive towers. They were often decorated with light, animated relief patterns in an attempt to counteract their earthbound mass. From the Oaxaca area of southern Mexico to the Isthmus of Panama, this building style, often referred to as Earthquake Baroque, prevailed throughout the colonial period.

In European Baroque painting, religious figures and saints were no longer represented as remote, idealized beings, but as common, contemporary people in real-life settings. At first glance these paintings appear to be secular, but their religious aspect is conveyed through dramatic, symbolic lighting, a technique known as tenebrism. Often a strong

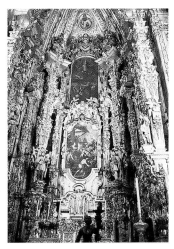

Altar of the Kings, Cathedral of Mexico, Mexico City, 1717-1738.

beam of sunlight enters the scene from above or from the side, dramatically highlighting the religious personage and imbuing him or her with a sacred or "chosen" quality. In some cases the only source of light is a soft glow emanating from the holy person and illuminating those nearby. Ironically, Baroque naturalism embodied a concept common to both the Protestant Reformation and the Catholic Counter-Reformation—that the mysteries of faith were not reserved for the elite, but were accessible to all people through inward experience or outward deeds. Consequently, Baroque naturalism appealed to both Protestants and Catholics and quickly spread throughout Europe. A concurrent style of illusion and exuberance also evolved. Populated with many figures, paintings in this style are full of exaggerated movement and emotion. Extreme foreshortening was often used to violate the picture plane and create the illusion that the viewer was being pulled into the painting's space.

Baroque naturalism was introduced into Mexico in the mid-seventeenth century by means of imported religious paintings and prints by European artists, probably

including examples by the great Spanish artist Francisco de Zurbarán, as well as by the emigration of Spanish artists trained in the style.[15] Mannerism persisted in Mexico much longer than in Europe and coexisted with Baroque naturalism, with some artists quite competent at both. In the 1680s Mexican painters began to follow the more exuberant Baroque style of Europe, exemplified by the work of Peter Paul Rubens. Even though these Mexican paintings are laced with allusions to European

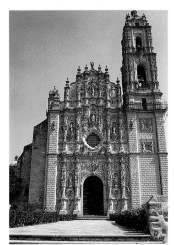

Facade, Jesuit church of Tepotzotlán, Mexico, 1762.

art, one can detect a new independence in the art of this period. The retention of Mannerist distortions and additions of details from Mexican culture and landscape set these paintings apart from both their European counterparts and their Mexican predecessors.

Painting in Central America seems never to have developed a regional style, but rather to have followed patterns set in Mexico. Large quantities of imported paintings from Spain and Mexico decorated Central American churches and influenced the work of local artists. The sculpture of Guatemala, however, was renowned for its fine carving and bright polychromy and was exported to other areas including Mexico.

Baroque sculpture in Europe was characterized by extreme realism, intense emotional energy, implied movement, and, often, an active relationship with the space around it. The religious sculpture of Spain in this period represents one of the highlights of Baroque expression. Intensely dramatic and powerful, the great sculptural compositions of Spanish artists rarely fail to move even the unbelieving viewer.

In New Spain the sculpture of the seventeenth century preserved the more restrained and serene temperament of the Counter-Reformation. Although late Mannerist characteristics were enlivened by slightly more exuberant poses and fluttering drapery, the mood remained less dramatic than that of Spanish Baroque

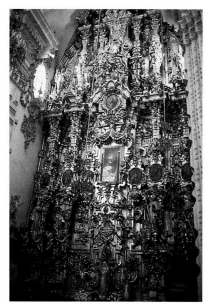

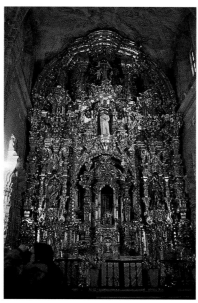

Retablo, church of Santa Prisca, Taxco, Guerrero, Mexico, 1751-1758.

Retablo, church of La Valenciana, Guanajuato, Guanajuato, Mexico, 1765-1788.

heaven, at times the fresco paintings of clouds and cherubs spill out of their architectural frames, turning into sculpted figures in a sort of celestial explosion.

In Mexico the theatrical quality of combined media found its epitome in the Baroque altar screen. No longer reserved for the main altar, large *retablos* now lined the nave and transept walls of churches. Sculpture and painting combined with architecture to create glittering backdrops for church ritual. Solomonic columns often replaced all other structural forms, flanking niches for sculptures or paintings of saints.

In Mexico all architectural elements, even the elastic Solomonic column itself, were covered over with a lush layer of carved, polychromed, and gilded decorative patterning. This tropical foliage in gold is one of the distinctive features of Mexican Baroque art and in many examples it escapes the altar screens to overtake the walls and ceilings of churches as well. In true Baroque fashion, the whole was then dramatically illuminated by the dome and by bursts of sunlight from strategically placed windows. All of these elements combined in Mexican churches to create a celestial illusion, as if one were glimpsing a fragment of heaven here on earth.

At the turn of the eighteenth century, the young Philip V and his court introduced French styles to Spain and, by extension, to the New World. The first important artistic commission of the 1700s in Mexico was the renovation of the cathedral in Mexico City between 1718 and 1737.[16] In the new screen for the high altar, a Spanish artist, Gerónimo Balbás, introduced two concepts to Mexico that, some would say, would be carried by Mexican artists beyond their logical extremes, creating a Baroque style that is decidedly Mexican in both concept and execution.

Underneath the lush carpet of decorative carving, seventeenth-century Mexican *retablos* had retained the rigid structural framework first introduced by Mannerist artists in the late sixteenth century. In the great Altar of the Kings by Balbás, this formula, consisting of niches flanked by columns and topped by horizontal entabla-

sculpture. The extreme realism and pathos of the latter was tempered in New Spain by the retention of a sense of the supernatural. The result is a graceful and ethereal, rather than a corporeal and emotional, theatricality. The viewer is able to empathize with the suffering of a saint, but at the same time senses that the figure is about to move into the realm of the holy. The best of Mexican and Guatemalan sculpture succeeds in capturing the calm moment of transfiguration, apotheosis, or religious ecstasy when a real human being makes the transition into the celestial world. In doing so, such work unites the two great manifestations of the Baroque style, naturalism and illusion.

Consequently, the Baroque sculpture of New Spain tends to be quieter in feeling and movement than European Baroque sculpture, in part because of the supreme role played by the composite altar screen in Mexican Baroque art. The more subdued sculptures functioned more successfully within the overall environment of the altar screen in New Spain.

One of the outstanding achievements of Baroque art throughout the world was the splendid fusion of all media to create conglomerate works of art. In Europe the apex of such Baroque schemes often occurred in domes, where architecture, painting, and sculpture united to form composite illusions. Usually representing scenes of

tures, was violated. He restructured the altar screen itself, eliminating the repetitive niches, breaking up the horizontal entablatures, and changing the shape of the screen from a flat plane against the back wall to a dynamic conglomerate filling all three walls and part of the apse ceiling. The possibilities implicit in this new design concept were expanded in a variety of ways by Mexican artists over the next eighty years.

In the Altar of the Kings, Balbás used a type of Neo-Mannerist column, known as an *estípite*, which he had included in his design for the altar screen of the Sagrario in the cathedral of Seville. The angular *estípite*, which is always wider in the middle of the shaft than at the base and capital, was popular in Roman decorative arts. It was used in Mannerist art, appearing on at least one Mexican altar screen of that period, and was common in Northern European decorative arts throughout the seventeenth century, having become widely known through engravings by the German artist Wendel Dietterlin. However, the use of the *estípite* as a major architectural decorative element was entirely a Spanish innovation, first in southern Andalusia and then, carried to a thunderous climax, in Mexico. So ubiquitous did the *estípite* become that the art of the eighteenth century in Mexico is often referred to as Estípite Baroque.

In 1749 an *estípite* altar screen in stone was erected as the facade of the Sagrario church in Mexico City. The breakdown of the structural framework and the use of the *estípite* on the church exterior were unknown in Spain and signal the emergence of Mexican Baroque art as a truly independent and self-possessed style. With its narrow base and top, the *estípite* itself already begins to deny its function as a structural support, which may be the reason for its popularity in Mexico. Combined with the breakdown in the structural integrity of the altar-screen framework, this quality provided Mexican artists with a freedom they seem to have been anticipating for several hundred years.

This development had been presaged by the unruly decorative carving on some sixteenth-century mission facades. Ever since decorative patterning had begun to camouflage the supporting function of columns and entablatures in the seventeenth century, Mexican altar screens had strained to burst free from the confines of gravity and logic. In the eighteenth century they did just

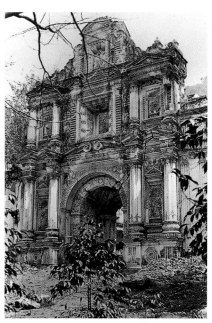

Facade, church of Santa Cruz, Antigua, Guatemala, 1731.

that—on interiors and exteriors alike. The altar screens still combined architecture, sculpture, painting, and decorative filler, but the structural elements were broken up, multiplied, pleated, and generally manipulated until they became visually unrecognizable and certainly nonfunctional as supporting members. As architectural integrity dissolved, columns and pilasters were flattened and expanded to serve as decorative niches or backdrops for sculptures of saints. In a sense the sculpture itself took the place of the shaft of the column, often standing on its base and canopied by its capital.

A similar development had occurred in southern Spain when the ornamental niche-pilaster became the leitmotif of the anastilo, or atectonic, style. In Mexico this style reached its climax in the altar screens of the Bajío region near Querétaro and in the retablo facades of the northern mining towns.[17] Essentially Rococo, but already using some of the motifs, if not the precepts, of the nascent Neoclassical style, the Estípite Baroque combined disparate motifs in an asymmetrical, anti-architectural riot of contrasting patterns. Three-dimensional imitations of drapery and Rococo textile patterns enlivened the flattened shadows of former columns and entablatures in a dizzying amalgam. Denying gravity and lifting toward the heavens in a vertical movement not seen since Gothic art, the altar screens seemed to vibrate upward with frenetic religious energy.

The true *estípite* column was never popular in colonial Guatemala; instead a column or pilaster made up of opposing palmettes was used in the eighteenth century. Facades in the Earthquake Baroque style built during the

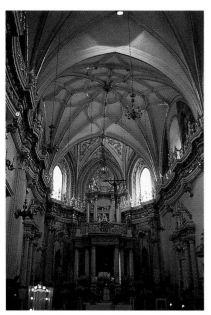

Interior, sixteenth-century Franciscan church of San Gabriel, Cholula, Puebla, Mexico; redecorated in nineteenth-century Neoclassical style.

1700s often contained sets of paired columns and a horizontally grooved or beaded column, distantly related to the Solomonic column. Builders in Central America took advantage of thick walls to recess and splay niches, doors, and windows. The diagonally inset walls were then used as surfaces for interlacing stucco or relief designs. The upward sweep of volutes and pedimental curves created an illusion of vertical movement and denied the heavy massing of the buildings with varying degrees of success.

The altar screens of Central America, like the architecture, had lower and wider dimensions than those of Mexico. Usually, the decorative motifs were larger and easier to read than their counterparts in Mexico, and asymmetrical curves and countercurves dominated the compositions. Statues of saints retained their integrity within the context of the Baroque altar screens of Guatemala.

A return to the more accurate use of classical orders began in Mexico City in the 1770s, but continued to be characterized by a distinctively Mexican mixture of disparate motifs and surface manipulation. A somewhat purer version of the European Neoclassical style was introduced with the founding of the Royal Academy of San Carlos in 1781. As part of the international reaction against the excesses of the Baroque, many Mexican churches, like their European counterparts, lost their Baroque decor in favor of imposing marble altars reminiscent of Greek and Roman temple fronts. Mexicans embraced this new style wholeheartedly, apparently associating it with the Enlightenment, executing it with a decidedly Mexican flair, using more gold leaf, decorative carving, and broken planes than would ever be seen in Europe.

During the colonial period in the Americas, an artistic freedom born of the distance from European sources seems to have prevailed. Consciously or unconsciously, artists took advantage of this freedom, and changes occurred in the translation from European sources to New World art forms.

New World artists effected these changes in several ways, one of which involved combining diverse styles in a single work of art. Frequently, they used Old World models in an unorthodox manner, applying decorative Greek temple fronts from the title pages of books to the facades of buildings, or enlarging grotesques from miniature illustrations to cover walls like giant grisaille tapestries.

Another common characteristic of the period, whether inadvertent or intentional, was a frequent disregard for the rules of styles, such as the classical orders. This disregard was accompanied by an apparent desire to deny, or at least to camouflage, the logical or structural elements of a work of art, particularly in architectural constructions.

Another method of transformation characteristic of most Spanish colonial art was the tendency toward elaborate surface decoration. Common in most pre-Hispanic art styles of the New World, such decoration was also a trademark of Hispano-Moresque art in Spain. Affinity between the two cultures in this area probably reinforced the tendency to cover surfaces with patterning throughout the Spanish colonies.

The art of colonial Latin America represents acculturation at its most tangible and imaginative. Whether the modifications that characterize Spanish colonial art and architecture represent errors in the understanding of models or liberties consciously exercised by the artists is impossible to know. Regardless of intent, the result is a unique blend of American and European elements, with a touch of Oriental influence, and represents the melding of cultures into an original expression in which the whole is greater than the sum of its parts. ∎

NOTES

1. Cortés (1986), *Fourth Letter*, p. 332.
2. Ricard (1966).
3. Kubler (1948).
4. McAndrew (1965).
5. Motolinía [Fray Toribio de Benavente] (1971), p. 242.
6. The most comprehensive discussions of the relationship between Spanish and Latin American art and architecture are found in Iñíguez (1945); Kubler and Soria (1959).
7. Toussaint (1982); E. I. E. de Gerlero, "La pintura mural durante el virreinato," in *Historia del arte mexicano*, vol. 7 (1986), pp. 1011-27.
8. Weismann (1950).
9. Reyes-Valerio (1978); idem, "El arte indocristiano o tequitqui," and E. Vargas Lugo, "Sobre el concepto tequitqui," in *Historia del arte mexicano*, vol. 5 (1986), pp. 706-25.
10. Mâle (1932); *Canons and Decrees of the Council of Trent* (1941), pp. 216-17, 484-85.
11. Kubler (1940).
12. Tovar de Teresa (1982).
13. Kelemen (1967); Tovar de Teresa (1981). See also M. B. Burke, "A Mexican Artistic Consciousness," and J. Hecht, "Creole Identity and the Transmutation of European Forms," in *Mexico: Splendors of Thirty Centuries* (1990), pp. 315-23; Lafaye (1976); Paz (1988).
14. Markman (1966). See also Kubler and Soria (1959); Kelemen (1967).
15. Bantel and Burke (1979).
16. J. Hecht, "The Liberation of Viceregal Architecture and Design," in *Mexico: Splendors of Thirty Centuries* (1990), pp. 357-60; Ruíz Gomar (1986), pp. 16-43.
17. Baird (1953), pp. 195-216; idem (1956) pp. 5-11.

58A.
Juan Correa
Mexican, b. 1645-50, active circa 1674-1734
Baptism of Christ
Oil on canvas, 82 ¾ x 53 in.
IIICA, Palace of the Governors, Santa Fe

58B.
Juan Correa
Mexican, b. 1645-50, active circa 1674-1734
Nativity
Oil on canvas, 68 ½ x 59 ¼ in.
IIICA, Palace of the Governors, Santa Fe

PAINTINGS

58. Juan Correa, along with Cristóbal de Villalpando (1645-1714), was one of the great painters of the Mexican Baroque period. Correa was born to a prominent mulatto physician from Cádiz and a free black woman from Mexico City. As a painter he was extremely productive and highly regarded during his lifetime. His workshop produced countless pictures to fulfill prestigious commissions in Mexico—for example in the cathedral in Mexico City—and exported all over the colonies, to Spain, and even to Rome.

Though two of these four paintings are signed, all of them probably were produced mainly by workshop staff. They are from a set of seven paintings which originally formed an altar screen. Several of the compositions are partially based on a series of Flemish prints by Schelte à Bolswert after paintings by Rubens (Bantel and Burke 1979, pp. 33-34, 97-99; Vargas Lugo and Victorio 1985, pls. II-31, III-7A).

After 1680 Correa and his workshop developed a style characterized by loose drawing with blurred edges and little attention to detail. This change was accompanied by an emphasis on brilliant color and overall decorative effect. As a result his paintings, usually intended to be seen from afar on altar screens or in other architectural contexts, seem almost unfinished or impressionistic when viewed up close. At a distance, however, they take on a rich, luminous quality.

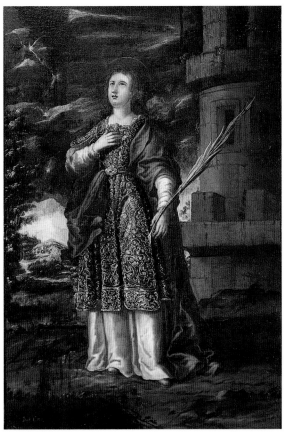

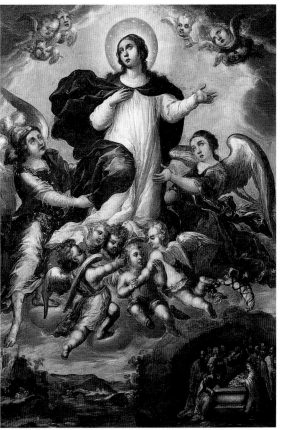

58C.
Juan Correa
Mexican, b. 1645-50, active circa 1674-1734
Saint Barbara (signed)
Oil on canvas, 84½ x 58 in.
IIICA, Palace of the Governors, Santa Fe

58D.
Juan Correa
Mexican, b. 1645-50, active circa 1674-1734
Assumption of the Virgin (signed)
Oil on canvas, 84 x 59 in.
IIICA, Palace of the Governors, Santa Fe

59. Cristóbal de Villalpando and his friend and sometime collaborator Juan Correa operated the largest, most prestigious workshops in Mexico in the late seventeenth and early eighteenth centuries. Together they produced hundreds of paintings and frescoes that decorate churches throughout that country and Central America.

This painting is one of the most accomplished works in Villalpando's considerable oeuvre. It depicts the mystic betrothal of Saint Rose of Lima (1586-1617) and the Christ child before God the Father, the dove of the Holy Spirit, the Virgin, and a host of angels. St. Rose was a nun in the Tertiary Order of St. Dominic, and her acts of charity have led some to call her the originator of social services in Peru. As one of her many acts of penance, Saint Rose wore a metal crown of thorns beneath her wimple; it is just visible in the painting. Saint Dominic kneels in the lower left-hand corner, as both the patron saint of Rose's order and the inventor of the rosary. The painting was intended to inspire both the denial of earthly things and a focus on eventual union with Christ in the heavenly realm, and to incite and assist devotion through the saying of the rosary.

Saint Rose was beatified by Pope Clement IX in 1668 and canonized by Clement X in 1671, the first American to be so honored. Commemorative prints issued in Rome near the time of these ceremonies provided Villalpando with both the central figural group and the inscriptions on the wreath and banner, which refer to Rose's mystic marriage. (Vargas Ugarte 1967, figs. 4, 7). The inscription on the wreath, ROSA CORDIS MEI TU MIHI SPONSA ESTO, may be translated as "Rose of my heart, you are my bride," and that on the banner, ANCILLA TUA SUM DOMINI MI IESU, as "I am your servant, O Lord my Jesus." The title in red on the trompe l'oeil plaque below, S. ROSA INDIANA, probably derives from the papal bull that declared the saint to be "Patroness of all provinces,

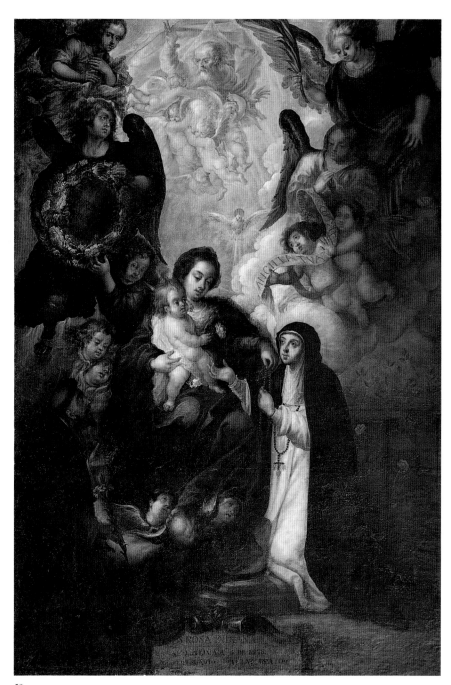

59.
Cristóbal de Villalpando
Mexican, 1645-1714
The Mystic Marriage of Saint Rose of Lima (signed)
Oil on canvas, 93 ¾ x 63 ⅛ in. (unframed)
Santa Barbara, University of California, University Art
Museum, Gift of Robert K. Woolf
1986.411

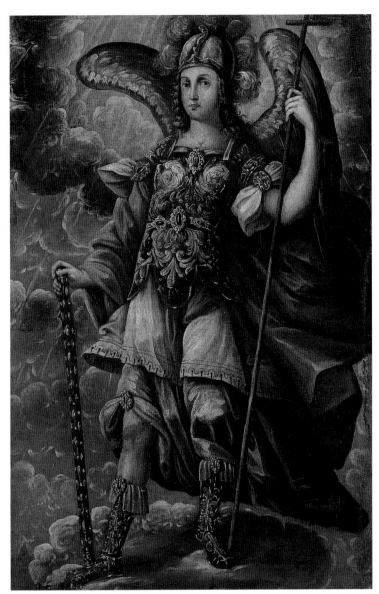

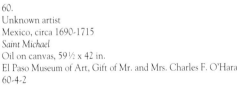

60.
Unknown artist
Mexico, circa 1690-1715
Saint Michael
Oil on canvas, 59½ x 42 in.
El Paso Museum of Art, Gift of Mr. and Mrs. Charles F. O'Hara
60-4-2

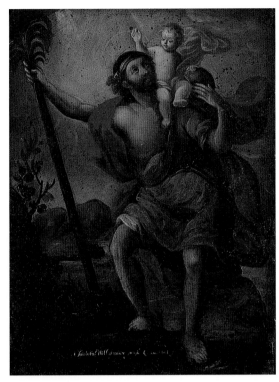

61.
Cristóbal de Villalpando
Mexican, circa 1645-1714
Saint Christopher (signed and dated 1614 [1694(?)])
Oil on copper, 16½ x 12¼ in.
El Paso Museum of Art, Gift of the El Paso Art Museum Association
Members' Guild
67.13.1

60. Both Juan Correa and Cristóbal de Villalpando had a profound impact on artistic production throughout New Spain. Many other colonial artists copied their compositions. This large painting could be a product of Villalpando's workshop or an anonymous work copying his style (Bantel and Burke 1979, pp. 110-111). In either case the composition is similar to depictions of Saint Michael by earlier artists active in Mexico, including the Spanish-born Baltasar de Echave Orio (in Mexico circa 1580, d. circa 1620) and Sebastián López de Arteaga (in Mexico circa 1635, d. 1652), as well as ones by Correa and Villalpando. In this version the short baton shown in European representations of the saint has been replaced by a long, silver-studded cane, similar to the staff, or *vara*, of office carried by local government officials in the Americas. This detail gives the painting a New World quality.

kingdoms, isles and regions of Tierra Firme in the whole of America, the Philippine Islands and India." The birth date given for St. Rose on this plaque (1566) is erroneous.

One of Villalpando's earliest works is a *retablo* dedicated to Saint Rose in the parish church of Atzcapotzalco, signed and dated 1681 (de la Maza 1964, p. 7). *The Mystic Marriage*, signed by the artist on the base of the stone plinth upon

which St. Rose kneels, is more detailed and intimate, despite its large size, than the *retablo* and was probably commissioned for a nearby rectory or convent. The central motif is nearly identical to that of another version of the same theme by Nicolás Correa, signed and dated 1691 (Mexico City, Pinacoteca Virreinal). These dates suggest that this painting probably was made sometime between 1681 and 1691. *BP*

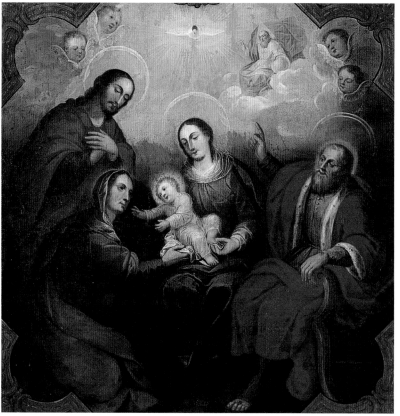

62.
Fray Miguel de Herrera
Mexican, active circa 1725-after 1753
Nativity with Saint Anne and Saint Joachim
Oil on canvas, 60 x 60 in.
IIICA, Palace of the Governors, Santa Fe

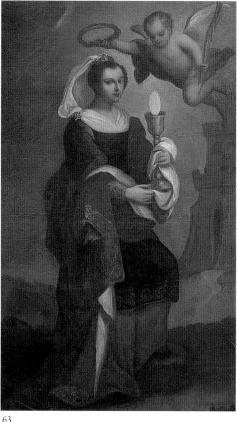

63.
José de Alcíbar (Alzíbar)
Mexican, active 1751-1803
Saint Barbara (signed and dated 1785)
Oil on canvas, 70 x 37 in.
Collection of Our Lady of Sorrows Church on loan to the
Santa Barbara Trust for Historic Preservation
T.575-2-1953

61. This small painting belies the traditional size of its subject. Legend has it that Saint Christopher was a giant who sought to serve Christ through deeds rather than by fasting and prayer. He lived in a hut near a ford on a river, where he aided those who wished to cross by carrying them on his shoulders with the help of his staff, an uprooted palm tree. One night a child came, and as Christopher bore him across the river, the waters rose, waves and wind roared, and the child grew heavier and heavier. When at last they reached the other bank, Christopher exclaimed that it seemed as if he had borne the weight of the world on his shoulders. The child replied that the giant had carried Him who had made the world, that his service was accepted, and that if he were to

plant his staff in the ground, it would bear leaves and fruit. This story was intended to encourage those in need to realize that divine aid is always near. *BP*

62. Fray Miguel de Herrera was an Augustinian monk in Mexico who painted not only numerous religious images like this one but also a large group of official portraits. His paintings have a naive quality and feeling of shallow space. His style is conservative, retaining some qualities of the Baroque, but with the sweetness of mid-eighteenth-century works.

Probably part of an altar screen originally, this canvas with painted corner frames depicts a Nativity scene with Jesus's extended family. The Christ child, seated on the Virgin's lap, reaches

out toward his maternal grandmother, Saint Anne. Saint Joseph stands behind Anne, while Joachim, the father of Mary and grandfather of Christ, sits in a chair at the right and points upward. The dove of the Holy Spirit flies above the family, and God the Father is seated in the clouds. Their presence completes a representation of the Holy Trinity as well as of the Holy Family.

63. A native of Texcoco, Mexico, José de Alcíbar was one of the founding members of the first academy of painting in Mexico in 1753, along with José de Ibarra (d. 1756) and Miguel Cabrera (1665-1768). In 1781 Alcíbar was named associate director of painting at the new Royal Academy of San Carlos. He retained this appointment even after the

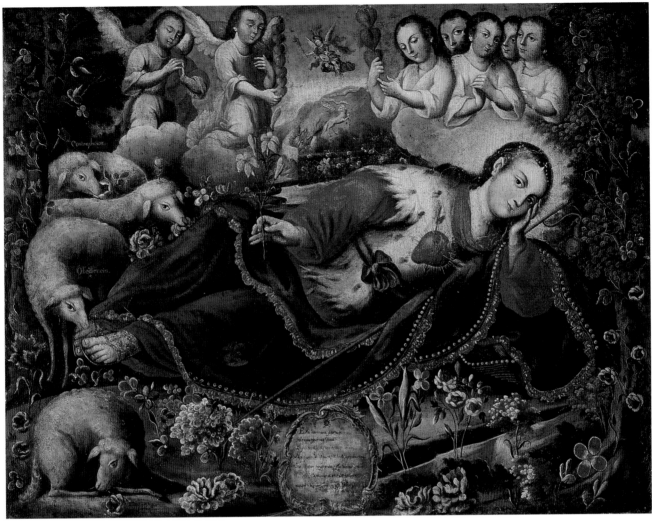

64.
Attributed to José de Paez
Mexican, circa 1720-1790
The Divine Shepherdess
Oil on canvas, 37 x 49 in.
IIICA, UNM
L.87.3.33

official faculty arrived from Madrid in 1786. In spite of his Mexican birth and education, he eventually became acting director of the academy, a position he held until 1806.

Alcíbar was a prolific painter, and his canvases, in all sizes, were shipped to many areas of New Spain, including New Mexico and California. This painting apparently was imported to California, where it hung in the chapel of the Royal Presidio of Santa Barbara.

64. The Marian advocation of the Divine Shepherdess is exclusively Spanish in origin and dates to the eighteenth century. According to legend she appeared to a venerable monk of the Capuchin order in Cataluña, Father Isidoro of Seville, dressed as a shepherdess and accompanied by her flock. Urging Isidoro to honor her as the Divine Shepherdess, she vowed to assist him in his missionary efforts. Isidoro had a banner made with an image of the Virgin as the Divina Pastora. When he hoisted it and embarked on an evangelical mission, he met with great success.

He also wrote numerous treatises exalting the virtues and deeds of his patroness. Devotion to the Divine Shepherdess was spread throughout Spain by Capuchin missionaries. They also introduced the cult to the Americas, where it enjoyed a widespread and devoted following.

This image is unusual in that the Divine Shepherdess is shown reclining, perhaps reflecting influence from images of the sleeping Christ child prevalent in Spain and the New World, especially among nuns, in the eighteenth century.

It may also be related to pastoral or allegorical scenes in secular painting of the era. The familiarity necessary to depict the Virgin Mary so casually may be a manifestation of the freedom inherent in art of the New World.

Here the reclining Virgin is attended by four sheep, labeled with inscriptions reading *Contemplación* (Contemplation), *Obedencia* (Obedience), *Humilidad* (Humility), and *Fe* (Faith). In a flight of artistic fancy, the last is shown wearing a chalice and wafer, symbolizing the Eucharist, balanced on his head. The Virgin herself is regally dressed, with a pierced heart painted on her breast to represent the Passion of Christ. She holds a lily branch, indicating purity, in one hand, and a shepherd's crook hangs over her other arm. In the clouds above her at the left are two angels and, at the right, five saved human souls. One in each group holds a string of hearts symbolizing souls (sheep) rescued from Purgatory by the Divine Shepherdess. In the same vein, a scene in the distance shows a lamb escaping from the jaws of hell as Saint Michael, flying above, prepares to smite the demon.

Attributed to the Mexican artist José de Paez, this image is typical of the many detailed, small-scale works, often painted on copper, by this eighteenth-century artist. The delicate faces, profusion of flowers, and overall precious quality are characteristic of devotional paintings by Paez and other late eighteenth-century Rococo artists in Mexico.

65. What a story this painting could tell! Once Salcedo had completed it and it had been placed in its finely wrought frame, it must have been very carefully packed in preparation for the dusty journey that lay ahead. For six months it would jolt northward along the Camino Real de Tierra Adentro, up through central Mexico, past Durango, Zacatecas, and Chihuahua City, across the deserts, until finally it came to rest in the church of Our Lady of Guadalupe in Santa Fe, New Mexico. It is mentioned in the earliest of this church's inventories, and it

can be discerned, light glinting off the silver decorations on its frame, in a shadowy nineteenth-century photograph. It eventually came into the hands of a doctor in northern New Mexico; he sold it to the Denver Art Museum, where it was discovered in 1975.

Many such paintings were carried northward to the mission churches of California, Texas and Arizona along other king's highways, or *caminos reales*. Arteries of commerce and conduits of change, these routes were vital to the Spanish colonization of the American Southwest. They were the means by which new crops, new technologies, a new language, and a new religion were introduced. Eventually, they also carried images of the highest artistic values from Mexico's glittering metropolitan center to the distant outposts of empire.

In December 1531, only ten years after the conquest of Mexico, a Christianized Indian named Juan Diego was walking to a church north of Mexico City to hear mass. As he approached the site of a former temple to the Aztec mother goddess, Tonantzin, on the hill of Tepeyac, he heard a beautiful voice calling his name. A young dark-skinned woman appeared before him. According to Nahuatl folk legend,

> Her garments were as brilliant as the sun; the rock on which she stood was shot through with rays of the sun and seemed like an anklet of precious stones, and it reflected on the ground like a rainbow. The mesquite trees, prickly pear, and the other plants that grow there, seemed to be made of emeralds; their leaves of fine turquoises; and their branches and thorns were as brilliant as gold. He knelt before her and heard her soft and courteous voice which charmed and awed him very much (Bergoend, S.J., 1968, p. 47).

She told Juan Diego that she was the Mother of the True God and that she wished to aid him and his brethren. She instructed him to go to the bishop of Mexico, Fray Juan de Zumárraga, and request that a temple be constructed in her honor on the hill of Tepeyac. The bishop received Juan Diego twice and

listed to his story, but requested proof of his encounter with the Virgin.

Juan Diego returned to Tepeyac and asked the Virgin to choose a more influential representative. She replied that he was her choice and bade him climb to the top of the hill, pick the flowers there, and take them to the bishop. He was astounded to find the hilltop covered with Castillian roses in full bloom in the middle of winter. He carried the roses to the bishop in his *tilma*, or maguey-fiber cloak. When he opened his *tilma* to display the roses, an image of the beautiful dark-skinned Virgin had been imprinted miraculously on the fabric of his cloak. The bishop was convinced by this miracle and immediately ordered the construction of a chapel on Tepeyac. The apparition became known as the Virgin of Guadalupe, and the *tilma* with her image still resides in a church on Tepeyac.

Because she appeared to an Indian and was dark-skinned herself, the Virgin of Guadalupe became extremely popular among the Indians. Her popularity spread quickly among Spaniards living in Mexico and was described by the English sailor Miles Phillips, as early as 1568: "Whensoever any Spaniards pass by this church, although they be on horseback, they will alight, and come into the church, and kneel before this image, and pray to Our Lady to defend them from all evil" (Hakluyt, 1589, p. 205). The Virgin of Guadalupe has been credited with numerous miracles through the years, including delivering Mexico City from a disastrous flood in 1621 and a plague in 1737, and her shrine has long been a pilgrimage site.

Due to her appearance on Mexican soil, by the mid-seventeenth century the Virgin of Guadalupe had become associated with Mexico itself and, by extension, with all Mexican-born citizens regardless of ethnic background (Lafaye, 1976). In 1746 she was declared patroness of New Spain. During the second half of the eighteenth century, the Virgin of Guadalupe became associated increasingly with the growing movement toward Mexican identity for

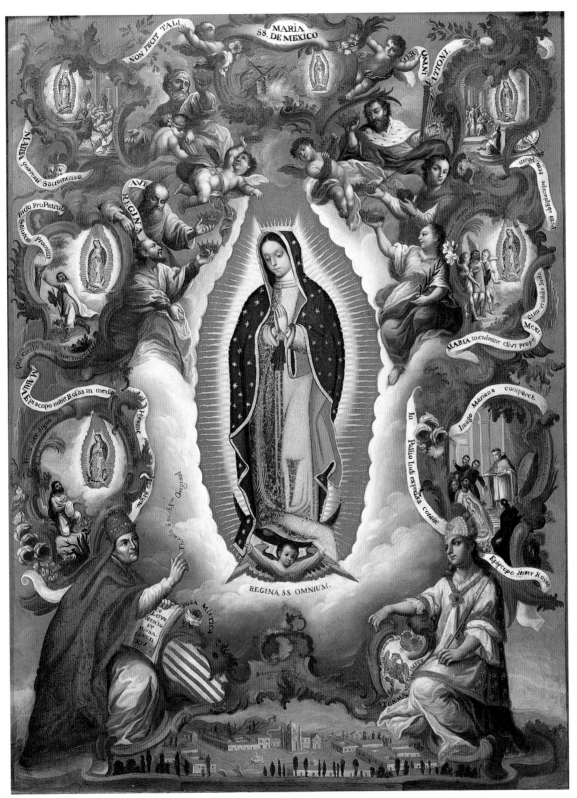

65.
Sebastián Salcedo
Mexican, known active dates 1779-1783
Virgin of Guadalupe, 1779 (signed and dated)
24 ¾ x 19 in.
Denver Art Museum, purchased with funds from Mr.
and Mrs. George Anderman and an anonymous donor
1976.56

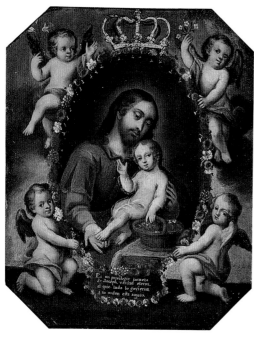

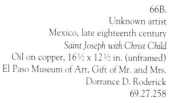

66A.
Attributed to Sebastián Salcedo
Mexican, known active dates 1779-1783
Saint Joseph and the Christ Child
Oil on panel, 10 x 8 in.
Collection of Dr. James F. Adams

66B.
Unknown artist
Mexico, late eighteenth century
Saint Joseph with Christ Child
Oil on copper, 16½ x 12½ in. (unframed)
El Paso Museum of Art, Gift of Mr. and Mrs.
Dorrance D. Roderick
69.27.258

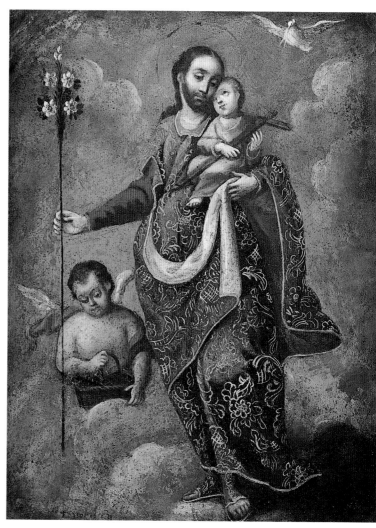

Spaniards born in Mexico (*criollos*) as opposed to those born in Spain (*gachupines*). By the time of the Independence movement, she had become the undisputed symbol of Mexico and soon became the emblem of the insurgents. She played the same role in the Mexican Revolution of the early twentieth century.

The story of the appearance of the Virgin of Guadalupe has some interesting parallels with that of the Virgin of Guadaloupe in the province of Estremadura, Spain, the home of many of the Spanish conquerors of Mexico. The depiction of the Virgin has similarities to

the Woman of the Apocalypse (pp. 93-95) and she stands on a crescent moon, symbolizing the doctrine of the Immaculate Conception (pp. 108-109). In art, images of the Virgin of Guadalupe are always faithful reproductions of the original. In this example vignettes of the story of her appearance to Juan Diego and miracles attributed to her are set in asymmetrical Rococo painted frames around the sides. Beneath her is the early church at Tepeyac, flanked on the left by Pope Benedict XIV, who approved her office and mass in 1754, and on the right by an Aztec princess, symbolizing Mexico and holding a shield with the

Mexican eagle emblem. Angels, prophets, and martyrs float in the clouds. The composition of this painting, like that of many others, probably was based on an engraving by the early eighteenth-century German artist Johann Sebastian Klauber (Smith, 1985, Vol. X, pp. 12-16).

66. Little is known about Salcedo. Four paintings of the Passion of Christ in the church of the Enseñanza in downtown Mexico City are dated 1779. Other paintings signed by him are dated 1779 and 1783. Undated, unsigned paintings attributed to him include many small-scale images on copper or wood in the

cloying style of the late Mexican Rococo.

Since the Counter-Reformation, the Church had encouraged devotion to Saint Joseph as both the patron of workers and a role model for husbands and fathers. He became extremely popular in the New World, particularly among the Indians of Mexico, and his image was often commissioned for village churches, private chapels, and home altars.

The basic composition of Salcedo's painting—a bust-length figure in three-quarter view—derived from a prototype established by the Spanish artist Murillo. The expression of quiet tenderness between Joseph and the Christ child, who was not even his biological son, is palpable here. Jesus looks at the viewer with an air of resignation, mindful of his destiny. He holds a basket of grapes and bread, symbolic of the Eucharist. The scattered cherubs, garlands of flowers, and pastel colors are all conventions of the Mexican Rococo.

Another example of this late eighteenth-century style, the anonymous painting shows the other standard means of representing Saint Joseph—as a full-length figure holding his attribute, the flowering staff. According to Christian legend this staff miraculously burst into bloom when he requested Mary's hand in marriage, thus prefiguring the coming of Christ. The child in his arms holds a cross, the instrument of his future death.

67. Just as it is common to find stylistic elements from diverse sources combined in a single work of art in the New World, it is also not unusual to find iconography from different religious images merged into a single scheme. In two of these paintings of the Virgin, distinct Marian advocations have been united.

The first example depicts the Virgin of the Apocalypse as described in the Book of Revelation (chap. 12), clothed in the sun with the moon at her feet and a crown of twelve stars . The painting captures the miraculous moment in which she was given the wings of an

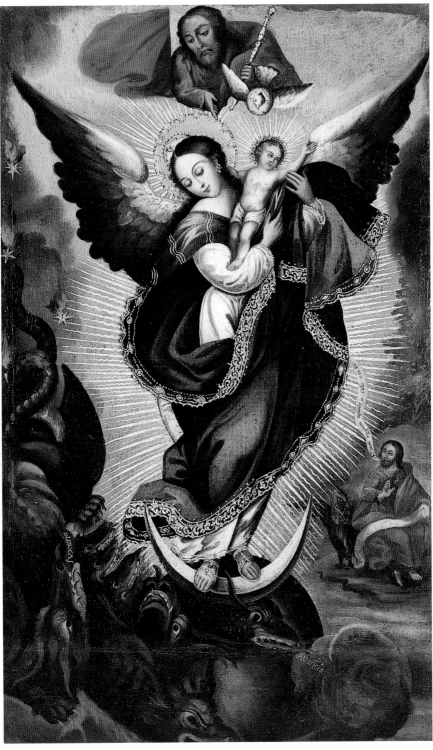

67A.
Unknown artist
Mexico (?), eighteenth century
Virgin of the Apocalypse
Oil on canvas, 48 x 29 in.
IIICA, Palace of the Governors, Santa Fe

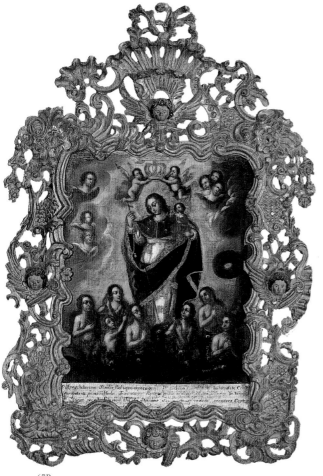

67B.
Unknown artist
Mexico, eighteenth century
Our Lady of the Rosary Offering Succor to Souls in Purgatory
Oil on canvas and gilded, polychrome wood, 48 x 34 in.
IIICA, UNM
L.87.3.16

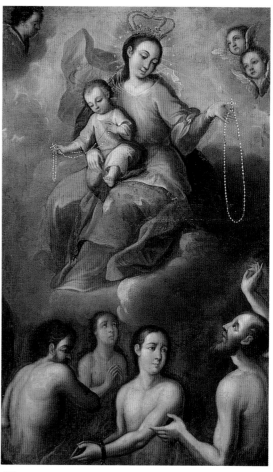

67C.
Unknown artist
Mexico, eighteenth century
Our Lady of the Rosary Offering Succor to Souls in Purgatory
Oil on canvas, 60 x 36 in.
IIICA, Palace of the Governors, Santa Fe

eagle to help her newborn son escape to heaven from the devil, disguised as a seven-headed dragon, who had threatened to devour him. Saint John the Evangelist, author of the Apocalypse, sits on the island of Patmos at the lower right, with his symbol, the eagle, by his side. A scroll issuing from his mouth quotes his own description of the event. God the Father and the dove of the Holy Ghost appear in the clouds above and, with the Christ child, form a vertical representation of the Holy Trinity. Derived from a painting by Rubens, this composition was used by many colonial artists in engravings and paintings.

Out of the rescue of the Christ child by the Virgin of the Apocalypse evolved the notion of the Virgin's ability to rescue humans from the grasp of the devil and to aid in their transfer to heaven. This aspect is graphically depicted in the other two paintings illustrated here. In both instances most of the attributes of the Virgin of the Apocalypse, including the eagle wings and new moon, have disappeared. In the second picture the seven-headed dragon, symbolizing the

seven deadly sins, is still present and holds seven human souls in his grip. In both representations the Virgin and Child hold rosaries. Use of the rosary and devotion to the Virgin of the Rosary were adopted by the Dominican, Franciscan, and Jesuit orders and spread by them throughout the New World.

The second painting unites aspects of the Virgin of the Apocalypse and Virgin of the Rosary. In the final painting no vestiges of the iconography of the Virgin of the Apocalypse remain other than the concept of her ability to aid in redeeming

68A.
Laurencio Rodríguez
San José del Parral, Chihuahua
Virgin of Guidance, 1773
Oil on copper , 23 x 15 in. (unframed)
El Paso Museum of Art, Gift of Mr. and Mrs. Charles F. O'Hara
60.4.4

68B.
Unknown artist
Mexico, late eighteenth century
Virgin and Child
Oil on canvas, 39 ¼ x 32 ½ in.
San Antonio Museum of Art, San Antonio Museum Association
77-691-21P

human souls. Instead the imagery of the Virgin of the Rosary has been combined with that of the Virgin as Queen of Heaven, in which she appears seated in front of or on an orb, wearing an imperial crown.

The expansion of imagery to incorporate several iconographic themes was particularly frequent in provincial areas of the New World in the late eighteenth century.

68. In Spain and the colonies certain images of the Virgin or Christ, and occa-sionally of other saints, came to be viewed as miraculous and developed a cult following. The faithful made pil-grimages to visit these images and request special favors or express grati-tude. As souvenirs, small paintings or popular prints of the divine images were often purchased and carried home. As in the great era of pilgrimage in Europe dur-ing the Middle Ages, these small depic-tions of statues were instrumental in disseminating artistic styles and iconog-raphy throughout the colonies and were frequently copied by local artists.

According to the inscription on the Virgin of Guidance, a Spaniard, Don Miguel de la Fuente, a merchant living in the mining town of San José del Parral in northern Mexico, commissioned a Mexican artist, Laurencio Álv(arez) Rodríguez, to paint the image. According to the inscription, it is a "true portrait" of the miraculous statue of the Virgin of Guidance in Fuente's hometown of Llanes, near Oviedo, Asturias, in Spain. Dated 1773, the painting is undoubtedly based on an engraving of the original statue, probably brought to the New

World by Fuente himself. Since San José del Parral was remote, located on the Camino Real to the northern province of New Mexico, an image of the Virgin of Guidance, protecting travelers, was particularly appropriate.

The statue-painting depicting the *Virgin and Child* has been cut down, losing any identifying inscription that may have been present. It is obviously another "portrait" of a statue of the Virgin and Child in the niche of a late eighteenth-century altar screen with attenuated *estípite* columns. Silver hanging lamps flank the Virgins in both paintings. The silver pedestals reflect the changing styles of the late eighteenth and early nineteenth centuries—one is Rococo, while the other is Neoclassical.

69. A handful of paintings signed "Josef de Ibarra," including this one, have nothing to do with the early eighteenth-century painter from Mexico City, José de Ibarra (d. 1756). Rather they indicate that a provincial master of the same name was active in the second half of the eighteenth century.* His style was influenced by the work of Mexican painters of a half century earlier, including Antonio Rodríguez (active circa 1655-1680), Juan Sánchez Salmerón (known active dates 1666-1679), and, to a lesser degree, Correa and Villalpando.

In a compositional device exemplified by El Greco's famous Burial of Count Orgaz (Toledo, Spain) and repeated frequently over the centuries, this painting is divided into two horizontal registers, one representing earth, the other heaven. The subject matter exemplifies the provincial New World tendency to combine iconographic schemes in one painting. The upper register is similar to scenes of the Assumption or Coronation of the Virgin. The Virgin kneels on a cloud in the center of the painting and is flanked by the apostles—some carrying attributes—and other saints. Above her, God the Father and Jesus are seated on clouds with the dove of the Holy Ghost between them, creating a horizontal representation of the Holy Trinity.

69.
Josef de Ibarra
Mexican, second half of the eighteenth century
Death of a Dominican (signed and dated 1765)
Oil on canvas, 30 x 25 in.
University of New Mexico Art Museum, Museum Purchase
75.177

The lower register represents the death of a Dominican, who lies on a bed surrounded by three kneeling friars. The pope, flanked by two papal officials, stands above and gives the sign of blessing. At the left an archangel, probably Gabriel or Raphael, holds out his hands and looks up toward Saint Michael, the only figure bridging the earthly and heavenly registers. Both angels assist in transferring the soul of the dying man to heaven.

At the right stand four friars dressed in the full habit of the Dominican order.

The most prominent friar, carrying a staff and lilies, appears to be Saint Dominic Guzman himself. Some late eighteenth-century compositions, including this one, may represent a form of political propaganda inserted into religious painting. During the eighteenth-century struggle between the pope and the Bourbon kings of Spain, the monastic orders, particularly the Jesuits, remained loyal to the former. The political maneuverings of the Jesuits eventually resulted in their expulsion from Brazil

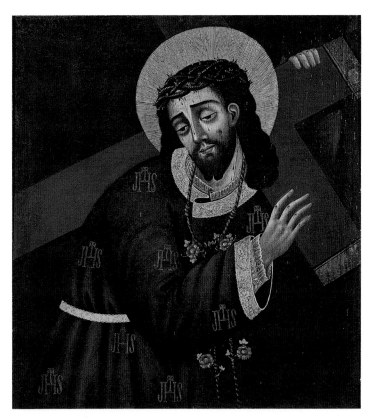

70A.
Unknown artist
Mexico, early nineteenth century
Christ Carrying the Cross on the Road to Calvary
Oil on canvas, 38 ½ x 28 in.
IIICA, Palace of the Governors, Santa Fe

70B.
Unknown artist
Mexico, early nineteenth century
Our Lady of Sorrows (Mater Dolorosa)
Oil on canvas, 22 x 16 in.
IIICA, UNM
L.87.3.9

in 1759, New Spain in 1767, and all Spanish dominions by 1773. This action alienated many people at all levels of colonial society. The Dominicans and Franciscans, outraged at the treatment of the Jesuits and fearful for their own fates, seem to have made an attempt to band together and consolidate their positions. Paintings such as this one may reflect that attempt at solidarity and cooperation as well as support for the papacy. The insertion of such political themes into religious imagery reveals the changing atmosphere of the late eighteenth century under the influence of the Enlightenment, and presages the era of revolutions all over Latin America in the early nineteenth century.

*I am indebted to Dr. Marcus B. Burke for the identification of this artist.

70. Devotion to the various aspects of the Passion of Christ evolved in Europe during the Middle Ages. Scenes from the Passion were depicted in art, passion plays, and religious pageants. Holy Week processions carrying sculptures of Christ, the Virgin, and other participants in the events of the Passion became particularly elaborate and popular in Spain and survive today in many areas.

These practices were transferred to the New World immediately after the conquest. Sixteenth-century chroniclers in Mexico described Holy Week processions with sculpted images and throngs of Indian participants (Grijalva 1924, pp. 227-31; Motolinía 1951, pp. 143-44, 148, 152, 178). Representations of Christ in the last week of his life—the Entry into Jerusalem, Agony in the

Garden, Flagellation, Road to Calvary, and Crucifixion—were depicted in sculpture and painting throughout the colonial period in all areas of the New World. Small devotional paintings like the present examples were probably copied from popular prints. Stylistically, such images are distantly related to Byzantine icons in their lack of spatial depth, large figures at the "front" of the picture plane, and flat application of gold detailing. Both of these paintings exhibit the rich colors, pink and blue details, and decorative flowers typical of the late eighteenth century. The image of the Virgin of Sorrows includes a painted frame with the opposing curves and scallops of Rococo art.

71. Much provincial religious painting survives from the eighteenth century in the New World. Often it is difficult to assign these images to an artist or even a provenance. The profusion of religious prints disseminated throughout the colonies helped to spread iconography and styles to remote areas, where they were copied by local artists. The reliance of such artists on print sources is obvious, but they often added their own interpretations of their models, creating new and local variations.

Saint Elygius, or Eloy, was the patron saint of metalworkers and silversmiths. In this image he protects the donors, probably members of a local silversmiths' guild, under his cape. Dressed in period clothing, they hold tiny examples of their handiwork, including a chalice, cruet set, and silver and silver gilt crosses.

The painting of Saint Michael, obviously based on a print source, harks back to a prototype used by Luis Juárez (active 1590-1637) in Mexico at the beginning of the seventeenth century (*Mexico: Splendors of Thirty Centuries* 1990, pl. 132. A partial inscription in the upper left of the painting illustrated here was a later addition and appears to refer to the death of a man, possibly the donor of the painting.). The ultimate source for this rendering was probably the great Italian painter Raphael (1483-1520), whose dynamic images of Saint Michael were widely distributed via prints and influenced Flemish and Spanish painters. In this charming New World example, however, the provincial artist interpreted the prototype in his own manner. Here Michael seems to be dancing gaily on the back of the devil as he prepares to smite him. He leans gracefully, if improbably, to one side as he twirls his sash in a huge flourish over his head, like a great lasso. The exaggerated pose, wildly flowing drapery, and precious quality of the image are Rococo traits and recall the contemporaneous sculpture of Saint Michael illustrated on p. 109.

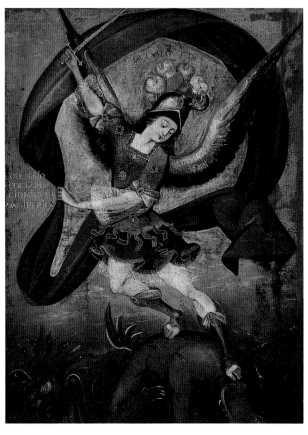

71A.
Unknown artist
Mexico(?), late eighteenth century
Saint Michael Archangel
Oil on canvas, 52 x 39½ in.
IIICA, UNM
L.87.3.32

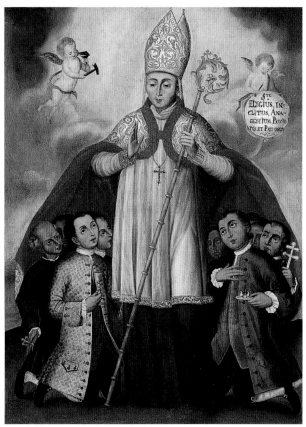

71B.
Unknown artist
Mexico(?), late eighteenth century
Saint Elygius
Oil on canvas, 31⅛ x 23½ in.
IIICA, UNM
L.87.3.40

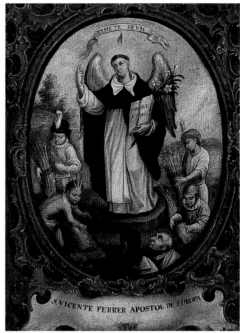

72B.
Unknown artist
Guatemala(?), eighteenth century
Saint Vincent Ferrer
Oil on canvas, 12 x 9 in.
Collection of Dr. James F. Adams

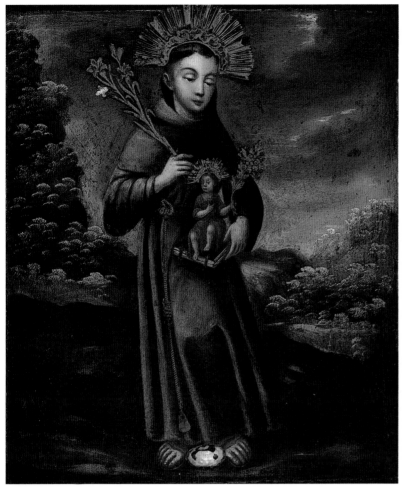

72A.
Unknown artist
Guatemala(?), eighteenth century
Saint Anthony of Padua
Oil on panel and white silver, 15 ¾ x 13 ½ in.
Collection of Dr. James F. Adams

72. Guatemala was known for its production of exquisitely carved sculpture with superb *estofado* decoration. Little is known abut the schools of Guatemalan painting, however, and it appears that many canvases were imported from Mexico. The present examples represent two eighteenth-century variations on a popular colonial type—the individual saint with attributes standing in a landscape. Used since the Middle Ages, such devotional images appeared often in sixteenth-century mural paintings in monastic establishments and became popular as individual images for private chapels and home altars.

Here the Franciscan saint Anthony of Padua stands alone in a lush American landscape holding the lilies of purity and the Christ child as he appeared to the saint in a vision. Silver halos were applied to the wood panel, a trait common in devotional paintings in all areas of the New World.

Saint Vincent Ferrer, a Spanish saint, stands in a landscape surrounded by people converted by his preaching. He hold lilies, symbolizing purity, and a book with his inscribed motto, *Vade et praedica* ("Go and preach"). He points upward to a banner bearing the words *Timete Deum* ("Fear the Lord"). A paint-ed Rococo frame, a standard convention of the late eighteenth century, surrounds the image, which probably derives from a contemporary engraving.

73. Cabrera, a mestizo, was abandoned at birth and raised by a godfather in Oaxaca. In 1719 he moved to Mexico City, where he and his contemporary José de Ibarra dominated painting production until after the middle of the century. Cabrera served as official painter to the archbishop of Mexico, Rubio y Salinas (1749-1756), and, along with Ibarra and other artists, attempted unsuccessfully to establish an academy of painting in Mexico in 1753. In 1751 he led several groups of painters in an official examination of the image of the Virgin of Guadalupe. Their findings were published in his book *Maravilla americana* in 1756.

Cabrera's shop produced large quantities of work, and numerous artists of varying quality copied his style, thus complicating analysis of his oeuvre. He was strongly influenced by the painting of Murillo and Rubens. His style also owes much to Ibarra—particularly in large Rococo compositions of religious subjects—but in small devotional images Cabrera conveyed an intimate, quietly devotional atmosphere of his own. His official court portraits have a remote, formal quality that contrasts with his familiar and psychologically revealing private portraits and castas paintings.

Mestizaje genre paintings, known as *castas* (breeds), were produced in the Americas from after 1720 into the early nineteenth century. Such paintings attempt to classify the complicated social structure based on the ethnic mix of whites, blacks, and Indians that had evolved by the eighteenth century in New Spain. The painting illustrated here is number 15 in a series of sixteen, the first and last of which are signed by Cabrera and dated 1763 (García Saíz 1989; *Mexico: Splendors of Thirty Centuries* 1990, pp. 432-33, no. 197; García Saíz 1985; García Saíz 1978, pp. 186-93).* In recent years the series has been divided between the Museum of America, Madrid, and a private collection in Mexico, with the exception of three paintings that were missing. This is one of the missing pieces; the whereabouts of the other two are still unknown.

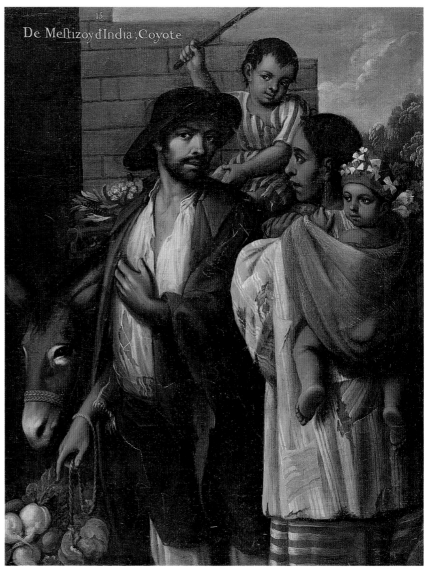

73.
Miguel Cabrera
Mexican, 1695-1768
Castas (Depictions of Racial Mixtures), 1763
Oil on canvas, 52 x 40½ in.
Collection of Elisabeth Waldo-Dentzel, Multicultural
Arts Studio, Northridge, CA

This painting represents the union of a mestizo with an Indian woman and their offspring, identified as "coyote." This example is identical in format with the other known paintings from the series, with a partially closed-off background and detailed attention to local costumes and native produce. The sense of dignity and intimacy with which Cabrera depicted his Mexican subjects is notable throughout the series.

* I am indebted to Dr. Marcus B. Burke for this attribution.

74. During the colonial period in the New World, a young woman had only two respectable options—marriage or the nunnery. Both usually required dowries; both were often a source of pride to the family and a reflection of their social standing.

The numerous convents for women

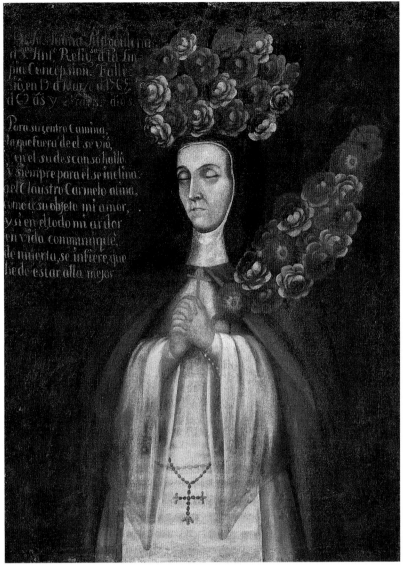

74.
Attributed to José del Castillo
Mexican, third quarter of the eighteenth century
Sister Juana Magdalena, 1769
Oil on canvas, 41 x 31 in.
IIICA, Palace of the Governors, Santa Fe

nist character of the orders and the power these women's groups acquired.

Beginning in the eighteenth century, families often commissioned portraits of young nuns, known as *monjas coronadas* (crowned nuns), on completion of their novitiates. Clad in her new habit, often accessorized with a rich cape, jewelry, candles, bouquets, and a floral crown, the nun was depicted as the bride of Christ, ready to profess her permanent vows. Like a wedding, the portrait, celebration, and accessories, including a nuptial ring, were paid for by the young woman's family. In more conservative or cloistered establishments, portraits did not include as much extravagant paraphernalia as those in the more liberal convents. The floral crowns and bouquets were made of wax and preserved or recreated at the time of death, when other portraits, such as this one, often were painted. According to its inscription, Sister Juana Magdalena de San Antonio was a member of the Carmelite order in the convent of the Immaculate Conception and died on March 19, 1769, at the age of sixty-two.

The painter, José del Castillo, was active in the town of Puebla around 1769, when he signed a death portrait of Sor María Clara Josefa (Mexico City, Pinacoteca Virreinal) (Armella de Aspe and Meade de Angulo 1989, p. 157). The overall format of the present example, the treatment and pose of the figure, and even the lettering in the inscription are very similar to the portrait of Sor María signed by Castillo, making it possible to attribute this painting to him.*

* I am indebted to Dr. Marcus B. Burke for this attribution.

provided a choice of lifestyles. For those following a truly inspired religious calling, there were conservative establishments dedicated to religious seclusion or public service such as nursing or teaching. Liberal houses made it possible for privileged nuns to live lives of luxury in elaborately furnished private suites of rooms, complete with personal servants. Often these women continued extensive social and intellectual contacts with the

outside world, even influencing politics. Sometimes they devoted themselves to the study of secular subjects such as literature or music, on occasion excelling in their chosen fields, as did the famous Baroque poet Sor Juana Inés de la Cruz. Ecclesiastical officials from Spain were shocked by the freedom of convent life in the New World and attempted repeatedly to impose reforms. Their lack of success in doing so illustrates the femi-

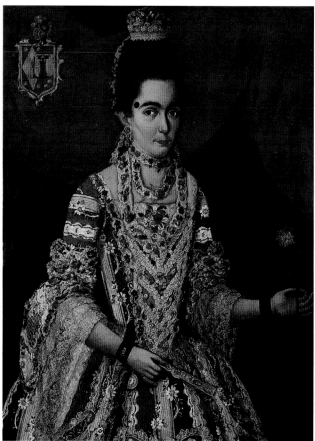

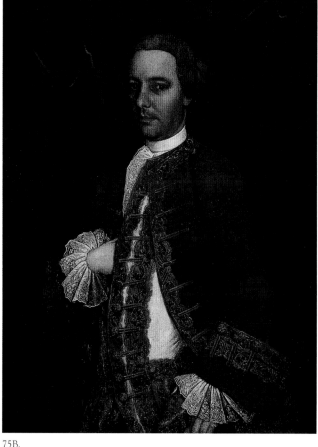

75A.
Unknown artist
Mexico, late eighteenth century
Portrait of a Woman
Oil on canvas, 41 x 31 in
Phoenix Art Museum, Gift of Mrs. Denison Kitchel
66.57

75B.
Unknown artist
Mexico, late eighteenth century
Portrait of a Gentleman
Oil on canvas, 41 ½ x 31 in.
Phoenix Art Museum, Gift of Mrs. Percy Douglas
66.58

75. Improvements in mining technology and increased silver production stimulated an era of economic prosperity in New Spain during the eighteenth century. As Mexican-born Creoles accumulated wealth, a desire for luxury goods and the trappings of the wealthy accompanied their demand for increased social standing and political power. One result of these changes was an increase in portrait commissions to keep abreast of contemporary European fashion and to document a sitter's Spanish heritage, past service to the Crown, and social status. (For a recent discussion of portraiture in New Spain see *El Retrato Civil en la Nueva España,* Mexico, 1991.)

These portraits—with the subjects elaborately dressed in silks, lace, gold galloon, and jewels—are typical of the late eighteenth century. The woman wears a fake beauty patch on her temple, extravagant earrings, double watches suspended from her waist, and holds a painted fan—all characteristics of women's fashions in Mexico at that time. The coat-of-arms of her family is represented in the upper left of the painting.

The gentleman wears a white linen shirt with lace ascot and cuffs under his white waistcoat and maroon jacket with large back-turned cuffs. Both are trimmed with intricate gold lace made from silk threads wrapped in fine gilded copper wire. He carries a black tricorn hat under his left arm and places his right hand inside his waistcoat in an affectation popular in both European and New World portraits and later associated with Napoleon.

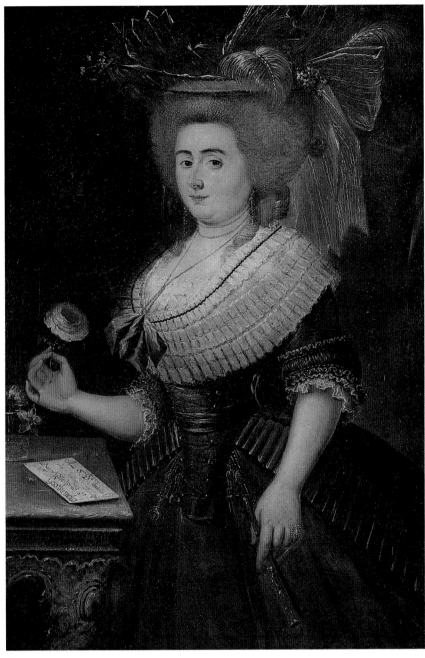

76.
Attributed to Rafael Jimeno (Ximeno) y Planes
Spanish, circa 1757-1825
Portrait of a Woman, circa 1794-1795
Oil on canvas, 46 x 31 in.
Santa Barbara Historical Society
6.62.57.1

76. Based on her costume, this portrait of a woman can be dated to circa 1794-95. Organdy collars with double or rolled pleats, fluffy powdered wigs, and elaborate hats perched high on the head were typical attire for upper-class women in the Americas during this era. The custom of wearing two watches or lockets suspended from the waist was a conceit of women's fashions in the New World in the late eighteenth century.

The letter on the table in front of the woman bears an intriguing inscription. Only partially legible, it reads: *A mi Sra. Da. Beatriz...Sta. Ma. An. Na. Goathemala* ("To my Señora Doña Beatriz...Santa María Asunción, New Guatemala"). The letter appears to be addressed to Doña Beatriz in the recently founded capital city of Guatemala, Santa María de la Asunción.

If the woman in the portrait is Doña Beatriz herself, she may have come from Guatemala to Mexico City or stopped in Mexico City on her way to Guatemala to have her portrait painted, since it appears to be by the Spanish artist Rafael Jimeno (or Ximeno) y Planes.* Born in Valencia around 1757, Jimeno y Planes had studied at the Academy of San Carlos there and, from 1774 to 1777, at the Academy of San Fernando in Madrid. In that city he was influenced by the Neoclassical court painter Anton Rafael Mengs (1728-1779) and by Mengs' protégé Francisco Bayeu (1734-1795). Appointed director of painting for the new Academy of San Carlos in Mexico, Jimeno y Planes arrived there in 1794 and became general director in 1798.

* Attribution by Dr. Marcus B. Burke.

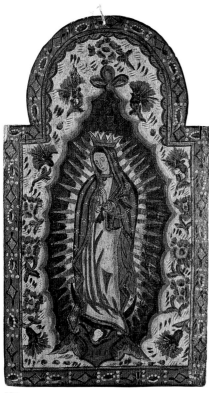

77A.
Attributed to School of Laguna Santero
Mexican(?), active New Mexico circa 1795-1845
Virgin of Guadalupe
Gesso, gold leaf, and water-soluble paint on pine panel,
26½ x 15⅛ in.
SCAS, MOIFA, Santa Fe
V.73.1-R

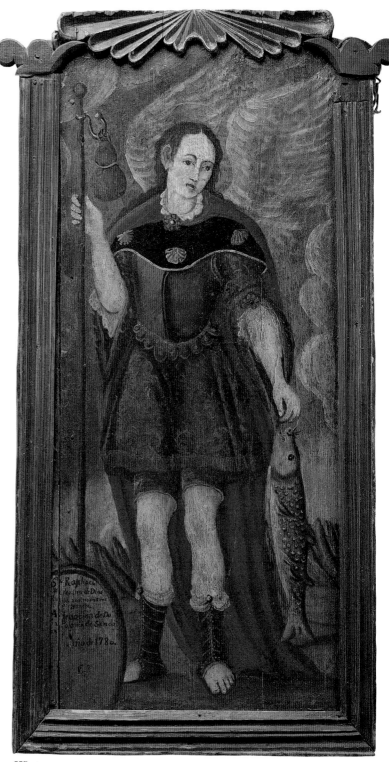

77B.
Captain Don Bernardo Miera y Pacheco
Spanish (to New Mexico circa 1751, d. 1785)
Saint Raphael Archangel, 1780
Oil on pine panel, 49 x 24½ x 2½ in.
SCAS, MOIFA, Santa Fe
L.5.54-77

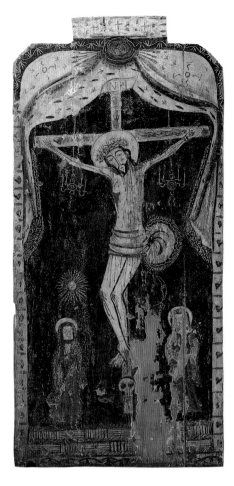

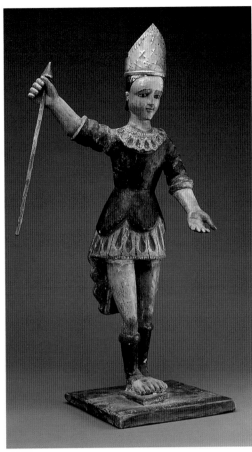

77C.
Pedro Antonio Fresquis (Truchas Master)
New Mexican, circa 1790-1840
Crucifixion with Mourning Figures
Gesso and water-soluble paint on
pine panel, 32 ⅝ x 15 ¼ x ¼ in.
IFAF, MOIFA, Santa Fe
FA.68.20-6

77D.
Attributed to School of Santo Niño Santero
New Mexican, circa 1830-1860
Saint Michael Archangel
Gesso, water-soluble paint, and tin on wood,
26 ⅞ x 14 ½ x 6 ⅝ in.
SCAS, MOIFA, Santa Fe
L.5.85-98

77. Distinctive provincial styles with ties to mainstream religious art developed in remote parts of the empire such as New Mexico. On the far northern frontier of New Spain, New Mexico was first explored officially by the expedition of Francisco Vásquez de Coronado in 1540-1542, a full eighty years before the Pilgrims landed at Plymouth Rock. By 1598 a Spanish settlement had been established, and by 1609 the village of Santa Fe had been founded. In 1680 the local tribes of Pueblo Indians had banded together to stage the most successful Indian rebellion in United States history, driving the Spaniards out of the area. By 1693, however, they had returned and reestablished the northernmost province of New Spain.

Paintings on hide had been executed in New Mexico and exported to northern Mexico before the Pueblo Revolt, and production resumed after the reconquest (Pierce, in press). By the 1770s sculptures, paintings, and altar screens were being produced locally by the earliest identified artist in New Mexico, Captain Don Bernardo Miera y Pacheco. By the 1790s several other artists had become active, including the Laguna Santero, along with his workshop and followers, and Pedro Antonio Fresquis, also known as the Truchas Master. By the early nineteenth century, at least a dozen local artists, including José Rafael Aragon (circa 1796-1862) and his disciple, known as the Santo Niño Santero, were producing prodigious amounts of religious art, including large altar screens (Boyd 1974; Wroth 1982). The early artists, particularly Miera y Pacheco, used imported oil paint alongside locally produced vegetable and mineral pigments, a technique probably learned from the Indians. By 1800 the majority was working exclusively in vegetable and mineral paints.

Extremely dependent on popular prints and small devotional images for iconography and composition, the New Mexican artists nonetheless developed a unique aesthetic. The colors they adapted from Rococo religious imagery took on a special translucence when executed in homemade tempera-based vegetable and mineral paints. The local shortage of materials like oil paint, refined tools, and silver and gold leaf was compensated for by a profusion of decorative minutiae, details made from tin, and the surprisingly effective technique of incising through the paint into the gesso ground. Despite their relatively small scale, some of these New Mexican images possess a monumentality and power far grander than their size would suggest.

78. As in Spain, the guild ordinances in the New World were exacting in regulating both the techniques of manufacture and the division of labor in the production of religious images. The carver, or *imaginero*, prepared the wood, filled knots and cracks, carved the figures in the round, and then gave them over to the painters. The technique for painting flesh areas, referred to as *encarnación*, consisted of a build-up of alternating layers of color and finish over a gesso ground, producing a lifelike translucency. The *encarnación* could have either a high gloss or a matte finish, although the former was much preferred, particularly in the New World. The garments were executed by separate artists in a different technique, called *estofado*, in which the entire surface was covered with gold leaf over a thin gesso primer. The gilding was then completely painted over in the various ground colors. Over this were added floral or geometric shapes in contrasting colors. Then the paint was etched in fine patterns to reveal the gold beneath, simulating the elaborate brocade fabrics of the era.

In the Baroque imagery of Spain, two parallel trends evolved. One was a highly dramatic, extroverted style, at times bordering on vulgarity, exemplified by the work of Gregorio Fernández (1576-1636) of Valladolid. The other, initiated by Juan Martínez Montañés (1568-1649) of Seville, was more introverted, producing reflective statues imbued with both an accessible humanity and a sense of mystery. Both styles flourished in the colonies with New World variations on the themes.

A superb New World example of the introverted Baroque style, this female saint conveys a feeling of dignity in her enigmatic face. The hint of a smile on her lips contradicts the look of sadness in her eyes, creating an air of ambivalence. One senses her strong spiritual life. The fine handling of her veil is

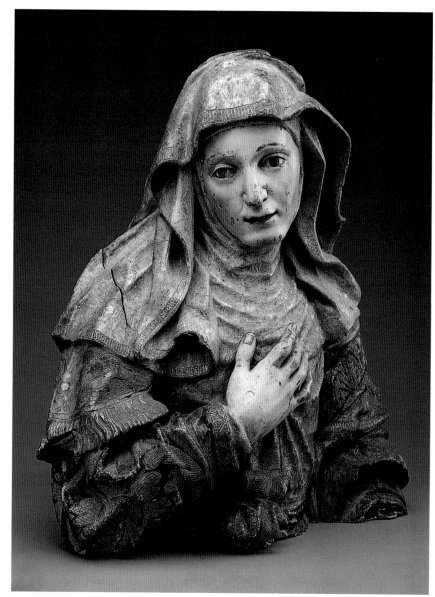

78. Unknown artist
Mexico/Guatemala, late seventeenth century
Female Saint
Gilded, polychrome wood, 23 x 22 x 12 in.
MOIFA, Santa Fe
A.10.56-10

reminiscent of, if not technically as adept as, those on busts of the Virgin of Sorrows carved by Andalusian sculptors in the mid-seventeenth century and exported to the New World. The extreme anguish, bloodshot eyes, and crystal tears of the Spanish images are not present here, making it impossible to identify this sculpture as a Virgin of Sorrows. Originally a full-length figure,

possibly of Saint Rose of Lima, her attributes have been lost, keeping her identity a mystery.

79. Images from Guatemala are distinctive in several ways. First, even at the height of the Baroque and Rococo eras, they never lost their individual identities in altar screen contexts, as such works did in Mexico. Second, the use of silver

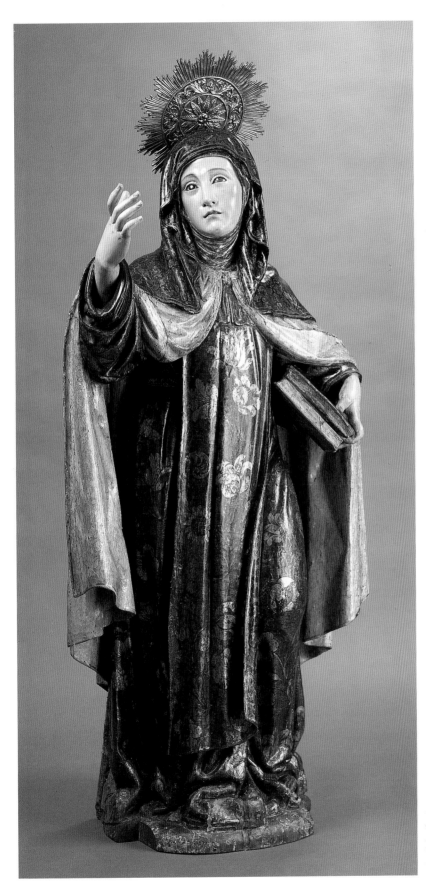

rather than gold leaf under the *estofado* paint is a technique attributed to Guatemalan workshops.

At the beginning of the seventeenth century, a discernible Guatemalan Baroque style developed in sculpture, characterized by ample but realistic and calm drapery and by oval faces with large eyes and small mouths. In a successful attempt to follow the introverted version of Baroque realism, the volumes of the figures increased, while the realism and expression of the faces were heightened as the century progressed. Toward the end of the seventeenth century, a sense of movement and brighter *estofado* were added. Despite fluttering drapery and pastel colors, a certain bulkiness persisted into the early eighteenth century. As in Mexico, only a few Guatemalan sculptors are known by name, among them Quirio Cataño (active 1500s), Alonso de la Paz y Toledo (active 1600s), and Juan de Chávez (active 1700s).

This statue of Saint Teresa of Ávila has the oval face with small mouth and large eyes as well as the sense of volume and heavy drapery characteristic of seventeenth-century Guatemalan Baroque sculpture. The faraway look in her eyes and expression of concentration on her face seem to indicate that she is experiencing one of her many mystical visions. Her outstretched hand seems to beckon an apparition toward her. Although the *estofado* still employs dark colors, the large size and busy patterning of the floral motifs reveal the influence of the late Baroque period. The lack of decoration on the back of the saint's clothing indicates that she was made for an altar screen, but one imagines her holding her own there, quietly commanding attention. All of these qualities make this statue an excellent example of a New World interpretation of the introverted Spanish Baroque style.

79. Unknown artist
Guatemala, late seventeenth century
Saint Teresa of Ávila
Gilded, polychrome wood, white silver, glass, H: 46 in.
San Antonio Museum of Art, San Antonio Museum Association
74-60-17P

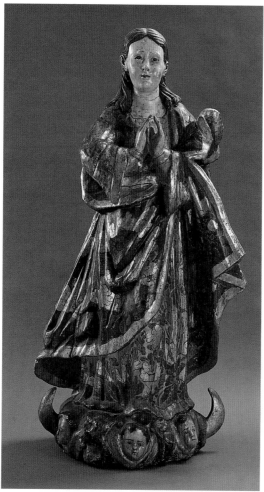

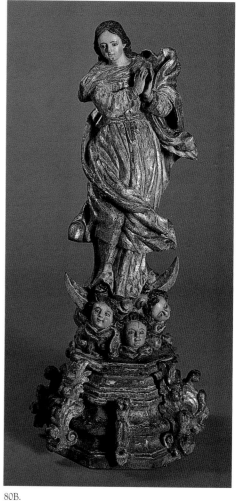

80A.
Unknown artist
Mexico, early eighteenth century
Virgin of the Immaculate Conception
Wood, gesso, paint, 42⅛ x 23¼ x 14⅛ in.
IIICA, UNM
L.87.3.41

80B.
Unknown artist
Mexico, Bajío region(?), late eighteenth century
Virgin of the Immaculate Conception
Gilded, polychrome wood, H: 31½ in.
Holler and Saunders, Ltd.

80. According to the doctrine of the Immaculate Conception, the Virgin herself was conceived by her parents, Anne and Joachim, without taint of original sin. This theory, championed by the Franciscans, has been widely believed by Catholics since the early fifteenth century, although it was not officially recognized by the church until 1869. Devotion to the Immaculate Conception, particularly strong in Spain, was transported to the New World by Franciscan missionaries.

The iconography of the Immaculate Conception, based on references from both the Old and New Testaments, was codified early on. In the Book of Revelation, the Woman of the Apocalypse is described as being pregnant and "clothed with the sun, and the moon under her feet, and upon her head a crown of twelve stars" (12:1). The devil in the form of a seven-headed dragon threatens to devour her child at birth. But when she gives birth to a male child, he is saved by being taken immediately into heaven. Images of the Virgin of the Immaculate Conception depict her in this manner, standing above a new moon, dragon, or both. Symbolism from the Song of Solomon was used in both litany and art to glorify the purity of the Virgin, with expressions such as "lily among thorns" (2:1-2), "locked garden" (4:12), and "fair as the moon, clear as the sun" (6:10). Eventually, the new or crescent moon at her feet, often with cherubs, came to be this figure's most frequent attribute, as is seen in these two examples. Due to their iconographic similarity, images of the Immaculate Conception, particularly sculpted ones, are often difficult to distinguish from those of the Virgin of the Apocalypse (p. 93).

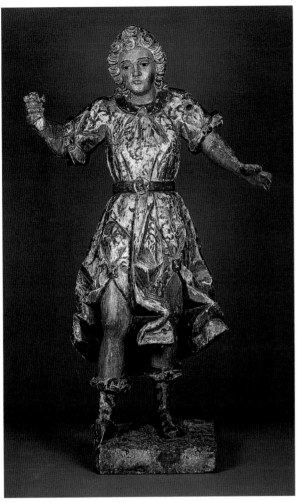

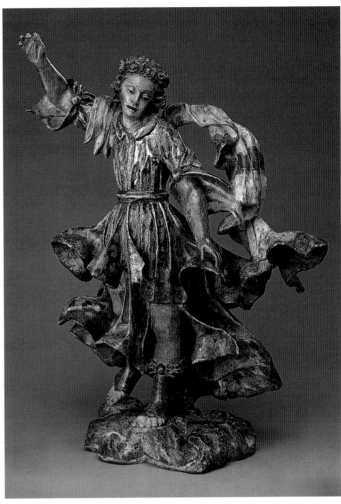

81A.
Unknown artist
Mexico, eighteenth century
Angel
Gilded, polychrome wood, H: 49 ½ in.
Holler and Saunders, Ltd.

81B.
Unknown artist
Mexico, late eighteenth century
Saint Michael Archangel
Gilded, polychrome wood, H: 20 ½ in.
SCAS, MOIFA, Santa Fe
V.61-4B

These two statues illustrate the transition from late Baroque to Rococo. The first example has the heavier billowing drapery with angular, sometimes V-shaped folds of the Baroque period; the second has implausibly swirling garments with the soft but agitated folds of the Rococo. The Baroque Virgin stands in a solid frontal pose with idealized yet realistic features. Although she may date from after the Baroque period, she retains many of its elements, possibly as a result of following an earlier model. Her slightly Oriental face and the heavy, striated carving of her hair may indicate the influence of imported ivories. The Rococo Virgin sways off-balance and has small, doll-like features characteristic of late Rococo statues. Her clothing is carved in a manner often seen in the Bajío region northwest of Mexico City, with the vertical folds of her dress bulging at the hips and narrowing at the ankles. The relatively straight lines of the dress are intersected at a diagonal by the swirling movement of the mantle.

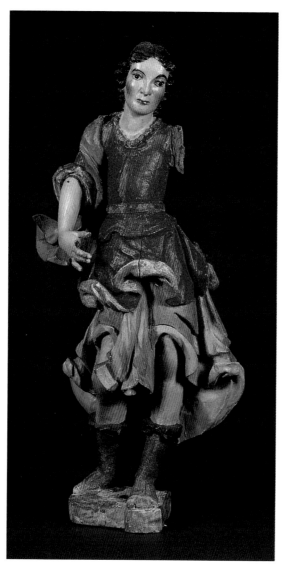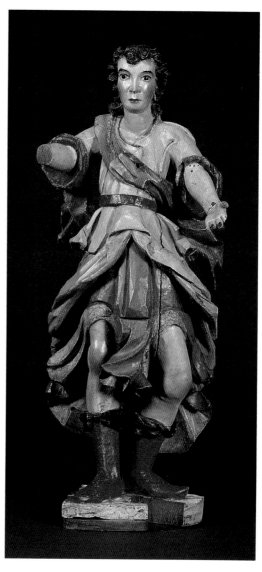

81C.
Unknown artist
Mexico,
early nineteenth century
Four Angels
Wood, paint,
H.: 27; 29; 38; 40 in.
Collection of Constance
McCormick Fearing

81. The stylistic differences between the Baroque and Rococo can be seen in these angels. The first example, though it may date from the latter part of the eighteenth century, retains the flavor of the earlier High Baroque style. Reportedly from Cholula in the state of Puebla, this angel is typical of that area, where the High Baroque evolved into a distinct regional style, remaining popular throughout the colonial period and, in some cases, up to the present. Rococo influence, so strong in Mexico City and the north in the late eighteenth century, was much less pronounced in the southern areas of Puebla and Oaxaca. Rather, the solid stance, heavy drapery with angular folds, and broad faces of Baroque statues continued to dominate artistic production there. The square face, wide-set eyes, and stylized, gilded hair are reminiscent of cherubs carved in stucco on the walls of Pueblan village churches such as Santa María Tonanzintla and San Francisco Acatepec.

The second angel is a classic example of the late eighteenth-century statues made to adorn altars in chapels and private homes. These small images, apparently made to stand on their own outside the context of large altar screens, were exported to remote areas of New Spain such as New Mexico. The rarified facial features contrast markedly with those of the angel from Puebla. In true Rococo fashion, the second angel stands precari-

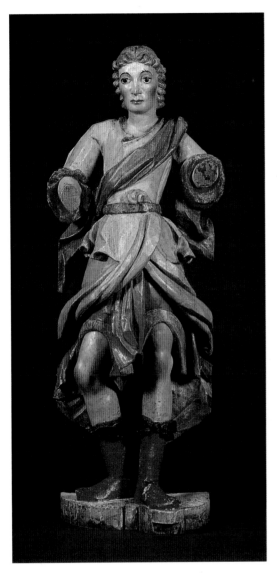 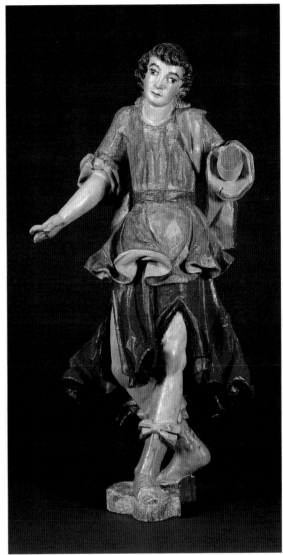

ously on one foot in a balletic pose. His airy clothing seems to have taken on a life of its own, twirling improbably around him in all directions.

Another characteristic of the late eighteenth and early nineteenth centuries was the international movement away from gilded *estofado* decoration as a result of Neoclassical influence. As in majolica ware, matte shades of pale blue, mauve, and ocher, among others, became popular on statues, as can be seen on the set of four angels illustrated here. These four have attenuated proportions and poses reminiscent of sixteenth-century Mannerism and revived during the Rococo era. The strangely organic fluttering of their drapery is a characteristic Rococo affectation, although their quietly reflective faces recall the introverted early Baroque. Combining elements from distinct styles is a mark of the freedom exercised by New World artists.

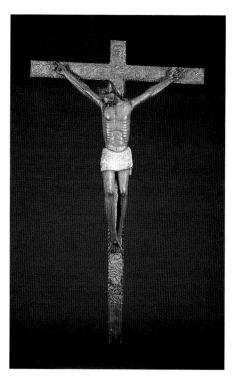

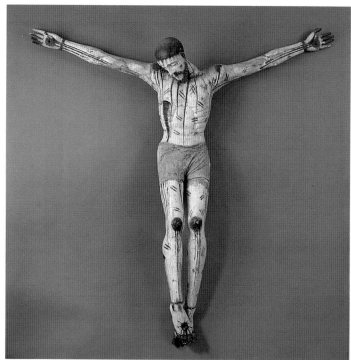

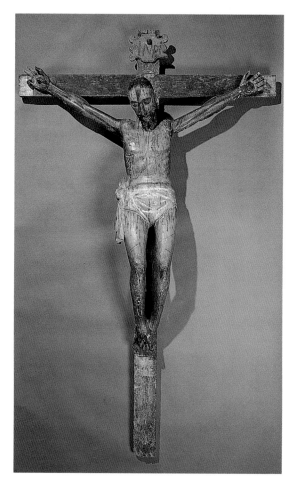

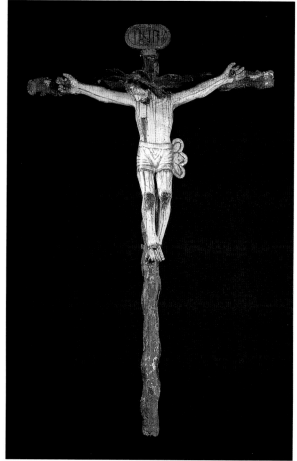

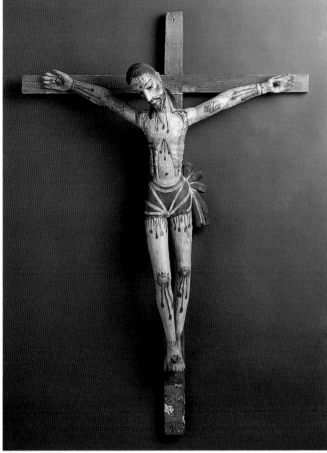

82E.
José Rafael Aragon
New Mexican, circa 1796-1862
Crucifix
Pine wood, gesso, water-soluble paint, 44 x 31 in.
Collection of Al Luckett, Jr.

82A.
Unknown artist
Mexico, eighteenth century
Crucifix
Wood, paint, 76 x 46 ½ in.
Collection of Constance McCormick Fearing

82B.
Unknown artist
Mexico, late eighteenth century
Crucifix
Wood, paint, 55 x 60 in.
Collection of Mr. and Mrs. Merle Wachter

82C.
Unknown artist
Mexico, early nineteenth century
Crucifix
Wood, paint, 83 x 53 in.
Santa Barbara Museum of Art,
Gift of Michael Butler
1971.4.12

82D.
Unknown artist
Mexico, early nineteenth century
Crucifix
Wood, oil paint, tin, 82 x 48 ¾ in.
Collection of Constance McCormick Fearing

82. During the early Baroque period in Spain, the great master Juan Martínez Montañés initiated a breakthrough in sculptures of Christ on the cross with his *Christ of Clemency* (1603-1606) for the cathedral of Seville. The contract specified that the image should appear to be "alive before his death...looking at any person who might be praying at his feet, as if Christ himself were speaking to him" (Kubler and Soria 1959, p. 148). Montañés's majestic work, one of the first in Spain to represent Christ as still alive, opened up new possibilities in Baroque sculptures of the Crucifixion. Examples capturing specific moments during the time Christ spent on the cross could now be carved. The most enduring image in both Spain and the colonies, however, remained the moment when Christ looked down with open eyes, and can be seen in these examples.

In Fig. 82A, the strain of the weight of Christ's body is indicated by the steep angle and taut muscles of the arms and the sharp delineation of the ribs as well as the abdominal muscles. The heaviness of the body is also evident in the manner in which the legs seem to push downward against the single nail in the feet.

In the later examples illustrated here, the implication of strain has become stylized. No longer do the arms pull down at a sharp angle, but rather the corpus seems to float in front of the cross with arms outstretched like wings. The ribs and stretched muscles are no longer as deeply carved; instead the physical horror of crucifixion and impending death are indicated by the off-color skin tones and rivulets of blood. During the nineteenth century these characteristics became conventions, with drops of blood following musculature rather than gravity or arranged in patterns resembling decorative fringe. Probably copied from popular prints of specific sculptures of Christ on the cross, some concepts were lost in the translation from a three-dimensional Baroque sculpture to a two-dimensional engraving and back again to a three-dimensional carving. This is evident in the last two examples shown here, in which the elaborate knot and billowing end of the loincloth from Baroque sculptures have been simplified into a two-dimensional bow.

83.
Unknown artist
Mexico, eighteenth century
Lion
Wood, 18 x 49 x 7 ½ in.
Collection of Constance McCormick Fearing

83. The marriage of Ferdinand V and Isabella I united the great medieval kingdoms of Castille and Leon, among others. The castle towers of Castille and the lions of Leon became key symbols in the emerging royal coat of arms. As other kingdoms were brought into the alliance and other dynasties united by marriage, new symbols were added to the royal emblem, but the castles and lions remain prominent at the heart of the Spanish royal coat of arms. Along with the eagle, the lion became one of the most enduring motifs in the decorative arts of Spain and the colonies into modern times.

In the New World the imagery of the lion was probably combined with that of the Mesoamerican jaguar, so important in pre-Hispanic mythology and art. Lions adorn objects as diverse as carved wooden clothes chests, majolica serving bowls, and silver church candlesticks. They guard entrances to private homes and the steps to church altars.

Although its glass eyes, inserted in the twentieth century, give this lion a slightly myopic gaze, the crouched position and tense muscles of his hindquarters indicate that he is ready to pounce. Both his stance and the somewhat human expression on his face convey a sense of interaction with the world around him. The somewhat inaccurate portrayal of his anatomy, particularly evident around the head, is typical of New World images of lions. Since they would have been carved from illustrations or engravings by artists who had never actually seen lions, they often have a rather confused and whimsical character.

WHEN CORTÉS AND HIS TROOPS arrived in Mexico, to their delight they found that gold and silver were abundant. The Mexican Indians had a long tradition of metalworking techniques, including filigree, hammering, and casting. In his second letter to Charles V, Cortés describes numerous gold and silver objects he was sending as gifts:

> Your Majesty's fifth came to more than 32,400 pesos de oro, exclusive of the gold and silver jewelry, and the featherwork and precious stones and many other valuable things which I designated for Your Holy Majesty and set aside....Let me say that all the things of which Mutezuma [Moctezuma] has ever heard, both on land and in the sea, they have modeled, very realistically, either in gold and silver or in jewels or feathers, and with such perfection that they seem almost real. He gave many of these for your Highness, without counting other things which I drew for him and which he had made in gold, such as holy images, crucifixes, medallions, ornaments, necklaces, and many other of our things. Of the silver Your Highness received a hundred or so marks, which I had the natives make into plates, both large and small, and bowls and cups and spoons which they fashioned as skillfully as we could make them understand (Cortés 1986, pp. 100-101).

When Cortés's gifts were exhibited in Brussels in 1520, the German artist Albrecht Dürer described his response to Aztec craftsmanship: "I have also seen the objects they have brought to the king from the new golden land: a sun of solid gold that measures a full fathom; also a moon of pure silver, equal in size....In all my life I have never seen anything that has so delighted my heart as did these objects; for there I saw strange works of art and have been left amazed by the subtle inventiveness of the men of faroff lands" (Anders 1970, p. 46).

After the conquest the Franciscan friar Motolinía described the craft of the Mexican indigenous metalsmith: In melting a piece of silver and in shaping it from the mold, they surpass the silversmiths of Spain in that they fashion a bird which moves its tongue, its head and its wings. Similarly, they fashion a monkey or some beast that moves its head, tongue, feet and claws; and in its claws they place some little playthings that seem to dance with them. Best of all, they take a lump of what is half gold and half silver, and fashion a fish with all its scales, some of gold and others of silver (Motolinía 1951, p. 299).

Silversmiths from Spain began to emigrate to Mexico and Guatemala shortly after the conquest. Documents regulating the production of metalwork in Mexico date from as early as 1526-1527, indicating that a thriving and competitive industry was underway by that time. Although Indian silversmiths were prohibited from joining the guilds, they worked outside them, particularly for the monastic orders, and, apparently, as unofficial assistants to master craftsmen. Silver shops were grouped together on one street in downtown Mexico City. In 1625 the British Dominican friar Thomas Gage wrote that "a man's eyes may behold in less than an hour many millions' worth of gold, silver, pearls, and jewels" (Gage 1958).

Silver objects made in Mexico and Guatemala during the early period often appear at first glance to be derivative of Spanish styles. Upon closer inspection, however, a New World detail always sets the piece apart, however subtly. Through time this synthesis of New and Old World styles became more integrated, culminating in the lush excesses of Mexican and Guatemalan Baroque and Rococo silver work ornamentation. ■

84. Artistic connections between Spain and Mexico remained strong throughout the sixteenth century. The Renaissance form and Mannerist motifs of this superbly crafted chalice reveal its links to Spain (Esteras Martín 1989, pp. 152-55, no. 15; *Mexico: Splendors of Thirty Centuries* 1990, pp. 395-96, no. 170). The Mexican silversmith, however, incorporated pre-Columbian techniques and materials—rock crystal carvings and feather mosaics—into the piece.

Mexican Indian sculptors had used rock crystal as a material for carving various objects, particularly skulls, for centuries. Here two carved rock crystal knobs are incorporated into the stem, and rock crystal columns with Ionic capitals decorate the hexagonal knop.

The production of elaborate mosaics made from cut feathers from a variety of New World birds was a highly developed art form among the Aztecs. On the chalice, feather mosaics appear in niches on the hexagonal knop of the stem and in teardrop insets on the base. In the latter location, they occupy the position usually reserved for polychrome enamels in Spanish silver work of the period. The feather mosaics serve as backdrops for tiny boxwood carvings of the twelve apostles on the knop and of Passion scenes on the base.

The embossed and chased decoration on the base of the chalice includes other scenes from the Passion of Christ, the four doctors of the Latin church (Augustine, Ambrose, Jerome, and Gregory), and the four evangelists (Matthew, Mark, Luke, and John). Paired cherubs holding medallions with the instruments of the Passion decorate the swell of the base. The lower portion of the cup is also decorated with portraits of the four evangelists.

The chalice bears hallmarks of Mexico City: a male head in right profile between the Pillars of Hercules (from the Spanish royal coat of arms), with a three-pointed crown above and the abbreviation for Mexico, Mo, below. The chalice also has an unidentified

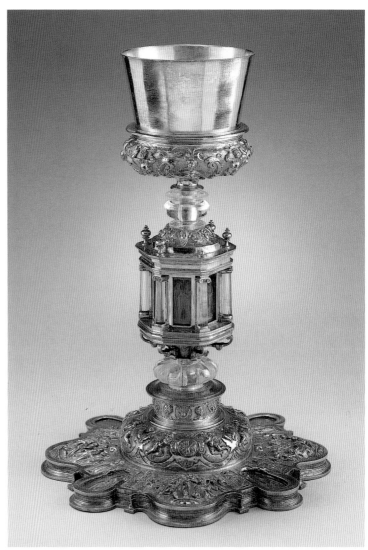

84.
Unknown artist
Mexico City, 1575-1578
Chalice
Silver gilt, rock crystal, boxwood, feathers,
H.: 13 in.
Los Angeles County Museum of Art,
Gift of William Randolph Hearst
46.24.20

hallmark representing a kneeling angel that may be that of the assayer. On the base beneath the stem, and visible only when the piece is dismantled, is a lightly incised head of a bearded man wearing a helmet which may be a donor portrait.

Even in the early period, when most silversmiths had been born and trained in Spain, the freedom to incorporate indigenous materials and artistic traditions was exercised in Mexico. This

chalice represents a truly successful marriage of the best of Spanish Renaissance-Mannerist style with Aztec technique and is a uniquely Mexican work of art.

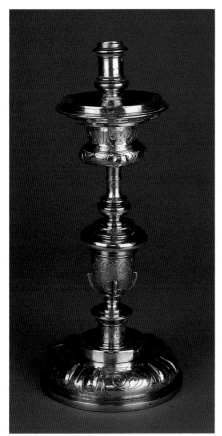

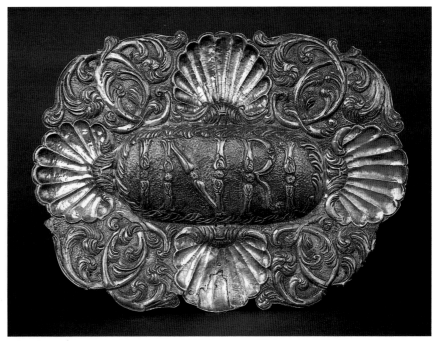

86.
Felipe Santiago(?)
Mexican, eighteenth century
Crucifixion Plaque, Guanajuato, 1741
White silver, silver gilt, 10 x 14¼ in.
Collection of Michael Haskell

85.
Unknown artist
Mexico City, circa 1630
Candlestick
White silver, H.: 15 in.
Holler and Saunders, Ltd.

85. In the late sixteenth and early seventeenth centuries, Mexico experienced an economic boom as a result of the unprecedented quantity of silver extracted from the great mines, particularly Zacatecas and San Luis Potosí. This in turn stimulated an increase and artistic florescence in the production of worked silver objects.

By this time Renaissance motifs had yielded to full-blown Mannerist elements, particularly patterns of delicately incised strap work alternating with raised ovoid bosses. In Mexico the execution of such motifs is sometimes exaggerated, as in this candlestick, where the strap work is delineated by shallow incising in contrast to the high relief of the bosses. As

here, the profiles of stemmed vessels from this period often reflect a fascination with turned balusters on furniture and other decorative arts of the period.

Thomas Gage, the Dominican priest from England, described the vast quantity of silver utensils in use in Mexican and Guatemalan churches in 1625. (Gage, pp. 68, 70-72, 165, 189-191, 202) So influential was this early expansion of the tradition that turned outlines, Mannerist strap work, and elongated bosses frequently recur in Mexican silver work of the later Baroque and Rococo periods.

This candlestick, made in Mexico City, has its location mark: the paired Pillars of Hercules with a crown above and a male head in right profile over the initials MO in the interior space. Hallmarks depicting the shield of the Dominican order indicate that the candlestick was commissioned for, or at least belonged to, a monastic establishment or church of that group at one time.

86. The second half of the seventeenth and early eighteenth centuries saw the development of the Mexican Baroque, characterized by a voluptuous use of ornament, often retaining Renaissance-Mannerist forms, and conveying a sensuous but symmetrical feeling of movement over the surface of objects. Color contrast, here of gold and silver, is also a trait of the Baroque period. The style spread to all art forms and all areas of Mexico, with regional variations evolving in many areas.

By 1741, when this plaque was made, Rococo motifs had just begun to be incorporated into the Mexican Baroque vocabulary, but were still being used with a Baroque sensibility. Here the vegetal scrolls alternate with scalloped shells in a busy but balanced composition, not yet showing the asymmetrical organization typical of later Rococo pieces.

The plaque would have been attached originally to the top of the life-size crucifix, since INRI represents the

Latin initials for the expression "Jesus of Nazareth, King of the Jews." An inscription on the reverse of the plaque reads: *En Gto. lo iso Felipe Santgo en 28 de marzo de 1741 A* ("In G[uanajua]to Felipe Sant[ia]go made [or did] this on the 28th of March of the year 1741"). Felipe Santiago could have been either the maker or the donor.

87. Throughout the colonial period, stemmed vessels such as chalices, candlesticks, monstrances, and ciboria were often executed without decoration. The beauty of these pieces lies in the emphasis on structure and in their elaborately undulating profiles, reminiscent of turned balusters on early Baroque furniture. In the eighteenth century the proportions of such pieces were lengthened slightly, as in this piece, resulting in more delicate, less ponderous profiles. This particular chalice shows evidence of much use, and traces of gold wash survive on the interior of the cup as well as on the underside of the base.

Stemmed vessels of this type were quite common. A similar chalice can be seen in the hand of a supplicant or donor in a painting of Saint Elygius, the patron saint of silversmiths (p. 98).

88. Another economic boom occurred in Mexico in the eighteenth century, stimulated by the development of new silver mines such as Taxco. This boom was accompanied by a concurrent expansion in artistic production of worked silver. Rococo motifs were gradually incorporated into the artistic lexicon of the late Mexican Baroque style during this period.

These candlesticks (which are not precisely identical) include various elements characteristic of the period, particularly the tripartite bases in the shape of volutes with progressively recessed outlines echoing the curves of the base. Repetitive stepped outlines, almost like fabric pleats, are a hallmark of the late Mexican Baroque style in all the arts, especially in the silver-rich Bajío region, northwest of Mexico City. Lightly incised floral and leaf patterns cover the knobs of the baluster, and cast floral motifs were

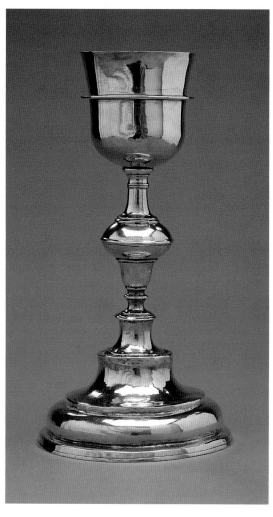

87.
Unknown artist
Mexico, early eighteenth century
Chalice
White silver, silver gilt,
9⅞ x 5⅛ in. (diam. at base)
SCAS, MOIFA, Santa Fe
L.5.72-34

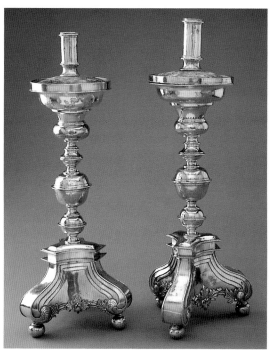

88.
Unknown artist
Mexico, late eighteenth century
Candlesticks
White silver, wood,
H.: 20 in.; 19¼ in.
IFAF, MOIFA, Santa Fe
FA.72.5-1a, 1b

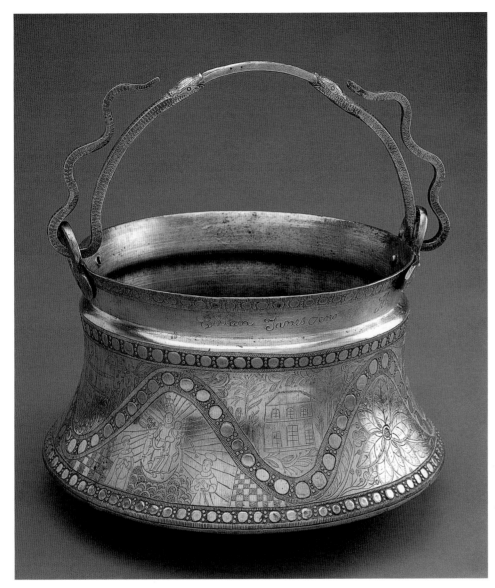

89.
José Antonio Mena M. Zojo
Mexican, early nineteenth century
Basin, 1805
Silver-plated metal, 13 ¼ x 11 in.
(with handle)
IFAF, MOIFA, Santa Fe
FA.79.64-139

applied on the bases. The restrained ornament probably indicates the beginnings of Neoclassical influence.

89. This silver-plated basin has no hallmarks, though it bears an inscription around its rim: *Echo por José Antonio Mena M. Zojo…Estebán Yañes Año 1805 A[ño] M[aría]* ("Made by José Antonio Mena M. Zojo…Estebán Yañes [in the] Year [of the] Virgin Mary 1805"). An almost identical basin bears the name "Juan Costo" and the date 1792 (Anderson 1956, fig. 12).

The basin seems to be a provincial piece, possibly from the Oaxaca area, with stylistic elements from the transitional period between the late Baroque and Neoclassicism. The large floral patterns, asymmetrical scrolls, and overall incised ornament are Rococo elements used in the late Baroque period. Bands of flat disks are typical of early Neoclassical ornament in Mexico, but the undulation of the band in the central field represents a Baroque handling of this Neoclassical element.

Figural scenes are incised among the undulations of the band. In one the Virgin and Child are flanked by Saints Dominic and Francis. The Virgin presents a rosary to Saint Dominic, and the child holds out a knotted cord to Saint Francis. Other scenes include a two-story house with a mansard roof and a man with a rifle aiming at a bird in a tree. The handle of the vessel depicts two opposing snakes with curvaceous tails. Both snakes and disks, used as numerical symbols, were popular motifs in the art of the pre-Columbian cultures of Mexico.

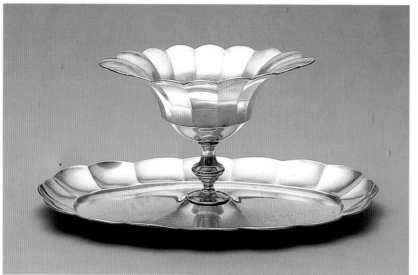

90.
Alejandro Antonio de Cañas(?)
Mexican, b. 1755; d. after 1804
Brazier, Mexico City, 1819-23
White silver, 4 x 8⅝ x 5⅛ in.
IFAF, MOIFA, Santa Fe
FA.79.64-5

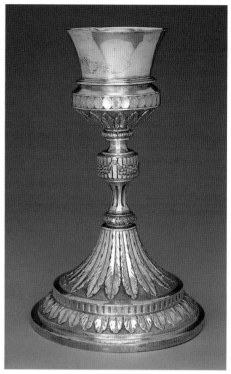

91.
Alejandro Antonio de Cañas
Mexican, b. 1755; d. after 1804
Chalice, Mexico City, circa 1800-1810
Silver gilt, H.: 9⅛ in.
IFAF, MOIFA, Santa Fe
FA.71.22-1a

90. Braziers were used to hold live coals for burning incense, warming the hands, or lighting cigarettes (both men and women smoked tobacco in Mexico). This elegant example consists of an oval cup attached to an oval tray by a simple knobbed stem. Both cup and tray are fluted with scalloped edges. The brazier is stamped with the maker's hallmark CANAS, indicating that it was made by the master silversmith Alejandro Antonio de Cañas or, possibly, one of his sons. The personal mark (DVLA) of the assayer Joaquín Dávila Madrid, in office from 1819 until his death in 1823, dates the brazier between these years. Also present are the Mexico City location mark (a crowned M) and the tax stamp (a lion).

91. With the opening for classes of the Royal Academy of San Carlos in 1785, the Neoclassical style was introduced to Mexico. Its influence became particularly strong in the arts taught at the academy, including metalwork. Initially, Neoclassical motifs were combined with Rococo elements and often executed with Baroque interpretations.

By the first decade of the nineteenth century, students trained at the academy and others had absorbed the teachings of the European masters and begun to produce works of silver in a Neoclassical manner, as can be seen in this chalice. No longer are motifs scattered in an intricate, asymmetrical composition; now they are uniform and regularly spaced. The wild vegetation of Mexican

Baroque art has been pruned back to identical leaves rigidly arranged in single file and tiny garlands of subdued flowers on the stem. Restrained bands of Neoclassical disks and oblong bars circle the cup and stem knop. In spite of the reserved accuracy of the classical motifs, the Mexican sense of horror vacui persists; every surface of the chalice is covered with ornament except, for utilitarian reasons, the lip.

The chalice is stamped with the maker's mark of the master silversmith Alejandro Antonio de Cañas. Born in Mexico in 1755, Cañas passed the master silversmith examination in 1786 and served as guild inspector in 1794 and 1804. Known for his gilt chalices, he is mentioned in an 1815 inventory in con-

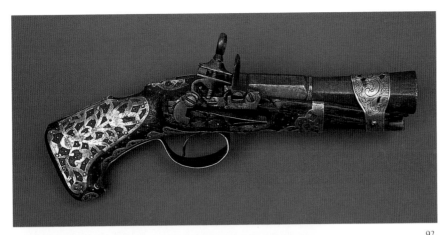

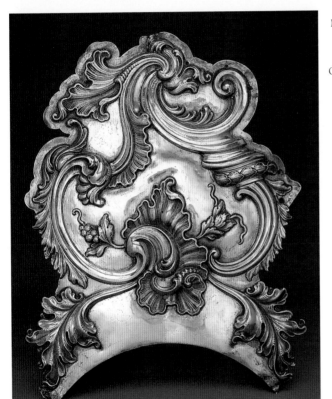

92.
Unknown artist
Mexico, eighteenth century
Pistol
Wood, steel, silver,
10 x 3½ in.
Collection of James M. Jeter

93.
Unknown artist
Guatemala, circa 1780-1790
Plaque
White silver, 14 x 11 in.
IFAF, MOIFA, Santa Fe
FA.1984.613-13

nection with a chalice and a cruet set by him in the cathedral in Mexico City. The chalice illustrated here also bears the marks used by the assayer Antonio Forcada y la Plaza. They include one of his personal marks (FOR/CADA), the tax stamp (an eagle in flight), and the location stamp indicating manufacture in Mexico City (an imperial crown).

92. Silver was used to decorate all types of utilitarian objects, such as horse gear and weapons, in the Spanish colonies. Openwork and incised silver overlay were used to embellish this flintlock pistol. The design on the handle represents an urn with a floral bouquet, a prevalent motif in the eighteenth-century decorative arts. The silver trigger guard is faced with cutout scallops, and the silver barrel band is engraved with asymmetrical scrolls that are also typical of Rococo decoration.

Flintlock firearms were used in the New World throughout the colonial period and are depicted in images of the archangels and in hunting scenes. Such weapons were muzzle-loaded and fired when the flint (missing here) struck the upright metal frizzen, creating a spark. The spark ignited a small amount of gunpowder in the frizzen pan and traveled through a touch hole from the pan into the barrel of the gun. The type of flintlock mechanism on this pistol, known as a miquelet lock, was used regularly by the Spaniards. Cruder than other forms of eighteenth-century flintlock mechanisms, it was more reliable and easier to repair, making it more practical for use on the frontier. This pistol was collected in northern New Mexico, a province of New Spain still plagued by attacks from hostile Plains Indians in the late eighteenth century.

93. This silver plaque fragment probably would have been the crest at the top of a tabernacle. It is made from a sheet of silver with repoussé designs and was probably intended to be mounted on a wooden backing. The motifs that adorn it belong to the vocabulary of the Rococo era: large leaves, C-shapes, and rocaille,

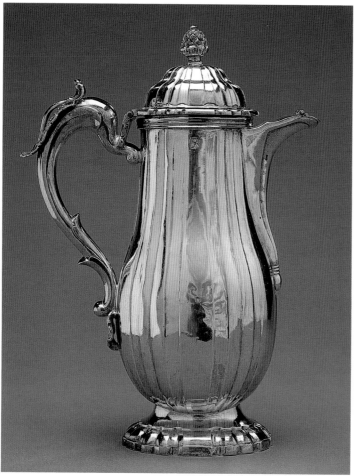

94.
Miguel Guerra
Guatemalan, late eighteenth/early nineteenth centuries
Coffee Pot, circa 1780
White silver, H.: 14⅛ in.
IFAF, MOIFA, Santa Fe
FA.71.7-1

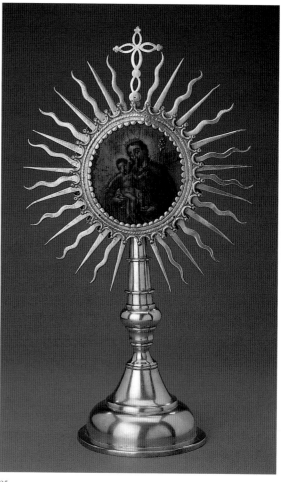

95.
Unknown artist
Guatemala, early nineteenth century
Confraternity Emblem
White silver, oil on canvas, H.: 10¼ in.
IFAF, MOIFA, Santa Fe
FA.71.15-135

as well as a bunch of grapes and a thorn, alluding to the Eucharist. The crest is a work of great beauty and artistic quality, even though the artist is anonymous and the piece lacks marks. It is in the same tradition as the tabernacle from the church of San Agustín Acasaguastlán. CEM

94. This pitcher is made of cast silver with embossed details. With an oval contour and pear-shaped body, it is covered over its entire length with vertical pleats that provide the piece with the sensation of movement. The hinged lid has a finial in the shape of an artichoke. The spout is in the shape of a duck bill, and the curved handle is decorated with an applied leaf and a scallop shell.

The three standard marks of Guatemalan silver work are present: location (Saint James on horseback over the volcanos of Agua and Fuego), fiscal tax (two variations of the imperial crown), and the personal mark of the artist (GUERRA). The marks indicate that the piece was made in Guatemala City by the famous silversmith Miguel Guerra, who based it on a type widespread in Portugal and Spain as well as in Mexico. Its Rococo style permits it to be dated around 1780. CEM

95. This is an emblem of the Confraternity of Saint Joseph in the form of a monstrance with the sun motif in worked silver. Most notable is the sun—formed of thirty-two alternating straight and undulating rays—in whose center is located a small painting depicting Saint Joseph with the Christ child. On the reverse is another small painting of the Immaculate Conception. Even though there are no regulatory marks, without a doubt the piece was made in the silver shops of Guatemala during the first half of the nineteenth century, since it resembles many others made there. CEM

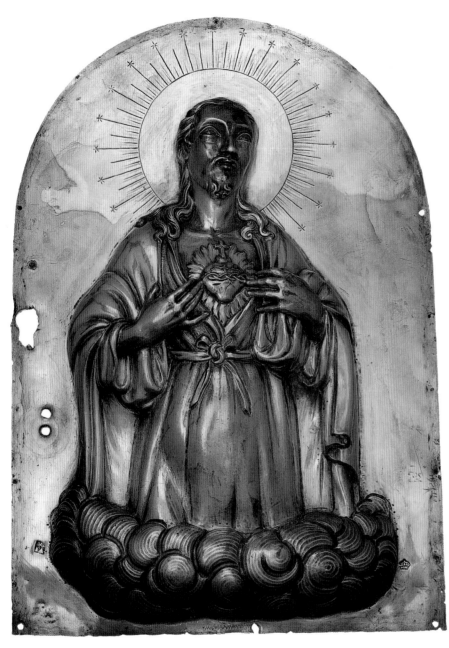

96.
Unknown artist
Guatemala City, early nineteenth century
Tabernacle Front
White silver, silver gilt, 12 ⅛ x 8 ¼ in.
IFAF, MOIFA, Santa Fe
FA.1984.613-14

96. An image of great plastic beauty, this piece was the central door of a tabernacle. It is in the shape of a rounded arch with repoussé motifs in a mixture of silver and silver gilt. Executed in high relief, an image of the sacred heart of Jesus floats over puffy clouds. Although the work is anonymous, we know that it was made in the city of Nueva Guatemala de la Asunción due to the hallmark of that city (Saint James riding a horse over two volcanos) and the tax stamp (imperial crown). CEM

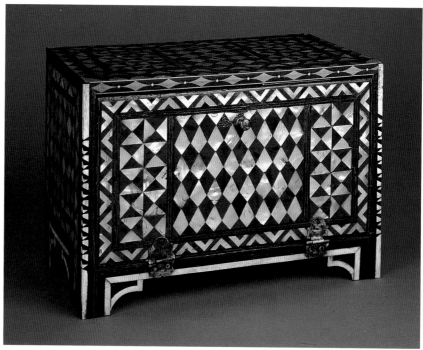

97.
Unknown artist
Puebla, Mexico, late seventeenth century
Chest with Drawers
Wood, tortoiseshell, mother of pearl, ebony, ivory, silver
hardware, 9 x 13 x 7⅜ in.
Holler and Saunders, Ltd.

SPANISH CABINETMAKERS apparently emigrated to the New World shortly after the conquest. Guild ordinances similar to those of Spain were issued in Mexico in 1568 for carpenters, sculptors, joiners, and makers of stringed instruments. Revised in 1589 for carvers and sculptors, these ordinances regulated the production of altar screens as well (Santiago Cruz 1960; Toussaint 1967, pp. 158-60).

Indians were allowed to practice the craft outside the guilds and were unrestricted by their ordinances. Shortly after the conquest, the training of Indians in various crafts, including woodworking, was initiated in convent schools under the direction of Franciscan friars. Indians also trained with Spanish master craftsmen, particularly in the manufacture of furniture for monastic establishments. ∎

97. The form of this small chest with miniature drawers follows the Spanish furniture tradition of portable writing or jewelry chests, popularly known as *vargueños* (or *bargueños*). As a result of centuries of warfare against the Moors, the furniture tradition evolved rather late in Spain, and early pieces were necessarily portable. Consequently, chests were the earliest and most widespread furniture form there. Since mobility was often a factor in the New World as well, chests with drawers continued to be popular there.

Elaborate inlay in geometric patterns was introduced by the Moors to Spain in the Middle Ages, becoming a highly developed art form. Marquetry or inlay became popular in Italy and, later, in the rest of Europe in the Renaissance and Baroque periods. The process consists of piecing together small sections of differently colored woods, ivory, mother of pearl, tortoiseshell, bone, and other materials (natural or dyed) into a surface pattern.

Beginning in the sixteenth century, artists in Mexico took advantage of the abundance of tortoiseshell in the New World for use in inlay, particularly to cover small chests. In the sixteenth and seventeenth centuries, designs were usually geometric, in both the Italian Renaissance-Mannerist and Hispano-Moresque traditions. In the eighteenth century, designs became more curvilinear in the Rococo tradition. In Mexico the production of tortoiseshell products seems to have begun in the Campeche-Yucatan region, spreading later throughout the Gulf of Mexico and inland to Puebla de los Angeles, where marquetry furniture made from various materials reached a florescence in the eighteenth century. Mexican tortoiseshell objects were popular import items in South America and Spain.

98. An example of exquisite marquetry from the workshops of Puebla, this piece incorporates plaques of bone engraved with delicate images. The Maltese cross on the angled face of the stand contains cartouches amid floral scrolls. The cartouches depict anagrams reading Viva, IHS (Christ), MAR (Mary), and JOSE/PH. Trefoil and heart-shaped medallions engraved with winged cherubs and floral patterns dot the right-angled intersections of tortoiseshell bands. A rectangular plaque on the front of the stand is engraved with an image of the Christ child holding a cross and making the sign of blessing.

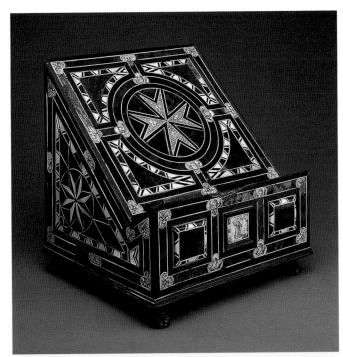

98.
Unknown artist
Puebla, Mexico,
late seventeenth/early
eighteenth century
Missal Stand
Wood, tortoiseshell,
bone, ebony, silver,
12 ½ x 12 ¼ x 10 ⅜ in.
SCAS, MOIFA, Santa Fe
L.5.65-24

The iconography of this piece suggests that it was commissioned as a missal stand for a Dominican church. The emblem of the Dominican order, a black and white eight-pointed star, is depicted on both sides of the stand in alternating panels of bone and ebony. The back of the stand exhibits a further Dominican emblem in ebony and another wood surrounded by ovals containing scroll designs delineated in thin bone and silver threads, a popular technique known in Mexico as *taracea de fideo* (spaghetti inlay).

99. Storage chests with locks were the most ubiquitous furniture form in Spain and the colonies from the sixteenth through the end of the eighteenth centuries, when wardrobes became fashionable. Chests with rounded lids, popular in the Baroque period, were replaced by ones with flat lids in the mid-eighteenth century. The geometric pattern of the inlay on this chest is reminiscent of Hispano-Moresque marquetry, but is probably based on engravings of Italian Renaissance designs copied from pattern books.

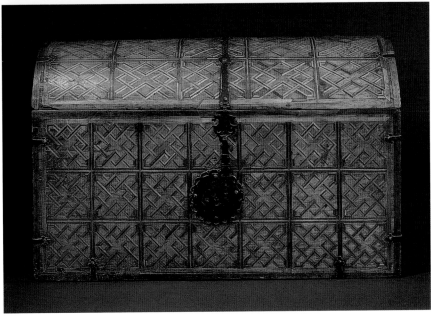

99.
Unknown artist
Mexico, late seventeenth century
Chest
Wood, iron hardware, 36 ⅛ x 22 ¼ x 16 in.
Collection of James M. Jeter

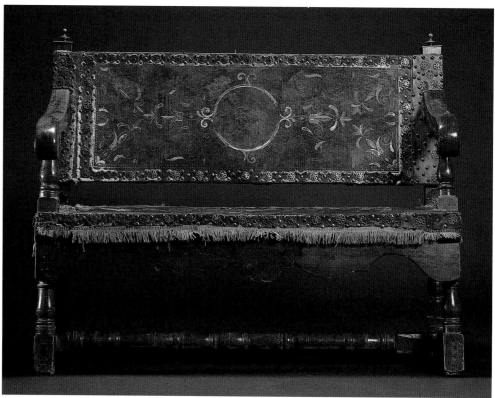

100.
Unknown artist
Oaxaca(?), late seventeenth/early eighteenth century
Bench
Wood, leather, paint, 51 ½ x 40 ½ x 19 in.
Collection of Constance McCormick Fearing

100. This bench is one of a pair possibly from the Oaxaca area of southern Mexico. The blocked and turned posts and stretcher are typical of benches and chairs of the seventeenth century in both Spain and Mexico. The curvilinear outline of the arms and valance reveal the initial stages of Rococo influence.

Leather-upholstered furniture was a Moorish tradition and had been used in Spain since the Middle Ages. The leather often was secured by elaborate iron or brass studs, as on this bench. Leather upholstery in Spain and Mexico was often tooled and painted and sometimes gilded; here it is painted with delicate Rococo motifs surrounding a circular medallion with initials.

101. Simple rectangular armchairs of mortise-and-tenon construction, popularly known as priest's chairs (*sillón de frailero*), became common in Spain in the early sixteenth century and were introduced into Mexico shortly thereafter. Such chairs usually had slightly raked back posts topped with bracket or ball finials, narrow arms resting on extended front legs, and low side stretchers, and sometimes had a high front stretcher replaced later by a valance or skirt.

The basic structure of the frailero remained the same throughout the seventeenth and eighteenth centuries, but the decorative elements changed. The straight arms and legs of the early chairs were blocked and turned in the seventeenth century, reflecting influence from the styles of Louis XIII and Louis XIV. In the eighteenth century the rigid forms were softened by curved and scalloped profiles and ornamental relief carving.

Heavy proportions and bold carving frequently distinguish Mexican armchairs, as here. The legs have been manipulated into cabrioles ending in ball-and-claw feet, a motif popular in Europe and ultimately inherited from the Chinese dragon claw with pearl. Mask grotesques and foliage are carved on the knees and front of the valance. Sculpted pelicans between the cabriole knees and arm volutes indicate that the

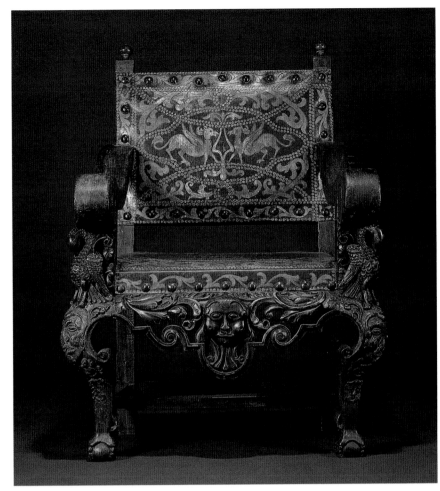

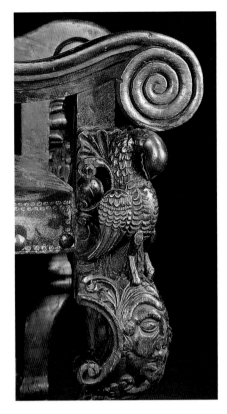

101.
Unknown artist
Mexico, mid-eighteenth century
Pair of Armchairs
Wood, leather, paint, each 42 x 29 ½ x 26 ½ in.
Collection of Constance McCormick Fearing

chairs may have been used in a church, since the pelican pecking its own breast to feed its young is a traditional symbol of the Catholic church.

The painted leather upholstery on these chairs is a modern reproduction based on remnants of the original.

102. During the eighteenth century, English furniture was imported in quantity to Spain and the colonies and exercised a major impact on furniture production there. Curvilinear chairs and settees in the Queen Anne style became particularly fashionable and were copied by New World furniture makers. Inspired by classic Chinese furniture, the Queen Anne style emphasized good design and fine workmanship over applied ornamentation. Distinctive characteristics included urn-shaped back splats, cabriole legs, and ball-and-claw feet.

The work of the English furniture maker Thomas Chippendale (1718-1779) was particularly influential in Mexico through copies of his catalogue, The Gentlemen and Cabinet Maker's Director, published in 1754. As a result Mexican furniture of the second half of the eighteenth century is popularly referred to as Mexican Chippendale in spite of the fact that many examples, such as this chair, were actually based on earlier Queen Anne prototypes.

The irrepressible exuberance of Mexican craftsmanship reasserted itself in locally produced variants. In this example the back splat has been perforated and elaborately carved, the knees of the cabriole legs have been enlarged, and even the crossed stretchers have been manipulated into broken Rococo curves. Uniquely Mexican are the tripartite scallops on the valance. Known as *guanteletes* (little gloves) or *faldoncitos* (little skirts), these motifs are hallmarks of the late Mexican Baroque style and are seen in all arts of the period including altar screens and architecture.

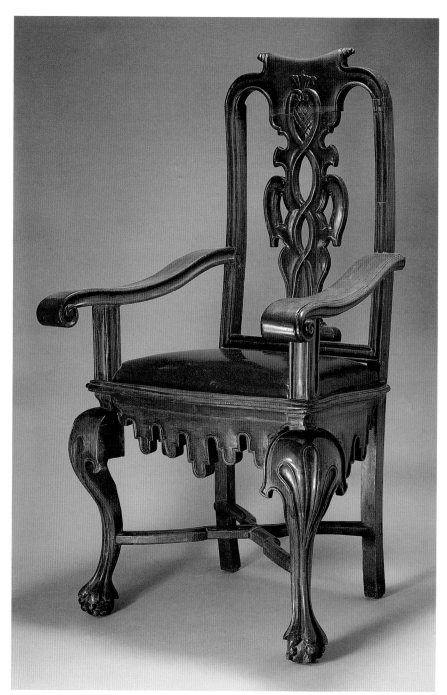

102.
Unknown artist
Mexico, second half of the eighteenth century
Armchair
Wood, leather, 48 x 28 ¾ x 22 ⅝ in.
IFAF, MOIFA, Santa Fe
FA.79.64-34

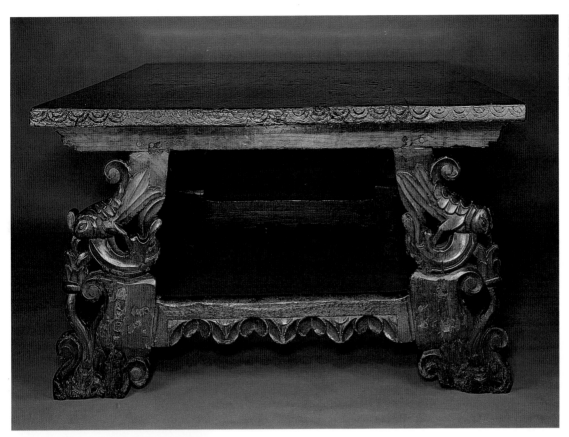

103.
Unknown artist
Michoacán, Mexico
eighteenth century
Table
Cyprus, 50½ x 82 x 31¼ in.
Holler and Saunders, Ltd.

103. During the late Gothic and early Renaissance periods in Spain, when mobility was still a factor, tables consisted of boards supported by crude trestles or chests. After the reconquest of Spain, portability became less of a concern, and two permanent table forms developed during the late sixteenth and early seventeenth centuries. In one the tabletop is supported by splayed trestles connected by iron braces, in the other by fixed legs braced by side or box stretchers, as in this example.

Probably a survival from the era when collapsibility was essential, the tabletop and legs were joined by a uniquely Spanish technique. Cleats or crosspieces were mortised to the legs and then dovetailed into the underside of the tabletop, as here. Both trestle tables and fixed-leg tables were produced in great numbers in Spain and the Americas throughout the colonial period, as they still are. In the seventeenth century the legs and stretchers of tables were often blocked and turned, while in the eighteenth century they were carved and scalloped.

Since the late sixteenth century the Michoacán area of west central Mexico has been well known for furniture production, particularly relief-carved, polychrome, or lacquered pieces. This table has large hummingbirds carved into the upper section of the legs and exhibits the bold relief typical of popular furniture from Michoacán.

104. The technique used to create the elaborate gilded altar screens of the Baroque period in Mexico was also applied to the decorative arts. To produce these objects, wood (usually cedar or walnut) was carved and then covered with a primer layer of gesso. Often the gesso was coated with a red pigment known as bole to give the gold a darker luster. The entire piece was then covered with gold leaf and burnished to bring out the rich sheen.

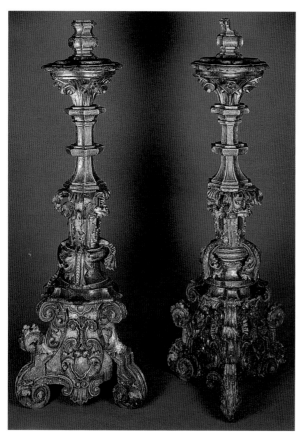

104A.
Unknown artist
Mexico, third quarter of the eighteenth century
Pair of Candlesticks
Wood, gesso, gold leaf, H.: 63 in.
Holler and Saunders, Ltd.

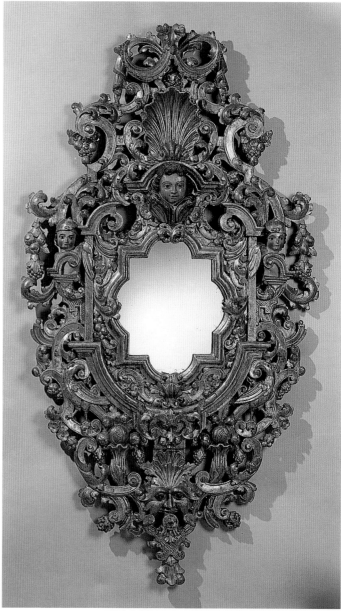

104B.
Unknown artist
Mexico City, circa 1760
Framed Mirror
Gilded, polychrome wood, 72 x 36 in.
Santa Barbara Museum of Art, Gift of Mrs. Robert Wood Bliss
1942.31

These large candlesticks were the type used in churches. The tripod bases are similar to those on silver candlesticks of the period. The lush vegetation, fluted shafts, and broken-curve scrolls are salient motifs of the late Mexican Baroque style.

The large mirror includes polychrome cherub faces, another technique borrowed from altar screen manufacture. The mixtilinear molding around the mirror, scallop shell, opposing scrolls, and, particularly, the round fruit or ball motifs are characteristic of the late Baroque or Estípite Baroque of central and northern Mexico in the second half of the eighteenth century. These elements frequently appear in the architecture and altar screens of the period.

105. Although these double doors with inset smaller doors are from a hacienda, they are similar to ones found on churches in the Bajío area of north-central Mexico in the late eighteenth century. They are studded with elaborate iron nails and carved with the recessed, mixtilinear molding characteristic of the period. The four panels are decorated with *guanteletes* or *faldoncitos* (p. 128). The *guanteletes* in the top panels are embellished with Rococo shells and asymmetrical leaf scrolls.

105.
Unknown artist
Dolores Hidalgo, Guanajuato, late eighteenth century
Pair of Doors
Wood, iron hardware, 140 x 112 in.
Holler and Saunders, Ltd.

THE INDIANS OF MEXICO had been producing hand-built, slip-painted, and fired ceramics for centuries before the arrival of Cortés. In the sixteenth century, Spaniards introduced the techniques of wheel-throwing and tin-glazing to ceramics of the New World.

The production of majolica (tin-enameled, soft-paste earthenware) had been brought to Spain by the Moors by at least the early thirteenth century. Eventually referred to as faience or delftware elsewhere in Europe, in Spain majolica popularly came to be called *talavera* ware after the ceramic center of Talavera de la Reina, near Madrid. The origins of the majolica industry in Mexico remain obscure, but certainly it was well-established in both Mexico City and Puebla by the late sixteenth century, and a pottery guild was founded in the latter city in 1653.

Initially, Mexican ceramics were based on imported European vessels, particularly Moorish-inspired luster-wares from Spain, Italian-influenced Spanish majolica from Talavera and Seville, and Renaissance-style Italian ceramics from Montelupo, Liguria, and Faenza. From the beginning, Mexican ceramists exhibited no qualms about combining elements from diverse sources on single pieces.

With the opening of trade between Spain and the Orient via the Philippines and Mexico in 1565, Chinese porcelain was imported to Mexico in large quantities. By the late seventeenth century, imitations of Chinese blue-on-white porcelain had begun to dominate Mexican majolica production, particularly in Puebla. At the same time, the popularity of Puebla-produced majolica apparently eclipsed the industry in Mexico City.

Vessels were made from a paste varying from white to brick-red in color and were decorated in underglaze blue designs over white enamel. Known as Puebla blue-on-white, this orientalizing style overwhelmed Mexican majolica production until the end of the eighteenth century. In spite of the fact that Chinese-inspired designs prevailed in this era, Mexican ceramics can never be considered as slavish copies. Rather they consistently reveal the Mexican penchant for intricate surface decoration, fanciful detail, and the use of motifs from other cultures. On Mexican majolica, borrowed motifs are often mixed together in compact designs with little hierarchy of form, and in this they are similar to the Baroque altar screens of the colonial period. All available surfaces are crammed with dot clusters, floral sprays, nonsensical geometric patterns, and abstract scrollwork, until the individual motifs become subservient to the overall effect. The end results are animated reinterpretations of inherited traditions. ■

106. From the late sixteenth to the mid-seventeenth century, a large variety of majolica was produced in Mexico. Although few whole vessels survive, archaeological excavations indicate that numerous types of multicolored wares were made and widely distributed (Lister and Lister 1982; Goggin 1968). By the mid-seventeenth century a type known to archaeologists as Puebla polychrome was being manufactured in quantity. It is characterized by Renaissance lace patterns painted in black lines combined with cobalt blue bands borrowed from Moorish-style Spanish lusterware. Extremely popular in the mid-seventeenth century, Puebla polychrome was superseded toward the end of the 1600s by blue and white ceramics in imitation of Chinese porcelains.

During the transitional period (1650-1700), black line details from Puebla polychrome were often retained and can be seen in both of these jars. Also characteristic of the transitional period was the use of both light and dark shades of blue, as seen in these jars, which may reflect influence from Chinese ceramics from the Chia-ching reign (1521-1566) of the Ming dynasty (1368-1644). Another quality of the transitional era is the continued influence of Italian Renaissance ceramics on Mexican majolica. Cherubs, suns, grotesques, allegorical figures, pastoral scenes, and heraldic motifs all appear in Mexican ceramics of the period. The large, if somewhat comical, face on the vase here was probably taken directly from an Italian or Spanish Renaissance vessel or from a book illustration. On both of these vases, the Mexican Baroque propensity for intri-

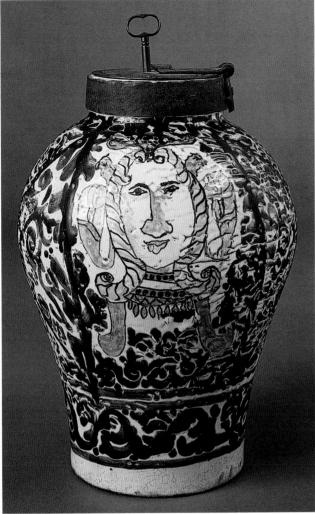

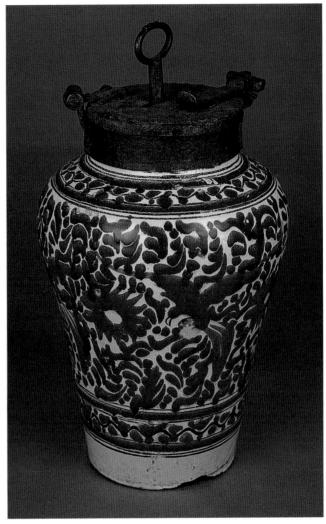

106A.
Unknown artist
Puebla, Mexico, late seventeenth century
Jar
Earthenware, tin glaze, cobalt and black in-glaze paint, iron hardware,
H.: 16 in.
Collection of Michael Haskell

106B.
Unknown artist
Puebla, Mexico, late seventeenth century
Jar
Earthenware, tin glaze, cobalt and black in-glaze paint,
iron hardware, H.: 9½ in.
Holler and Saunders, Ltd.

cate detail and crowded surface pattern-
ing is apparent.

In Mexico, storage jars of both
Chinese porcelain and Mexican majolica
were often fitted with locking iron lids.
Popularly referred to as *chocolateros*, or
chocolate jars, they were used to safe-
guard delicacies such as spices, choco-
late, vanilla, and wine.

107. During the initial peak of trade
with China (1570-1620), late Ming
dynasty export, or carrack ware was
imported to Mexico and Europe in quan-

tity (pp. 136-137). One of the distin-
guishing traits of Chinese export ware is
the use of vertical bands to divide the
field of composition on the walls of
bowls and vases. This device was also
common on Hispano-Moresque ceram-
ics. Its use on this basin may reflect
influence from both sources. The ogival
pointed terminals along the rim at the
top of the vertical dividers are reminis-
cent of lotus-petal panels or cloud-collar
(*ruyi*) motifs on Ming porcelains. The
diaper pattern used here in alternating
ogival panels is also a frequent filler on

Ming-dynasty vessels.

The flat bottom of the basin depicts
a man in exotic costume riding a horse
through a landscape. Pastoral and hunt-
ing scenes were popular on European
ceramics of the period, and garden
scenes with birds, animals, and pavilions
were prevalent in Chinese porcelain.
Although the rider is dressed in non-
European, possibly Moorish or Chinese,
attire, the horse is outfitted with the bri-
dle, breastplate, wide saddle skirt, and
rump cover used in Europe in the seven-
teenth century. Dot clusters and oversize

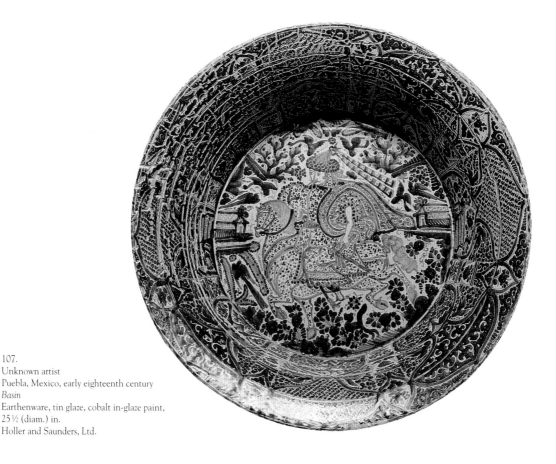

107.
Unknown artist
Puebla, Mexico, early eighteenth century
Basin
Earthenware, tin glaze, cobalt in-glaze paint,
25 ½ (diam.) in.
Holler and Saunders, Ltd.

floral sprays were used on Spanish ceramics, but the unrestrained use of them as random space fillers is an exaggeration characteristic of Mexican ceramics.

In Muslim tradition since the ninth century, the outlines of living forms frequently had been filled with random dotting. The convention eventually was adopted by Spanish, Mexican, and even Chinese ceramists. Here both horse and rider are covered with a profusion of tiny dots. Also inherited from Moorish ceramics is the form of the vessel itself. Unknown in Chinese ceramics, the large-scale, flat-bottomed, vertical-walled, wide-mouthed basin, or *lebrillo*, was introduced to Spain by the Moors in the eighth or ninth century.

The Mexican tendency to mix ele-

ments from distinct sources is exemplified in this basin. Distinctly Mexican, however, are the crowded space and deliberate surface patterning.

108. Various compositions seen on Chinese vases from the late Ming dynasty were adapted by Mexican craftsmen. These frequently included garden scenes with rabbits, deer, insects, standing cranes, flying phoenixes, human figures, and pavilions (pp. 136-137). In Mexico these motifs were often stylized into a form of shorthand and mixed with local or European elements. In Mexican versions like this vase, the space is crowded with detail and the scale is often unrealistic.

A series of late Ming vases with the same composition as this vase is docu-

mented as having been exported to the West (*Mexico: Splendors of Thirty Centuries* 1990, pp. 472-73). On all of them the field is divided into three horizontal bands, one wide central band flanked by two narrow ones. The central band is then separated into four cartouches by vertical stripes with cloud-collar, or *ruyi*, lappets at top and bottom. The shoulder band is filled with a diaper pattern interspersed with alternating vertical stripes and medallions with flowers or fruit. Many Mexican vases, including this one, follow the compositional layout of these Ming vases.

On the present vase the garden crane, a Taoist symbol of longevity, deviates from the Chinese models in several ways. On Ming vases cranes are represented flying with outstretched wings

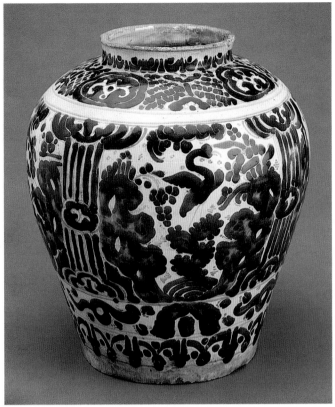

108.
Unknown artist
Puebla, Mexico, circa 1700
Vase
Earthenware, tin glaze, cobalt in-glaze paint, H.: 11 ½ in.
MOIFA, Santa Fe
A.69.45-23

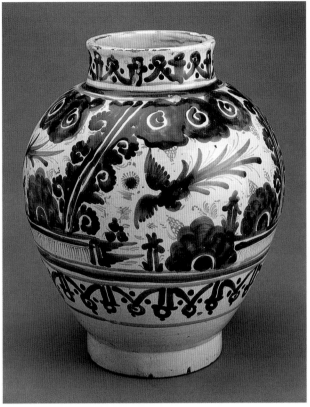

109.
Unknown artist
Puebla, Mexico, eighteenth century
Vase
Earthenware, tin glaze, cobalt in-glaze paint, H.: 13 ⅛ in.
MOIFA, Santa Fe
A.69.45-17

or perched with folded wings; here the crane is perching but holds his wings spread. Cranes on Chinese porcelain are sometimes perched on the branch of a pine tree; here the pine branch has been converted into a Mexican nopal cactus. An eagle with outstretched wings, holding a snake in its mouth and perched on a nopal cactus, has been a symbol of Mexico since Aztec times. The lower frieze seems to derive from a base pattern of dragons among rocks and waves used on Chinese vessels since the fourteenth century. The dragon's legs are missing on the Mexican version, making it appear to be a snake, also reminiscent of the Mexican emblem.

The Mexican maker of this piece took a standard Ming export-ware composition and altered it playfully. The

result is not only Mexican in style but in content as well.

109. Phoenixes flying over landscapes were standard motifs on Ming-dynasty porcelains. Mexican ceramists borrowed the composition, which became extremely popular in the eighteenth century. Characteristically, however, this Mexican artist took liberties with the Chinese formula, converting the elegant phoenix into the short-billed, long-tailed quetzal bird so prized in Mexico.

The vertical divider bands ubiquitous on Chinese export, or carrack, ware have been twisted into the diagonal swirls frequently seen in Mexican versions of Baroque and Rococo decoration. Classic Chinese elements such as the fungus motifs on the diagonal bands, the

cloud collars on the shoulders, and the "rock of ages" patterns beneath the bird have been stylized by the Mexican craftsman into decorative scrolls and volutes. The decorative bands around the rim and base may be related to lotus-petal panels or stiff plantain leaves in the same location on Chinese vessels, but have been distorted beyond recognition on the Mexican vase.

110. Related to both Spanish olive jars and Chinese *kuan*, or storage jars, pear-shaped vessels with narrow mouths and serpentine handles became popular in the mid-seventeenth century. This example combines classic Ming motifs with European Rococo designs. Chinese cloud-collar lappets with peach blossoms decorate the neck of the vessel, and pan-

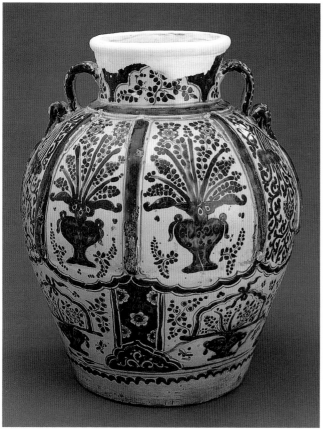

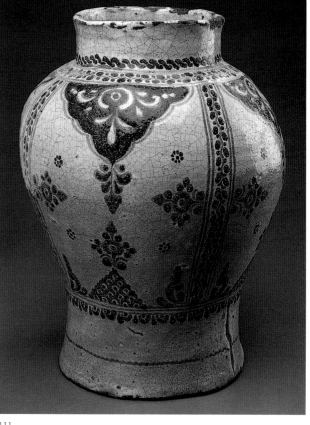

110.
Unknown artist
Puebla, Mexico, eighteenth century
Vase
Earthenware, tin glaze, cobalt in-glaze paint,
H.: 14 ⅛ in.
MOIFA, Santa Fe
A.69.45-1

111.
Unknown artist
Puebla, Mexico, eighteenth century
Vase
Earthenware, tin glaze, cobalt in-glaze paint,
H.: 17 ¾ in.
MOIFA, Santa Fe
A.69.45-22

els on either side of the handles contain Oriental floral sprays and cloud scrolls. Parallel panels on the shoulders and alternate ones in the lower frieze sport Renaissance-style urns filled with floral bouquets, stock Rococo decorative elements. Alternating with the flower urns in the lower frieze are cloud lappets supporting vertical bands with flowers in negative coloring, a motif derived from Chinese designs. On this vase a Mexican artisan took the theme of floral patterns and willfully paired examples from diverse cultures on a single work of art.

111. Influenced by Oriental embroideries, eighteenth-century brocade patterns frequently consist of delicate floral motifs evenly spaced over an empty field.

Rococo textile patterns in turn had an impact on majolica production, as well as on other decorative arts, in Mexico in the 1700s. This large vase demonstrates the use of textile designs and, at the same time, retains motifs from Chinese porcelain, such as the cloud-collar lappet with negative white designs on solid blue. Bands around the neck and on the vertical walls contain a vine motif that is probably a Mexican adaptation of the classic Chinese scroll used around the necks and rims of Ming-dynasty ceramics. This vessel is more restrained than most Mexican examples.

112. Some Mexican vessel forms were inspired by Chinese shapes; this elegant wine bottle is such a form. The Oriental

impetus carried over into the decorative concept as well, inspiring the maker to refrain from the exuberant, if heavy-handed, surface decoration typical of most Mexican ceramics.

On the decorative band around the neck, the thick application of blue pigment, creating a raised effect, is uniquely Mexican. Cobalt oxide, used to create the blue color on ceramics, had been known in the Middle East since the Neolithic period, but was not applied to ceramics until the ninth century. On Middle Eastern ceramics the blue coloring often bled during firing. After its introduction to China, the formula for its application to ceramics was improved during the Yuan dynasty (1279-1368).

112.
Unknown artist
Puebla, Mexico, mid-eighteenth century
Bottle
Earthenware, tin glaze, cobalt in-glaze paint, H.: 11 in.
MOIFA, Santa Fe
A.69.45-47

113A.
Unknown artist
China, late sixteenth-early seventeenth century
Bowl
Porcelain, underglaze blue paint, 11 ⅝ x 2 ⅛ in.
MOIFA, Santa Fe
878 FE

113B.
Unknown artist
Puebla, Mexico, late eighteenth century
Bowl
Earthenware, tin glaze, cobalt in-glaze paint,
11 ⅛ x 2 ¾ in.
MOIFA, Santa Fe
A.69.45-55

To create an intense blue, the cobalt oxide on Mexican ceramics was often saturated into a thick, dark pigment. On European ceramics the surface of a vessel was glazed and fired, the decoration was painted on, and the vessel was reglazed and fired again. In Mexico the surface was glazed, but left unfired before the application of cobalt designs. The vessel was then reglazed and fired only once. During this single firing the thick cobalt pigment fused into the glaze layers, producing raised and sunken areas. The resulting rippled surface is a technical characteristic distinctive to Mexico.

113. Chinese porcelain manufactured for export to the West was popularly known there as *kraakporselein*, or carrack

ware, after the Portuguese carrack ships loaded with it that were captured by Dutch pirates in 1602 and 1604. On this carrack-ware bowl, vertical dividers flank lotus-petal panels containing alternating flowers and auspicious Taoist symbols. Petal borders of the sacred lotus, found throughout Buddhist art, are seen on Chinese porcelains from the Yuan dynasty until the present. In this example each panel depicts the outline of a single lotus petal with the tip turned down. The bottom of the bowl reveals a

Chinese garden scene with a peony flower, cricket, and honey bee. A cloud scroll can be seen in the sky at the upper left of the composition. The impact of late Ming-dynasty carrack ware was still being felt in Mexican ceramic production in the late eighteenth century. This occurred through either the direct influence of Ming vessels or the importation of contemporary Ch'ing-dynasty (1644-1921) porcelain, featuring revivals of classic Ming motifs.

The walls of the Mexican bowl illus-

114.
Unknown artist
Puebla, Mexico, late eighteenth/
early nineteenth century
Plate
Earthenware, tin glaze, in-glaze paint, 13½ (diam.) in.
MOIFA, Santa Fe
A.69.45-62

trated here retain the vertical bands separating debased lotus-petal panels framing flowers. The central medallion on the bottom of the bowl is framed by a polygonal border, as on the carrack-ware bowl, but the angular pattern on the Chinese example has been softened by a curving floral scroll typical of the European Rococo. The scalloped or lobed shape of the bowl itself, as well as the undulating border around the edge, are also standard Rococo motifs.

114. On the heels of the extended popularity of blue-on-white ceramics in both East and West, a revival of polychrome vessels occurred all over the world in the eighteenth century. Beginning in Europe and typified by the famille rose and famille verte porcelains from the Orient, vessels with grounds of rose, green,

cream, yellow, and light blue were decorated with multicolored figures. Beginning in the late eighteenth century in Mexico, the change in palette was exemplified by the extreme popularity of ceramics with a pastel blue base color. Popularly referred to as *azul punche* after the similarity in color to a candy made in Puebla, these vessels are usually decorated with figures and flowers in orange, yellow, green, black, white, and cobalt. Called Tumacacori Polychrome by archaeologists, the appeal of this style is attested to by its abundance and wide distribution at sites from the late eighteenth and early nineteenth centuries (Goggin 1968).

The shallow plate form with scalloped edge was inherited from the European Rococo. The large floral spray and evenly spaced bouquets around the

rim are related to eighteenth-century brocade patterns. The scattered cobalt dot clusters are a survival from Puebla transitional and blue-on-white majolica.

115. Another result of the eighteenth-century shift in palette away from strictly blue-on-white ceramics was the use of a cream ground. In Mexico cream base enamels are usually decorated in either mauve or orange with green, black, yellow, and sometimes cobalt. Vessels glazed with these colors often reflect Neoclassical influence.

On this plate the subdued designs around the rim show just such an influence in the delicate chevron pattern, graceful swags, and solid cream cavetto wall. In the flat of the plate, however, typical Mexican exuberance and whimsy have reemerged. The floral garland

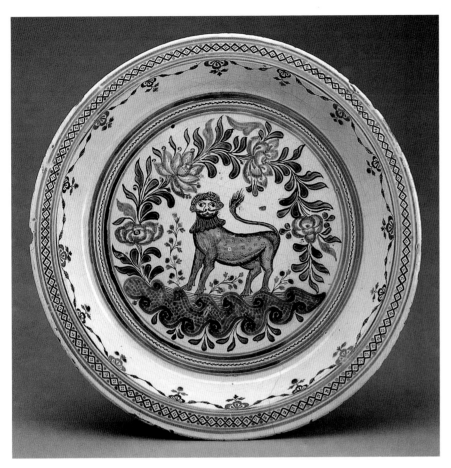

115.
Unknown artist
Puebla, Mexico, early nineteenth century
Plate
Earthenware, tin glaze, in-glaze paint, 15 ⅝ x 2 ½ in.
MOIFA, Santa Fe
2553 MA

across the top, resembling those on Rococo-style Tumacacori ware, has been expanded out of proportion to tower above the alert lion. The green ground foliage or water beneath him preserves the asymmetrical rocaille profile used in Rococo decorative arts. In true Mexican fashion, all blank space in the central composition, even that between the lion's legs and the green volutes, has been filled with floral sprays.

A MAJOR CONSEQUENCE of the conquest of the Americas was the exchange of ideas and materials between continents. Cotton and *ixtli* (maguey or agave fiber) were native to the New World and unknown in Europe; linen, silk, and wool were used for textiles in Europe and unknown in the Americas. Various new dyes were also exchanged after the conquest, the most notable being cochineal—dye from a small insect grown on the Mexican nopal cactus that produces a rich red color. Cochineal was exported to Europe in great quantities during the colonial period.

Textiles produced in New Spain during the colonial era were a blend of Old and New World traditions. After the Spanish introduced sheep to the New World, wool was used alone or combined with silk or native cotton. The Spaniards also brought large frame looms that came to be used instead of, or alongside, indigenous back-strap looms. Dyes from both continents enlarged the number of colors available to weavers.

In the sixteenth century the cultivation of silk was initiated in New Spain by Bishop Juan de Zumárraga. By the mid-1500s it had become a flourishing industry, especially in Oaxaca. Workshops in which Indian laborers produced fine silk fabrics and clothing were observed in Mexico City in 1568 by the English sailor Miles Phillips (Hakluyt 1884-90, vol. 14; Motolinía 1951, pp. 276-77, 325-27). By the end of the sixteenth century, however, large quantities of cheap silk were being imported from the Orient following the opening of the Manila galleon trade and royal decrees suppressed the Mexican silk industry to protect that of the mother country. This resulted in the drastic decline, if not the total demise, of silk production in New Spain. Weaving of fabrics with imported silk thread, however, continued in Mexico.

The Tlaxcalan Indians of east-central Mexico were one of the first groups to ally themselves with the Spaniards against the Aztecs during the conquest. Afterwards Tlaxcalans, along with Otomí Indians, were instrumental in the pacification and settlement of the northern frontier of New Spain. Proficient weavers, they were well known for their production of *sarapes* (serapes or ponchos) and *rebozos* (shawls) and introduced both sheep-raising and weaving to the northern frontier area. Weaving became a major industry in San Miguel el Grande (now San Miguel de Allende), San Luis Potosí, Querétaro, and, particularly, Saltillo. Later in the colonial period, weaving centers also developed in New Mexico, Texas, and Arizona.

In southern Mexico and Guatemala, various types of weaving were produced, with ikat-dyed textiles being the most distinctive. Ikat patterning results from a complicated resist-dying process in which the warps, wefts, or both are tied and dyed according to a predetermined pattern before weaving. The tied binding resists the dye, producing a pattern in the yarn that eventually reveals itself in the finished textile. Ikat, apparently practiced in Central and South America before the conquest, continued afterwards. The simpler form, in which only the warp is dyed, was also used in central Mexico by the Tlaxcalans. ■

116. Both Mexicans and Spaniards used a form of serape, or manta, for protection from the cold. In pre-Columbian Mexico, serapes, or tilmas, were woven of *ixtli* or native cotton; after the conquest they were made of wool, cotton, or a combination of the two. The materials in this serape represent a union of Old and New World products—the weft is wool and the warp is cotton—creating a warm but pliable textile. Red colors were obtained from New World dyes—cochineal and huisache—and blue from the strain of indigo plant introduced from Europe.

Serapes consistently have three areas of decoration—the central lozenge or circle, the vertical border bands, and the background field. In this example the ground is filled with a colorful mosaic of tiny diamonds and zigzags in vertical rows. Although it is impossible to trace the sources for these design motifs, archeological finds in northern Mexico indicate that many of them, particularly the concentric and serrated diamonds, were present in pre-Columbian textiles (Juelke 1978, p. 12). Repetitive geometric patterning, often including zigzags and diamonds, was also a trait of Hispano-Moresque art in Spain and North Africa. The Mexican serape represents an interface between these two traditions.

117. Most serapes, particularly from the late eighteenth and early nineteenth centuries, were woven in two strips on a narrow loom and then stitched together. This later example was woven

116.
Unknown artist
Saltillo, late eighteenth/early nineteenth century
Serape
Wool weft, cotton warp, natural dyes, 7 ¾ x 48 in.
Santa Barbara Museum of Natural History
NA-MA-ME-4G-10

117.
Unknown artist
Saltillo, mid-nineteenth century
Serape
Wool weft, cotton warp, silk, metallic thread, natural dyes
91 ⅜ x 48 ½ in.
IFAF, MOIFA, Santa Fe
FA.79.64-90

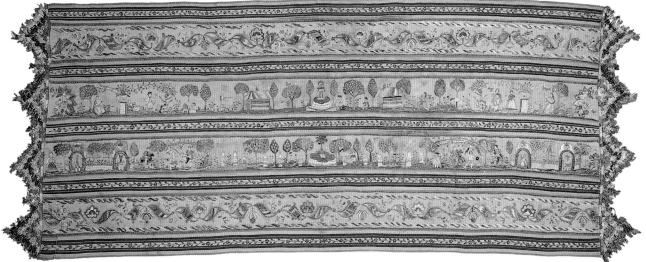

118.
Unknown artist
Mexico, circa 1790
Shawl
Silk, cotton, metallic thread, 34 x 88 in.
San Antonio Museum of Art, San Antonio
Museum Association
87-11P

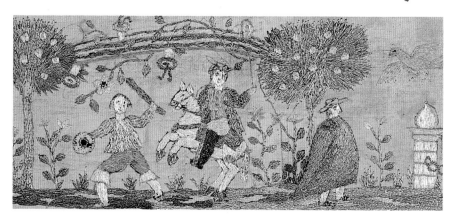

in one piece on a wide loom. It incorporates silk and metallic threads into the design. The complicated lozenge, known as an aggregate diamond, became fashionable in the nineteenth century.

The name "Epifanio Jiménez" is woven into the lower border of this serape. Whether it represents the name of the artist or, more likely, of the owner, it reveals the high regard placed on Saltillo serapes. In the early 1850s, an American travelling in Mexico and New Mexico (recently annexed from Mexico by the United States) commented on the value of serapes. "The personal costume (of a Mexican gentleman) is complete with a beautiful serape thrown over the shoulder or laid across the saddle-bow. They are made wholly of wool, woven in gay colors, and some of them cost a hundred dollars. They are always carried when

mounted, and afford the wearer good protection from the weather" (Davis 1938, p. 63).

118. Pre-Hispanic and early colonial manuscript paintings show Indian women wearing long strips of cloth, often edged with decorative bands, wrapped around their shoulders (Anawalt 1981; Robertson 1959). The shawl, or *rebozo*, remained one of the most important garments in a woman's wardrobe and was adopted by women of the Spanish aristocracy in Mexico as well. In 1625 Thomas Gage noted the manner in which Mexican women always wrapped the shawl around themselves, throwing the short end over their left shoulders (Gage 1958, p. 69).

Mexican shawls were also exported to Spain and can be recognized in portrait paintings (Kubler and Soria 1959, fig.

147). Through the Manila galleon trade, cotton shawls were imported to New Spain from India, particularly from the west coast ports of Gujarat, and may have influenced shawl production in Mexico. The chevron-patterned fringe may be related to similar decoration on pre-Hispanic clothing which was sometimes executed with feathers woven into the fabric.

A series of embroidered silk shawls like this one is divided into horizontal bands with figurative or floral scenes separated by striped or geometric borders (Armella de Aspe and Castelló de Yturbide 1990). The figurative scenes often represent people engaged in activities in identifiable locations around Mexico City. The top central band of this shawl apparently depicts the popular Alameda park in downtown Mexico

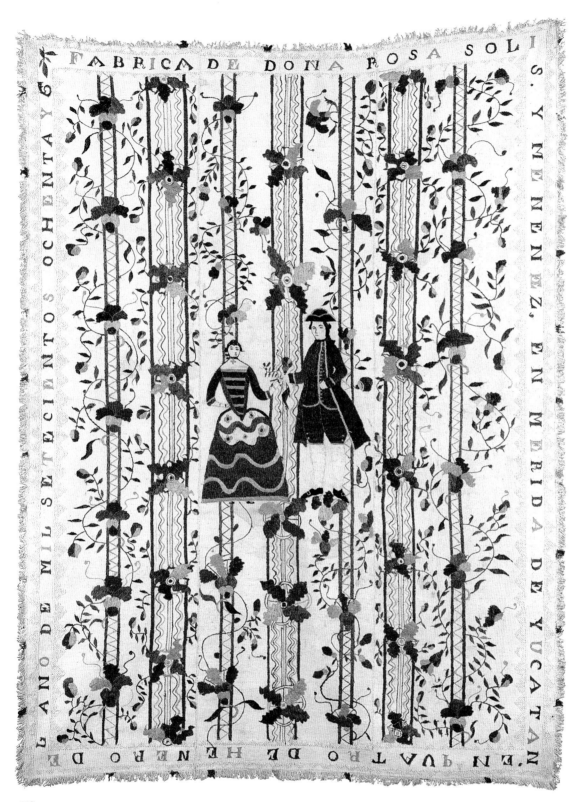

119.
Doña Rosa Solís y Menéndez
Mérida, Yucatán, eighteenth century
Bedspread, 1786
Cotton, silk thread, 99 x 72 ½ in.
The Metropolitan Museum of Art, Everfast Fund, 1971
1971.20

City, which was relandscaped in the late 1700s and outfitted with elegant fountains and benches. The lower band represents the Zócalo, the city's main plaza, recognizable by the central fountain topped by a sculpture of the Mexican eagle. The fountain was removed when the Zócalo was renovated in 1797.

In the 1820s Fanny Calderón de la Barca, the Scottish wife of the Spanish ambassador to Mexico, advocated the use of both the shawl and the serape: "It is certainly always the wisest plan to adopt the customs of the country.... A dress...as short as it is usually worn, a reboso tied over one shoulder, and a large straw hat, is about the most convenient costume.... As for the serape, it is both convenient and graceful, especially on horseback" (Calderón de la Barca 1843, p. 163, 187).

119. With the exception of Peru, the technique of true embroidery, using a needle, seems to have been little used in the New World before the conquest. The first documentation of a Spanish master embroiderer in the New World is the arrival in Mexico in 1534 of Sancho García de Larraval, the nephew of Bishop Juan de Zumárraga. Hired to teach embroidery to the Indians, García remained in Mexico until 1539. Mexicans were also instructed in the art of embroidery at San José de los Naturales, the Franciscan college for Indians run by Fray Pedro de Gante. Ordinances for an embroider's guild, admitting Indians, were promulgated in 1546. Spanish and Indian embroiderers produced elaborate priest's vestments, altar cloths, and other church textiles, as well as fabrics and clothing for secular use.

Outside the guilds rich embroideries were produced by both men and women in the monastic establishments of New Spain. As in Europe, the art of embroidery was also considered an essential part of a young woman's education. In the late eighteenth century a Peruvian traveler in Mexico City described a young woman in an aristocratic home overlooking Alameda park: "Their daughter was engaged on a piece of embroidery for the altar of the chapel. The ground was the very richest and thickest white satin; the design was a garland of vine leaves, with bunches of grapes. The vine leaves were beautifully embroidered in fine gold, and the grapes were composed of amethysts" (Weismann 1976, p. 35).

The bedspread illustrated here was made around the same time by another young woman in the city of Mérida on the Yucatán peninsula of Mexico. Probably for her trousseau, it may depict her and her bridegroom on their wedding day. An inscription around the border reads: *Fábrica de Doña Rosa Solís y Menéndez en Mérida de Yucatán en quatro de henero del año de mil setecientos ochenta y 6* ("Made by Doña Rosa Solís y Menéndez in Mérida of Yucatán on the fourth of January of the year 1786"). The style of the embroidery, with curvilinear floral motifs in parallel patterns, appears on fabrics and embroideries in Spain and elsewhere in New Spain. Influenced by imported Chinese and Philippine embroideries as well as the ubiquitous painted chintz fabrics from the Coromandel coast of India, textile patterns all over the Western world followed this formula in the late eighteenth century.

BIBLIOGRAPHY

Alcedo y Herrera, A. de. *Diccionario geográfico-histórico de las Indias occidentales o América.* 5 vols. Madrid, 1776.

Alonso de Rodríguez, J. *El arte de la platería en la capitanía general de Guatemala.* Guatemala City, 1980.

Anawalt, P. R. *Indian Clothing before Cortés: Mesoamerican Costume from the Codices.* Norman, Okla., 1981.

Anders, F. "Las artes menores/minor arts." *Artes de México* 17, no. 137. Mexico City, 1970.

Anderson, L. *El arte de la platería en México.* Mexico City, 1956.

Angulo Iñíguez, D. *Historia del arte hispanoamericano.* 3 vols. Barcelona, 1945.

Armella de Aspe, V., and M. Meade de Angulo. *Tesoros de la Pinacoteca Virreinal.* Mexico City, 1989.

Armella de Aspe, V., and T. Castelló Yturbide. *Rebozos y Sarapes de México.* Mexico, 1989.

Bach, C. "Treasured Chests of History." *Américas* 42, no. 5 (1990), pp. 36-41.

Baird, J. A. "Eighteenth-Century Retables of the Bajío, Mexico: The Querétaro Style." *Art Bulletin* 35, no. 3 (1953), pp. 95-216.

—. "The Ornamental Niche-Pilaster in the Hispanic World." *Journal of the Society of Architectural Historians* 15, no. 1 (1956), pp. 5-11.

Bantel, L., and M. B. Burke. *Spain and New Spain: Mexican Colonial Arts in Their European Context.* Exh. cat. Art Museum of South Texas, Corpus Christi, 1979.

Barrenechea, R. P., ed. *Los cronistas del Perú.* Lima, 1962.

Bergoend, Bernardo, S. J., *La Nacionalidad Mexicana y La Virgen de Guadalupe, 1968.*

Bernales Ballesteros, J. "Iconografía de Santa Rosa de Lima." In *Homenaje al prof. dr. Hernández Díaz.* Seville, 1982, pp. 31-41.

Bomchil, S., and V. Carreño. *El mueble colonial de las Américas y su circunstancia histórica.* Buenos Aires, 1987.

Boyd, E. *Popular Arts of Spanish New Mexico.* Santa Fe, 1974.

Burke, M. *Spain and New Spain.* Exh. cat. Art Museum of the Southwest, Corpus Christi, 1979.

Burkholder, M. A., and L. J. Lyman. *Colonial Latin America.* New York, 1990.

Burr, G. H. *Hispanic Furniture from the Fifteenth through the Eighteenth Century.* New York, 1964.

Bushnell, G. H. S. *The Arts of the Ancient Americas.* London, 1965.

Calderón de la Barca, F. *Life in Mexico.* Boston, 1843.

Cali, F. *The Spanish Arts of Latin America.* New York, 1960.

Canons and Decrees of the Council of Trent. Original text with English trans. by Rev. H. J. Schroeder. Saint Louis and London, 1941.

Cervantes, E. A. *Loza blanca y azulejo de Puebla.* 2 vols. Mexico City, 1939.

Coletti, J. D., S.J. *Il gazetierre americano.* 3 vols. Livorno, 1763.

Colonial Art of Peru: A Selection of Works from the Collection of Marshall B. Coyne. Exh. cat. Museum of Modern Art of Latin America, Washington, D.C., 1980.

Cortés, H. *Letters from Mexico.* Trans. and ed. A. R. Pagden, introduction by J. H. Elliott. New Haven and London, 1986.

Cruz Cevallos, I., ed. *Flora huayaquilensis: La expedición botánica de Juan Tafalla a la real audiencia de Quito 1799-1808.* Quito, 1991.

Davis, W. W. H. *El Gringo, or New Mexico and Its People.* 2d. ed. Santa Fe, 1938.

D'Harcourt, R. *Textiles of Ancient Peru and Their Techniques.* Seattle, 1962.

Dorta, M. "Andean Baroque Decoration." *Journal of the Society of Architectural Historians* 5 (1946-47), pp.

El Retrato Civil en la Nueva España. Mexico, 1991.

Elliott, J. H. *Imperial Spain: 1469-1716.* New York, 1963.

Esteras Martín, C. "Noticias acerca de la plàtería puneña: Los frontales de la catedral de Puno y la iglesia de Carabuco." *Archivo español de arte* (Madrid), no. 218 (1982).

—. "Aportaciones a la historia de la platería cuzqueña en la segunda mitad del siglo XVII." *Anuario de estudios americanos* (Seville) 37 (1983).

—. *Platería hispanoamericana, siglos XVI-XIX.* Badajoz, 1984.

—. *Orfebrería hispanoamericana, siglos XVI-XIX.* Madrid, 1986.

—. "Platería virreinal novohispana: Siglos XVI-XIX." In *El arte de la platería mexicana: 500 anos*. Ed. L. García-Noriega y Nieto. Exh. cat. Centro Cultural de Arte Contemporaneo, Mexico City, 1989.

—. "Orfebrería americana en Andalucía." In *Los Andaluces y América*. Madrid, 1991.

Gage, T. *Thomas Gage's Travels in the New World*. Ed. and introduction by J. Eric S. Thompson. Norman, Okla., 1958. Third printing, 1985.

García Saíz, M. C. "Pinturas 'costumbristas' del mexicano Miguel Cabrera." *Goya*, no. 142 (1978), pp. 186-93.

—. *El mestizaje americano*. Exh. cat. Museo de America, Madrid, 1985.

—. *Las castas mexicanas: Un género pictórico americano/The Castes: A Genre of Mexican Painting*. Mexico City, 1989.

Gasparini, G. "Análisis critico de las definiciones de 'arquitectura popular' y 'arquitectura mestiza.'" *Boletín* (Caracas) 3 (1965), pp. 51-66.

Gisbert, T. "El lago, Copacabana y las islas." *Encuentro: Revista boliviana de cultura* 2, no. 3 (March 1989), pp. 59-64.

—. *Los descendientes de los Incas*. La Paz, n.d.

Gloria in Excelsis: The Virgin and Angels in Viceregal Paintings of Peru and Bolivia. Exh. cat. Center for Inter-American Relations, New York, 1986.

Goggin, J. M. *Spanish Majolica in the New World: Types of the Sixteenth to Eighteenth Centuries*. Yale University Publications in Anthropology, 72. New Haven, 1968.

Grijalva, Fray J. de. *Crónica de la orden de N.P.S. Augustin en las provincias de la Nueva España*. 1624. Mexico City, 1924.

Gutierrez, R. *Arquitectura virreynal en Cuzco y su región*. Cuzco, 1987.

Hakluyt, R. *Principal Navigations, Voyages, Traffiques, and Discoveries of the English Nation (1589)*. Ed. E. Goldsmid. 16 vols. Edinburgh, 1884-90. Vol. 4.

Hanke, L. *The Imperial City of Potosí: An Unwritten Chapter in the History of Spanish America*. The Hague, 1956.

Haring, C. H. *The Spanish Empire in America*. New York, 1963.

Historia del arte mexicano. 2d ed. Vols. 5-9. Mexico City, 1982-86.

Juan, J., and A. de Ulloa. *A Voyage to South America*. Baltimore, 1963.

Juelke, P. M. "The Saltillo Serape: History." In *The Saltillo Serape*. Exh. cat. Santa Barbara Museum of Art, Santa Barbara, 1978.

Kamen, H. *A Concise History of Spain*. New York, 1973.

Kelemen, P. *Baroque and Rococo in Latin America*. New York, 1967.

—. *Peruvian Colonial Painting*. New York, 1971.

—. *Vanishing Art of the Americas*. New York, 1977.

Kitson, M. *The Age of Baroque*. New York, 1966.

Kubler, G. *The Religious Architecture of New Mexico*. Colorado Springs, 1940.

—. *Mexican Architecture of the Sixteenth Century*. 2 vols. New Haven, 1948.

—. "On the Colonial Extinction of the Motifs of Pre-Columbian Art." In *Essays in Pre-Columbian Art and Archaeology*. Cambridge, Mass., 1961, pp. 14-34.

—. *The Shape of Time*. New Haven, 1962.

—, and M. Soria. *Art and Architecture in Spain and Portugal and Their American Dominions, 1500-1800*. Baltimore, 1959.

Lafaye, J. *Quetzalcoatl and Guadalupe: The Formation of Mexican Consciousness, 1531-1813*. Trans. B. Keen. Chicago and London, 1976.

Lavalle, J. A. de, and J. A. González García, eds. *Arte textil del Perú*. Lima, 1988.

Lavalle, J. A. de, and W. Lang, eds. *Arte y tesoros del Perú*. Lima, 1973.

Lister, F. C., and R. H. Lister. *Sixteenth-Century Majolica Pottery in the Valley of Mexico*. Anthropology Papers of the University of Arizona, 39. Tucson, 1982.

—. *Andalusian Ceramics in Spain and New Spain: A Cultural Register from the Third Century B.C. to 1700*. Tucson, 1987.

Livermore, H. V., trans. and ed. *Royal Commentaries of the Incas*. Austin, 1966.

Los Cristos de Lima. Lima, 1991.

Markman, S. *Colonial Architecture of Antigua, Guatemala*. Memoirs of the American Philosophical Society, 64. Philadelphia, 1966.

de la Maza, Francisco. *El Pintor Cristóbal de Villalpando*. Mexico, 1964.

McAndrew, J. *The Open-Air Churches of Sixteenth-Century Mexico: Atrios, Posas, Open Chapels and Other Studies*. Cambridge, Mass., 1965.

de Mesa, J. "Diego de la Puente, pintor flamenco en Bolivia, Perú y Chile." In *Arte y arqueología*, nos. 5-6, pp. 223-250. La Paz, 1978.

—, and T. Gisbert. "Renacimiento y manierismo en la arquitectura 'mestiza.'" *Boletín* (Caracas) 3 (1965), pp. 9-44.

—. "Determinantes del llamado estilo mestizo: Breves consideraciones sobre el término." *Boletín* (Caracas) 10 (1968).

—. *Holguín y la pintura virreinal en Bolivia*. La Paz, 1977.

—. *Historia de la pintura cuzqueña*. Lima, 1982.

Mexico: Splendors of Thirty Centuries. Exh. cat. Metropolitan Museum of Art, New York, 1990.

Motolinía (Fray T. de Benavente). Motolinía's History of the Indians of New Spain. Trans. and annotated F. B. Steck. Washington, D.C., 1951.

—. Memoriales, o libros de las cosas de la Nueva España y de los naturales de ella. Ed. E. O'Gorman. Mexico, 1971.

Owens, R. J. Peru. London, 1963.

Palmer, G. G. Sculpture in the Kingdom of Quito. Albuquerque, 1987.

Parry, J. H. The Discovery of South America. New York, 1979.

Paz, O. Sor Juana, or the Traps of Faith. Trans. M. Sayers Peden. Cambridge, Mass., 1988.

Phelan, J. L. The Kingdom of Quito in the Seventeenth Century. Madison, Wi., 1967.

Picon-Salas, M. A Cultural History of Spanish America. Trans. I. A. Leonard. Los Angeles, 1962.

Pierce, Donna. "The History of Hide Painting in New Mexico." In The Segesser Hide Paintings: An Anthology. Santa Fe, in press.

Pintura en el virreinato del Perú. Lima, 1989.

Prescott, W. H. History of the Conquest of Peru. New York, 1847.

Quirarte, J. "The Study of Latin American Art: How Did We Get This Way?" Research Center for the Arts Review 2 (October 1979), pp. 1-3.

—. "Mexican and Mexican American Artists: 1920-1970." In The Latin American Spirit. Exh. cat. Bronx Museum of the Arts, New York, 1988.

Reyes-Valerio, C. Arte indocristiano: Escultura del siglo XVI en México. Mexico City, 1978.

Ribera, A. L., and H. H. Schenone. Platera Sudamerica de los siglos XVII-XX. Munich, 1981.

Ricard, R. The Spiritual Conquest of Mexico: An Essay on the Apostolate and the Evangelizing Methods of the Mendicant Orders in New Spain, 1523-1572. Trans. L. B. Simpson. Berkeley, Los Angeles, and London, 1966.

Romero de Terreros y Vinent, M. Los artes industriales en la Nueva España. Ed. and annotated by M. T. Cervantes de Conde and C. Romero de Terreros de Prevoisin. Rev. ed. Mexico City, 1982.

Robertson, D. Mexican Manuscript Painting of the Early Colonial Period: The Metropolitan Schools. New Haven, 1966.

Roig, J. F., Pbro. Iconografía de los santos. Barcelona, 1950.

Ruíz Gomar, R. "Capilla de los reyes." In Catedral de México: Patrimonio artistico y cultural. Mexico City, 1986, pp. 16-43.

Rumazo, J., ed. Documentos para la historia de la audiencia de Quito. 8 vols. Madrid, 1948. Vol. 1, Pedro Maldonado.

Santiago Cruz, F. Las artes y los gremios en la Nueva España. Mexico City, 1960.

Smith, Miguel C. Leatham. "The Santuario de Guadalupe in Santa Fe and the Observations of Fr. Estéban Anticoli, S. J." In New Mexico Studies in the Fine Arts 10, pp. 12-16.

Stastny, F. Pérez de Alesio y la pintura del siglo XVI. Buenos Aires, 1970.

Taullard, A. Platería sudamericana. Buenos Aires, 1941.

—. Tejidos y ponchos indígenas de Sudamerica. Buenos Aires, 1949.

Toussaint, M. Colonial Art in Mexico. Trans. and ed. E. W. Weismann. Austin and London, 1967.

—. Pintura colonial en México. 2d ed. Ed. X. Moyssén. Mexico City, 1982.

Tovar de Teresa, G. México barroco. Mexico City, 1981.

—. Renacimiento en México: Artistas y retablos. Mexico City, 1982. Rev. ed. of Pintura y escultura del renacimiento en México. Mexico City, 1979.

Ugarte, Padre Ruben Vargas, S. J. Santa Rosa en el Arte. Lima, 1967.

Vaca Guzmán, G. I. "La pascua en Tarija." Encuentro boliviano 2, no. 4 (July 1989), pp. 42-47.

Vargas, J. M. El arte ecuatoriano. Quito, 1967.

—. Patrimonio artístico ecuatoriano. Quito, 1967.

Vargas Lugo, E., and J. G. Victorio. Juan Correa: Su vida y su obra. Mexico City, 1985.

Vega, J. J. Ropa y atavíos de lc mujer incáica. Lima, 1982.

Velasco, J. de. Historia del reino de Quito. Quito, 1789.

Villa Moreno, J. La escultura colonial mexicana. Mexico City, 1942.

Weismann, E. W. Mexico in Sculpture, 1521-1821. Cambridge, Mass. 1950.

—. Americas: Latin America in the Era of the Revolution. Washington, D.C., 1976.

—. Art and Time in Mexico: From the Conquest to the Revolution. New York, 1985.

Wethey, H. E. Colonial Architecture and Sculpture in Peru. Westport, Conn., 1949.

Witaker, A. P., ed. Latin America and the Enlightenment. Ithaca, New York, 1967.

Wroth, W. Christian Images in Hispanic New Mexico. Exh. cat. Taylor Museum of the Colorado Springs Fine Arts Center, 1982.

INDEX